Dorothy
and Otis

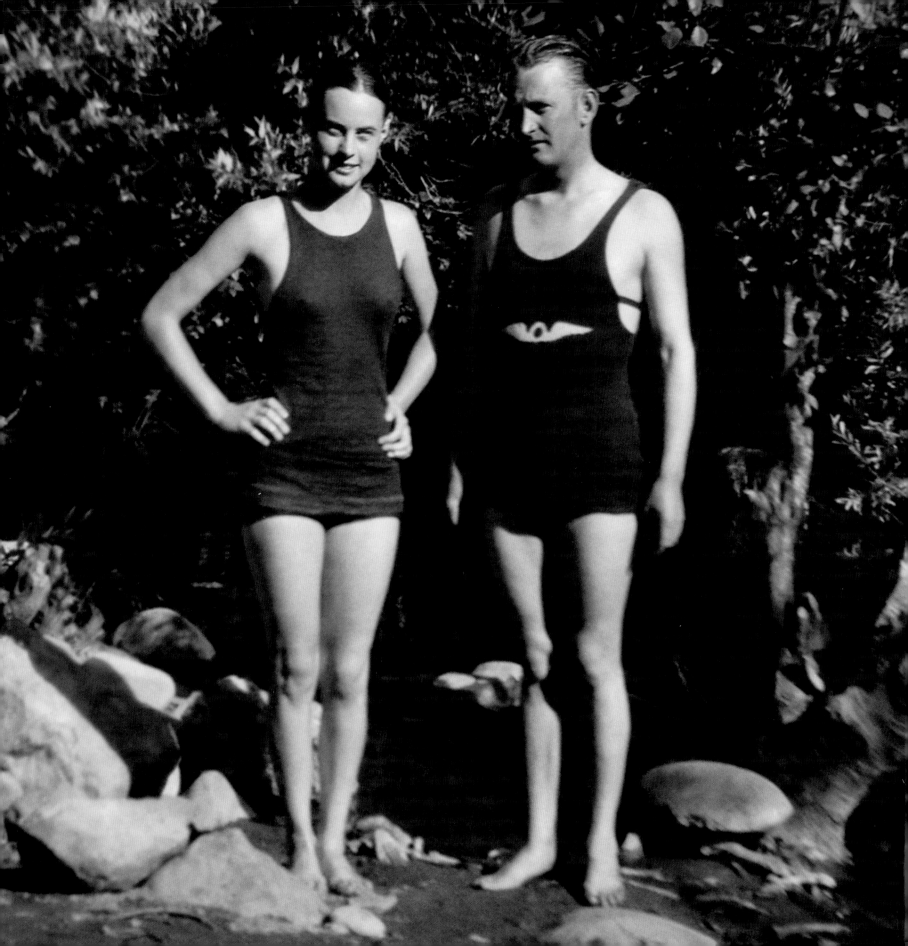

Dorothy and Otis

Designing the American Dream

Norman Hathaway and Dan Nadel

HARPER
DESIGN

An Imprint of HarperCollinsPublishers

HarperCollins books may be purchased for educational, business, or
sales promotional use. For information, please e-mail the Special Markets
Department at SPsales@harpercollins.com.

Published in 2014 by:
Harper Design
An Imprint of HarperCollins *Publishers*
195 Broadway
New York, NY 10007
harperdesign@harpercollins.com
www.harpercollins.com

Distributed throughout the world by:
HarperCollins *Publishers*
195 Broadway
New York, NY 10007

Library of Congress Control Number: 2014935025

ISBN: 978-0-06-226242-4

Printed in China, 2014

Previous page:
**Dorothy and Otis,
Morgan Hill, California.
Circa 1928–1929.**

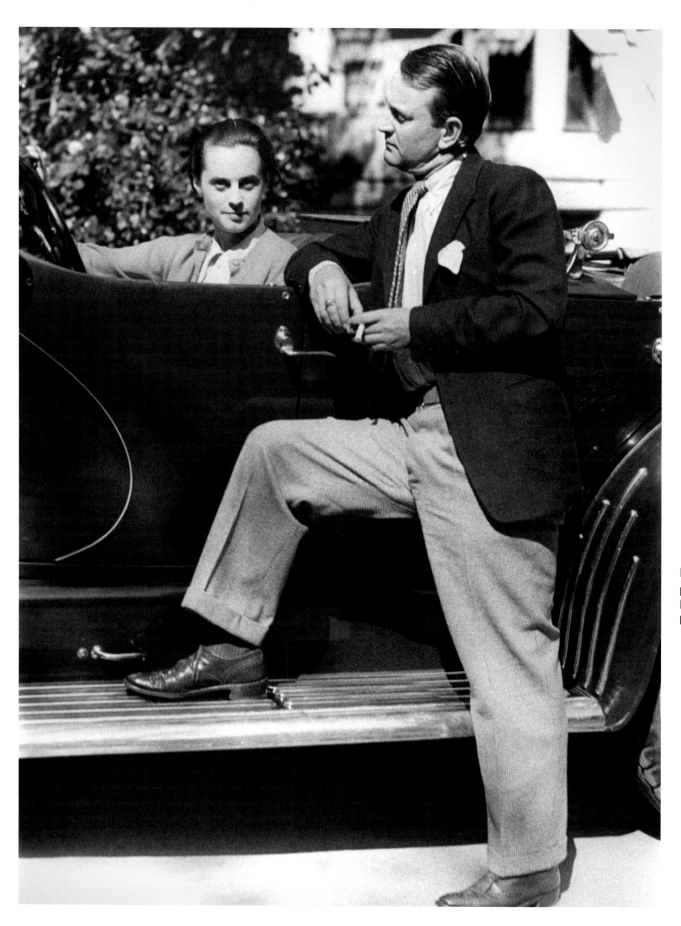

Dorothy and Shep
pose with their beloved
Packard Roadster, circa
late 1920s.

Introduction

Dorothy and Otis Shepard are responsible for some of the most memorable designs of the twentieth century. They worked both as a team and individually, introducing modernism to American design and defining the look of early billboards, Wrigley Chewing Gum, the Chicago Cubs, and Catalina Island, a resort island off the coast of California. With an eye for the big picture and the skill to create stunning illustrations and lettering, they implemented innovative campaigns through paper advertisements and signage. They also designed clothing, interior spaces, and even the Cubs' stadium. Their work was ubiquitous from the 1920s to the 1960s, and while their lives were as remarkable as their work—glamorous, successful, and progressive—their names are all but unknown today.

So how did we arrive at this book? Norman started it. A longtime aficionado of unheralded graphic culture, he authored *Overspray: Riding High with the Kings of California Airbrush Art*, which examines the history of 1970s commercial airbrush art in Los Angeles. I published it through my now-defunct imprint, PictureBox. The airbrush has a long history, some of which leads back to Otis Shepard, "Shep," who was one of the first Americans to truly master it for the creation of luminous images.

Norman knew of Shep before he created *Overspray*, having come across instructional texts by Shepard in nearly every how-to-airbrush book he'd picked up as a kid, and all of the artists featured in *Overspray* cited Shep as an influence. But when researching the designer, Norman found

very few images of him or text written about him. So, as is his wont when exploring a subject, he started a Flickr group to house the images he *could* find. There he put all the ones by Shep his research turned up, and one day—to his shock—Shep's granddaughter, Erin, commented on an image. She mentioned her grandmother, Dorothy Shepard, in the post. Norman had been researching Shep, but he'd never heard of Dorothy.

After a few exchanges with Norman, Erin began posting work made by Dorothy, and it was immediately apparent that she had been a huge talent in her own right. Norman wanted to find out more, and so, at Erin's urging, he called Erin's father (Shep and Dorothy's son), Kirk. Kirk told stories that left no doubt that Dorothy and Shep had a story far more thrilling than history documented—one of artistry, sure, but also of glamour and modernity, baseball and Americana, and the first great female talent in North American modernist graphic design. To Norman's great excitement, Kirk revealed that he had loads of ephemera documenting his parents' work and personal lives.

Shortly after his phone call with Kirk, Norman invited me into his discovery, and we decided to explore it together. Erin, who lives in Paris, visits her father in Arizona once a year, and the four of us decided to converge at Kirk's house in August 2010. Both Norman and I vividly remember walking through Kirk's door and being stunned. There, on the front table, was his parents' legacy: scrapbooks piled high; portfolios bulging with posters and drawings; notebooks; file folders; and boxes of negatives. When we saw that huge trove, we knew we had material for a book that was not just about the design of iconic American images but also about the lives of their designers— for these were dynamic people who had created unparalleled work at a time when the nation was on a social and economic roller coaster. Amazingly, Dorothy had kept meticulous records of her life and Shep's, as if she knew someone might one day come looking for them.

So how is it that Dorothy and Shep are almost unknown today? Well, the medium that initially made them famous, the billboard, lost its glamour once the use of color became the norm in magazines, and later radio and television took over the airwaves and advertising budgets. Dorothy and Shep didn't produce the kind of design work that is most frequently lionized, such as stand-alone

wall posters or book covers. And because billboard designs were rarely archived or credited to their designers, little exists in the design history books about them or the people who made them. The Shepards also created almost too much work in too many mediums for anyone to grasp the entirety of their achievements. Baseball historians might know the Cubs work and graphic design historians might know the Wrigley billboards, but no one besides Kirk and Erin seems to know that the designers diversified so extensively. In the first half of the twentieth century, that kind of portfolio seemingly couldn't exist outside of Europe. Dorothy and Shep also worked on the West Coast and in Chicago, places that have not received the same level of attention as work made in New York; even today, there is much design that remains unexamined from those regions. All these reasons, and perhaps the lack of a concrete legacy of followers, contributed to the Shepards' being left out of most design history books. This book aims to right that wrong and bring the entirety of the Shepards' talents back into focus.

A note on sources: Our knowledge of the Shepards' lives together and apart comes from the sources noted in the text, many of them tucked into Dorothy's scrapbooks, and from our multiple interviews with Kirk and Erin Shepard. Where no source is cited, the information came from Kirk and Erin Shepard.

Shep

From Kansas City to the trenches of World War I:
the early life of a raconteur

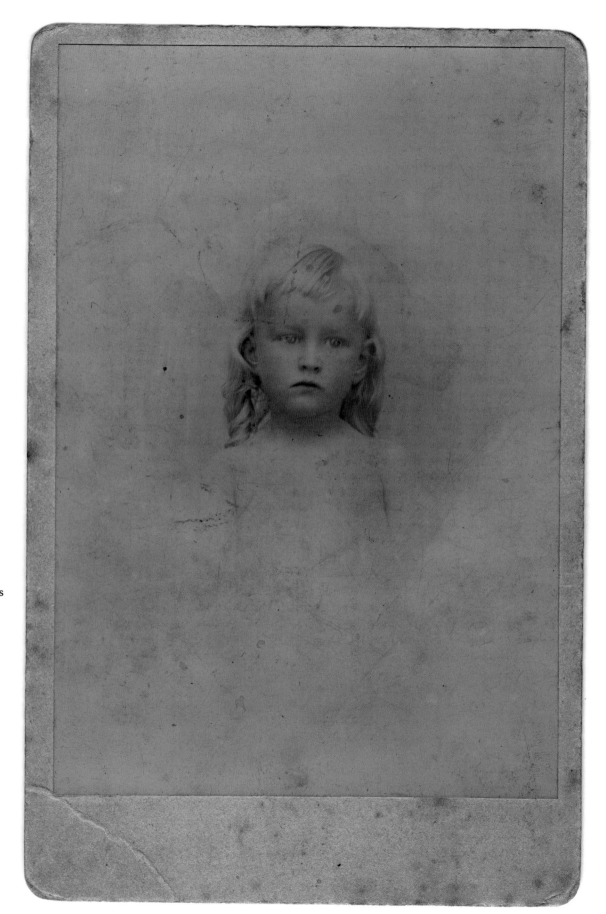

Right: **An undated photograph of Shep.** Opposite page: **Shep and his mother, Nancy Shepard.**

The stories of Otis Shepard's early life are almost too over-the-top to believe. What was documented in various profiles published during his life and in Otis's own colorful autobiographical writings is vast—sometimes contradictory, but always entertaining.

Otis was born in 1894 in Smartville, Kansas. His mother, Nancy, was notoriously tough and was said to have killed a Native American who wandered into her kitchen one afternoon. His father, Lucius Franklin Shepard, was either a traveling salesman or a circus performer; his array of unusual skills included specialties in sword swallowing and fire eating. Some accounts claim that Lucius was an expert sprinter, others that he was a fabulous tenor singer or skilled pool player. A 1945 article in *Sporting News* quotes Otis—or Shep, as he was nicknamed—stating that one of his earliest memories was watching his father "run 45–60 balls to the distress, humiliation, and amazement of some local bumpkin."[1]

In 1906, at age twelve, Shep left home, having completed only the fourth grade. He landed in El Paso, Texas, where he briefly worked at the Humphries Photoengraving Shop as an errand boy. "I was privileged to waste paper and ink in a one-man art department," he later wrote.[2] This was likely his first foray into the world of commercial art endeavors. After this, he was an assistant to a scenic artist and became interested in the stage. Then, in the latter part of 1906, he moved to California, settling in Napa Valley, where he worked with his uncle, who maintained vineyards. There, out in the quiet countryside, Shep and four-horse teams hauled wine between small and large wineries. After a year of this hard physical labor, he went south to San Francisco, where he secured jobs in the bubbling media world. Shep worked first at the *Oakland Herald Tribune* and then at the *San Francisco Chronicle*, where he became something of a teenage wonder, penning political and sports cartoons under the mentorship of the cartoonist Bud Fisher of *Mutt and Jeff* fame.

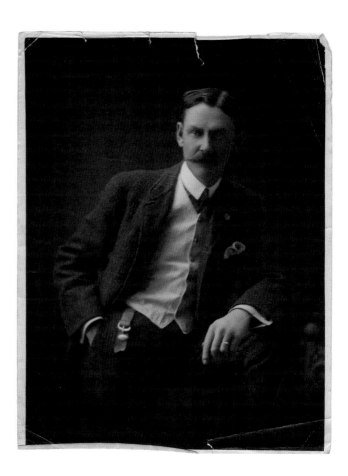

Left: **Shep's astonishing early talent is on display in this drawing, done when he was just eight years old.**

Fisher wasn't the only Bay Area notable Shep encountered. One day, in Oakland, Jack London took young Shep out to the waterfront to give him a lesson in "what life is really like." London picked a fight with the bartender and got badly beaten. Then, sitting on the curb nursing his wounds, London turned to Shep. "There, that's what life is really like," he said.

In 1909 Shep continued his education in drawing and printing by apprenticing for "an old German lithograph artist."[3] But he wasn't done with the theater. Late 1909 found him with the Bishop Players Stock Company, first working on scenery and then, having been encouraged by the actors, taking the stage himself. He performed with them and also with local barnstorming companies in the area until 1912. His future

boss, Charles Duncan, would later tell of Shep's life during this period for a 1929 profile in *Poster* magazine:

> The itinerant aggregation toured the country in a truck and presented melodramas in which Shep was given old man parts because his boyish voice was changing and had falsetto range. When the truck backed down an incline, demolishing the scenery, that venture was ended. The boy crawled into a freight car containing various sets, props, and one broken-down horse, and when the car was unloaded they took him and the horse out of the scenery.[4]

After three years of adventures in theater, Shep "hung out ... [his] shingle"[5] as a freelance

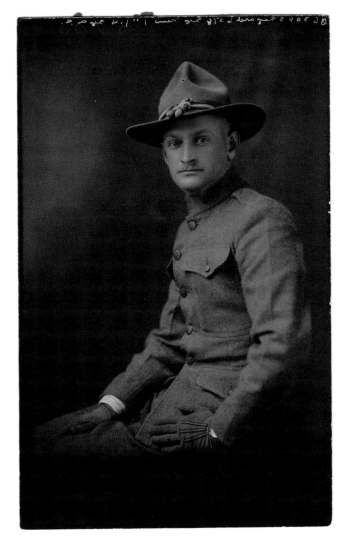

commercial artist. He spent five years on his own, during which time Duncan later described Shep as having completed "pen-and-ink sketches in a peculiar technique developed by himself—chiefly of furniture."[6] Duncan then hired him first as an artist, and then as art director and general manager of Foster & Kleiser Outdoor Advertising Company.

After less than a year in the art department of Foster & Kleiser, working in a realistic, painterly style, Shep, now twenty-four, joined the army's 115th Pioneer Engineers unit. In 1918 he shipped out from Hoboken, New Jersey, to France to fight in World War I. But Shep always liked a good time, so he didn't leave without a going-away party and ceremony. Duncan, Shep's drinking pal Davey Davenport, and various artists

and actors went out to Golden Gate Park and buried Shep's favorite golf club.

Though he began with a pick-and-shovel assignment in the army, Shep eventually became the regiment's official artist. He saw action on three major fronts: Meuse-Argonne, Marbache, and Metz. Through his drawings, Shep recorded everyday life on the ground; he also ascended to the sky by balloon and plane to draw aerial views of the regiments and the battlefields. These drawings were then used for strategic planning purposes. Of course, this was not without danger. One trip was cut short when his plane crash-landed onto a frozen lake. Shep was thrown from the plane and slid across the ice. When he staggered to his feet, his flying jacket tore apart. The back of it had been burned off in the crash. His pilot wasn't so lucky: he was cut in half at the waist.

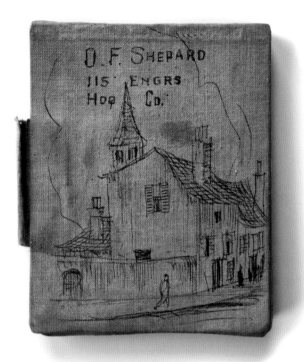

Left: **Shep's 4-by-5-inch sketchbook from his time overseas. In it he drew meticulous portraits of his fellow army engineers (shown below). Though by this time Shep was a professional commercial artist, he had no training, which makes the sensitivity and precision of these pen-and-ink drawings all the more remarkable.**

Earl S. T. Clifford
Pont et Pont-a-Mousson
France 1919
Oakland Cal
577 34th St.

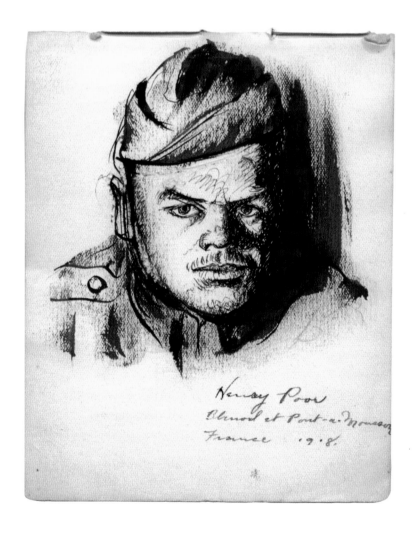

Henry Poor
Pont et Pont-a-Mousson
France 1918

16

Earl H. Farnsworth
Pont-a-Mousson France
Jan 1919

San Francisco
550 19th Av

John Stanley Ross
Pont-a-Mousson France
Jan 1919

Palo Alto Calif

Another time, on a morning sketching jaunt, Shep sat down on a tree stump to draw. As the sun came up, and with it some warmth, Shep and his companions realized that the "morning mist" was actually residual poison gas that had been activated by the sunlight. They'd forgotten their gas masks and they ran from the scene, skin lightly singed.

Shep was injured in the war under somewhat mysterious circumstances. There are two versions of the story: In the version Shep told his children, his colonel ordered him and another soldier to go into a French town that had supposedly been abandoned by the Germans. As the two walked down the main street, a German machine-gunner opened fire. Shep was wounded in the knee and his companion was killed. The story told to Kirk by the colonel, who remained a friend of Shep's after the war, was that a number of the men in Shep's unit were of Serbian descent and had a special hatred for their Turkish and German foes. At night, many of them would crawl across the no-combat zone, maneuver into the German trenches, and cut the sleeping German soldiers' throats. During one such raid, Shep was shot in the knee. For a short time he was reported missing and presumed dead.

Right: **A 19-by-25-inch charcoal sketch rapidly done in the field in 1918. The dirigible pictured here was the kind of balloon Shep would have been in when drawing from the air.** Below: **A 1918 drawing of armaments on the battlefield.**

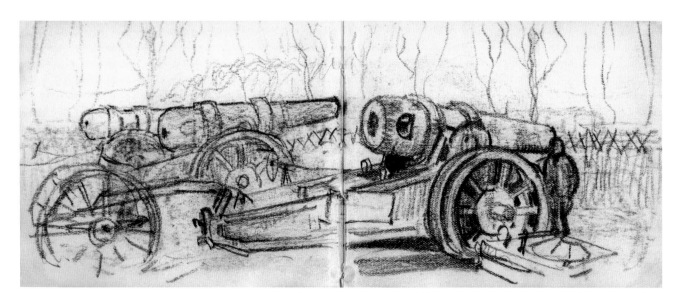

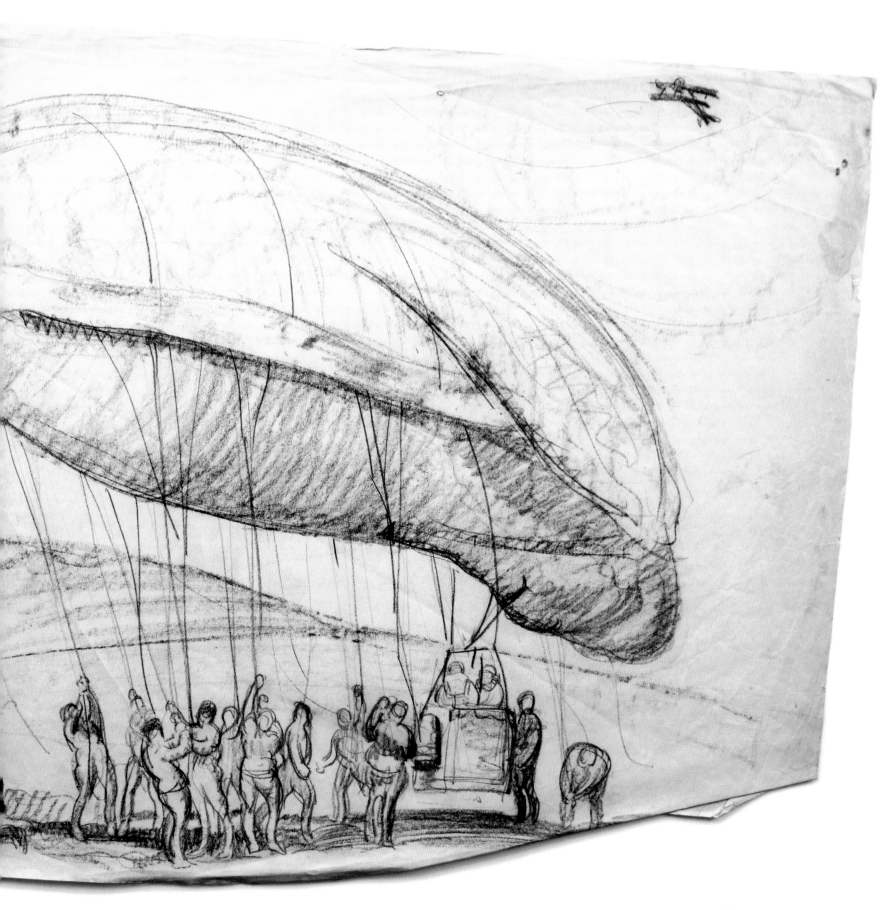

Above: **Shep, the regiment artist, in 1918.**
Right: **An evocative drawing from the sky typical of Shep's work during World War I. Shep's caption reads:** "Moselle Valley. From observation balloon Jan 10, 1919. Pont-á-Mousson, France."

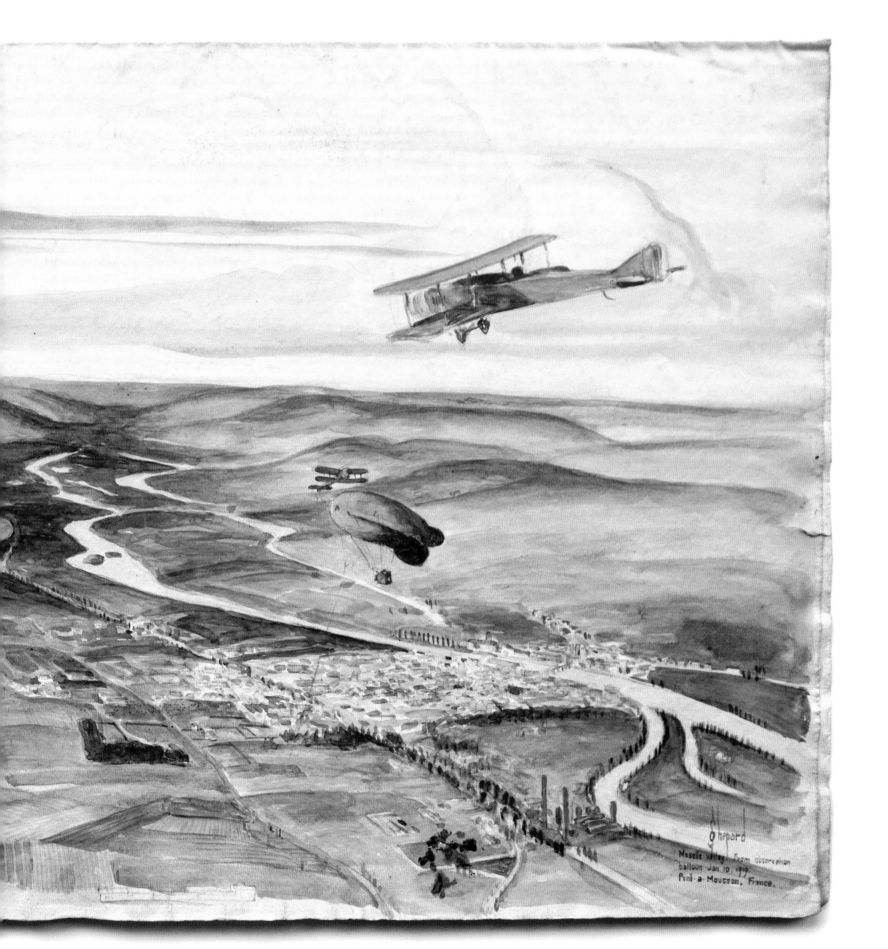

Sheppard

Moselle valley from observation
balloon Jan. 10, 1919
Pont-a-Mousson, France.

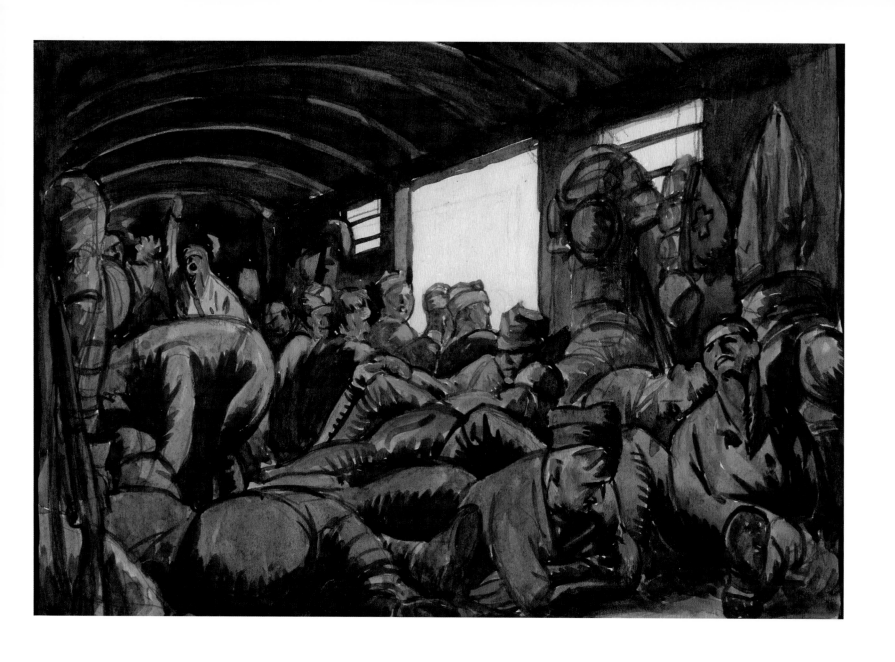

Above: **Shep's haunting watercolor of a crowded train carrying exhausted and wounded troops in 1918.**

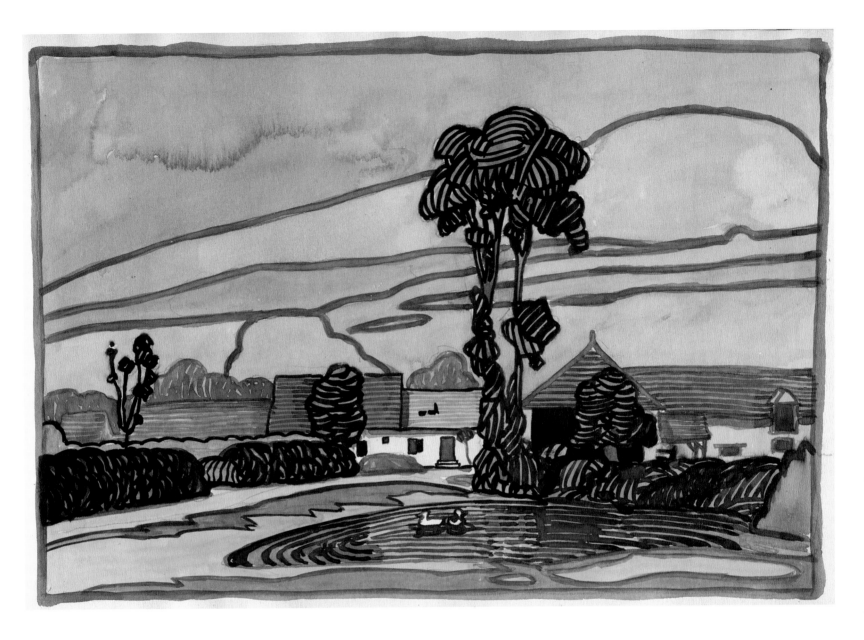

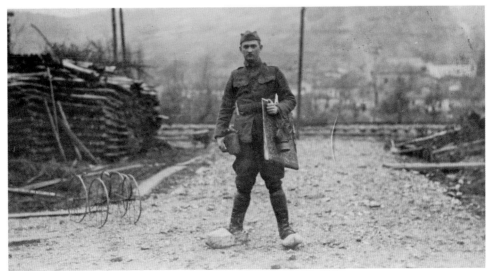

Above: **A serene landscape Shep painted while in Germany in 1919.**
Left: **Shep wearing wooden clogs and carrying his gas mask and sketch pad, 1918.**

After the Allied nations' 1918 armistice with Germany, Shep renewed his theatrical interests. He organized a "show troop of talent"[7] from his own regiment, and in two large trucks they toured American outposts in Europe, even performing before the Grand Duchess of Luxembourg. He also produced at least one poster for the troop. Once that adventure was over, Shep stayed on in Ruhr, Germany, to enjoy the scenery. He used to say that despite it all, he liked the Germans and bore them no ill will, except that his bullet wound screwed up his golf game. When he finally made it back to San Francisco, he ran into Davey Davenport on Market Street, who nearly fainted—"dead" Shep was back among the living.

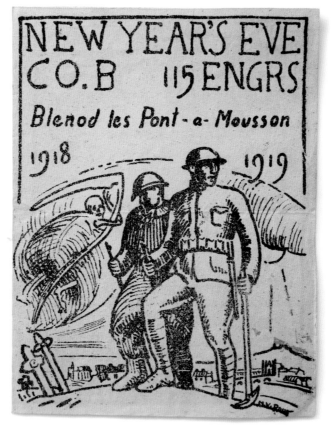

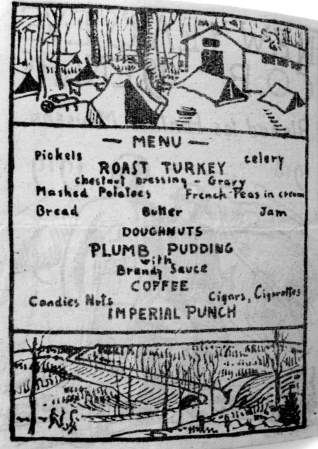

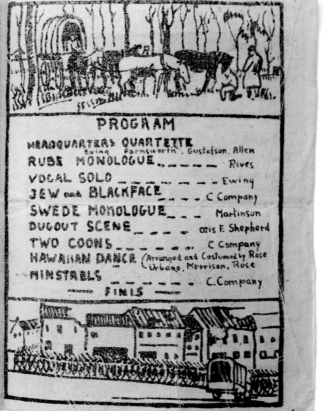

Opposite page: **Shep's program for a New Year's Eve performance of the variety show he organized. Note Shep's own contribution: "Dugout Scene."**
Right: **Back in San Francisco in 1922, Shep designed this poster for a benefit carnival for World War I veterans.**

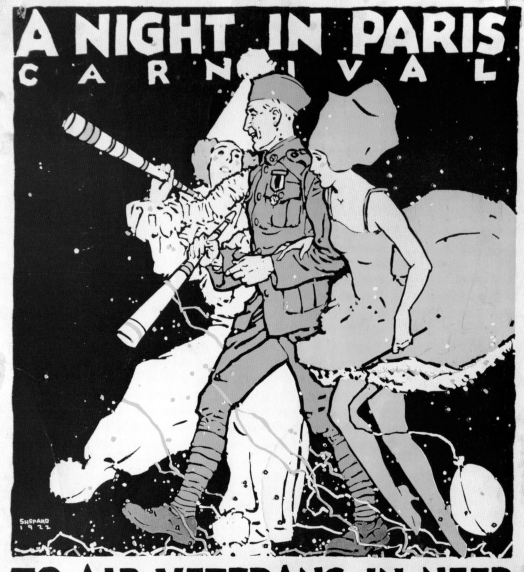

Dorothy

Growing up modernist:
Dorothy Van Gorder in Berkeley and San Francisco

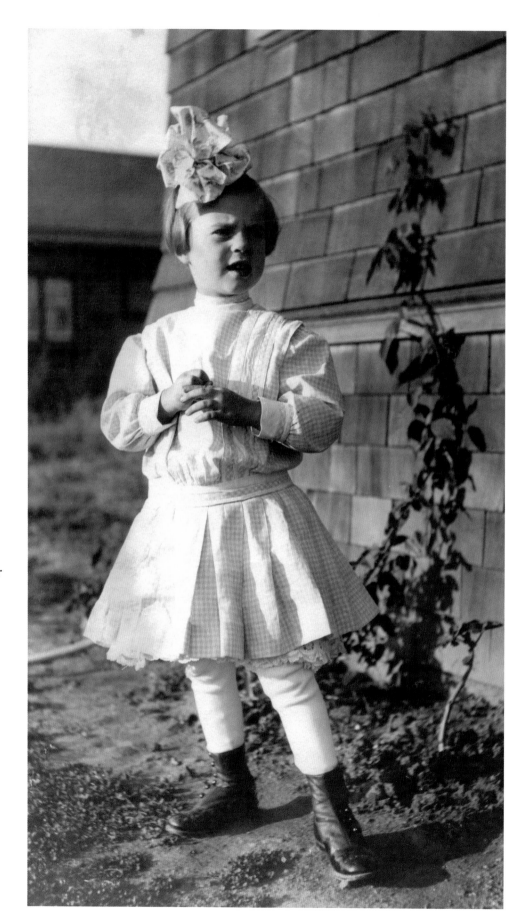

Right: **Dorothy as a toddler in Berkeley.**
Opposite page, above:
Arthur Grant Van Gorder.
Opposite page, below left:
Dorothy's calling card, early 1920s.
Opposite page, below right:
Dorothy and her brother, Hale, in the late 1910s.

Dorothy Van Gorder was born in Berkeley, California, in 1906 to Arthur Grant Van Gorder and Jessie Van Gorder. Arthur was a professor at the University of California, Berkeley, and Dorothy was one of two children born to the open-minded and supportive couple. She grew up in Berkeley and then moved to rural Morgan Hill, where Arthur took a job as a high school principal.

As a teenager, Dorothy was strong-willed, confident, and popular. She used to tell a story about a classmate who thought he might impress her by taking her out shooting. Dorothy shocked the young man when with a Colt single action .45, she displayed excellent marksmanship.

Dorothy seemed to have it all together, and yet she chafed within the confines of the small town (she referred to Morgan Hill as "Morgan Hell"). In only three years, at age sixteen, she graduated from Morgan Hill High as class valedictorian. She was determined to get back to city life in Berkeley, and while her father was supportive, he was also nervous at the prospect. He told her, "Do what you're going to do, but just don't be a damn fool." So she did what she was going to do and enrolled at the California School of Arts and Crafts. She was a favorite of the teachers at CSAC, particularly the dean, who enthusiastically supported Dorothy's interest in fine art. Dorothy again graduated in three years, and again was valedictorian.

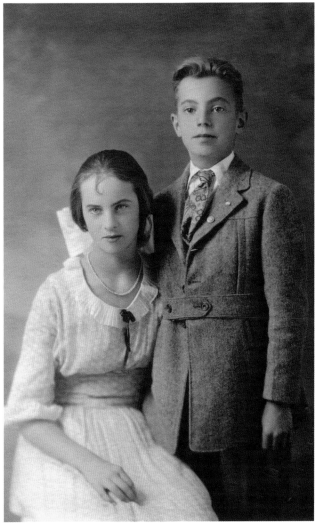

Miss Dorothy Van Gorder

Below, left: **Dorothy, age eighteen.**
Below, right: **Graduation day at CSAC. Dorothy's favorite professors, from left to right: Perham Nahl, Xavier Martinez, Dr. Porter** (a patron, not a professor), **and Frederick H. Meyer.**
Opposite page: **Dorothy's interpretation of a dance movement at the Estelle Reed school.**

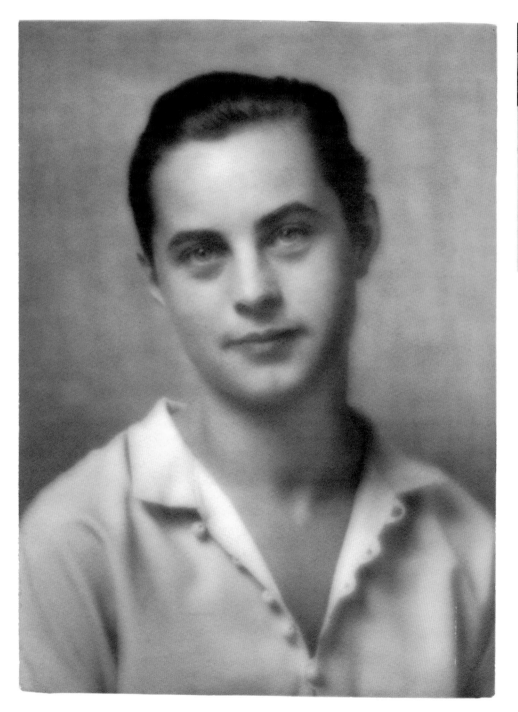

Firebird

32

Every bit the bohemian, Dorothy favored short hair and sleek, dark clothing. After college she lived at 1217 Lombard Street in San Francisco before being evicted for nude sunbathing on the roof of the building. She attended night classes for dance and fine art and designed costumes and programs for the Estelle Reed Dance Company, an avant-garde dance troupe. Her costume designs were exuberantly modern—asymmetrical, vibrantly colorful, and sexy. She also made uniquely beautiful holiday cards. Their formal compositions and abstraction displayed a virtuosic hand.

When Shep asked Dorothy's former classmate Magenta Wilson, a young artist excelling at Foster & Kleiser, if there were more talents like her at her school, Magenta recommended Dorothy. In 1927, just after her graduation, twenty-one-year-old Dorothy was hired as an artist. Her early work reveals that she was keenly aware of the new European visual culture that was so prized at Foster & Kleiser and that she had the skills not just to emulate it, but also to make work that was personal and original.

According to family lore, Dorothy was hired, quickly fired for her brashness, and then re-hired because they needed her skills. It's unknown what Shep's first impression of Dorothy was, but despite—or maybe because of—her attitude, a courtship began. Dorothy, the young bon vivant. Shep, the established raconteur.

Opposite page: **Dorothy's portrait of her roommate and lifelong friend Agnes Boberg, 1927.**
Right: **A sketch from a life drawing class, circa 1927.**

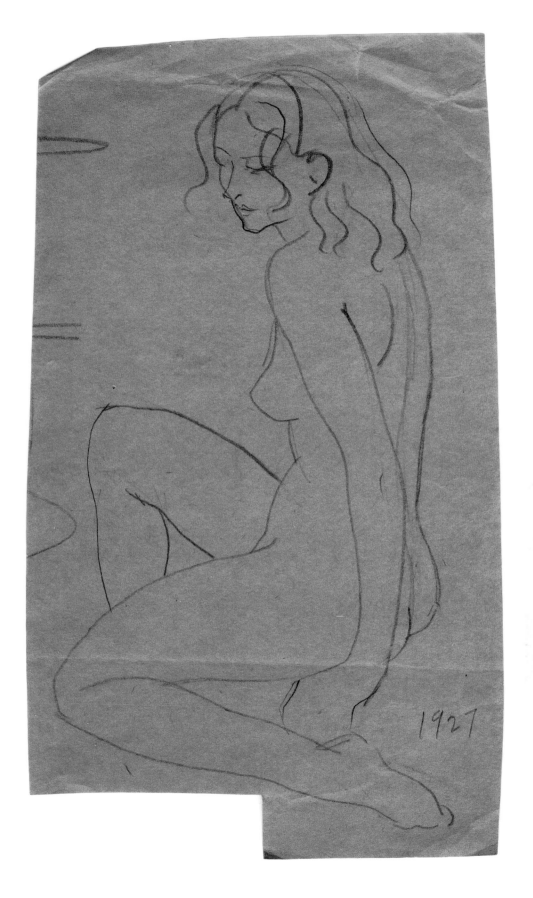

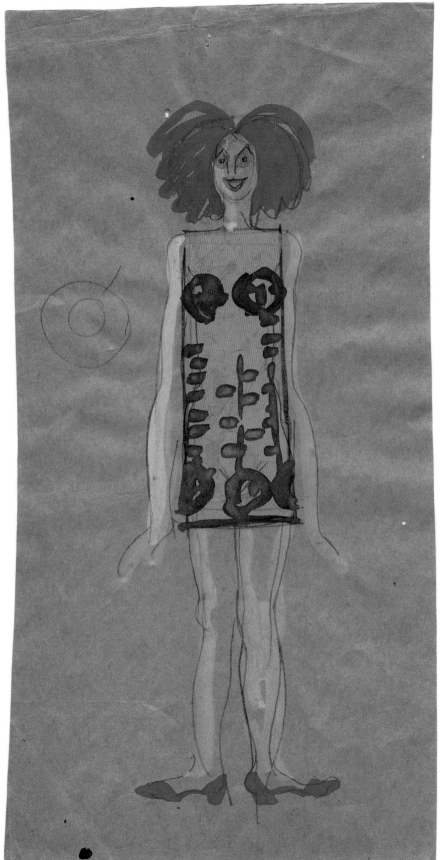

Dorothy's exuberantly modernist designs for the dancers at the Artists Ball in San Francisco, 1927. These designs show the influence of the German expressionist movement then filtering into the United States.

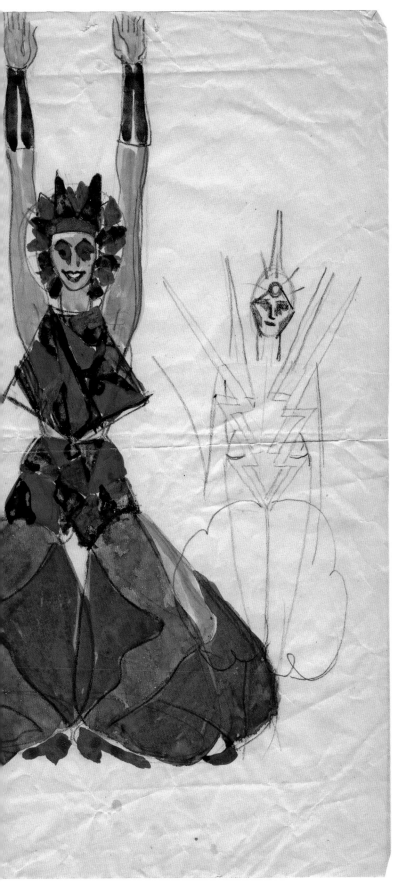

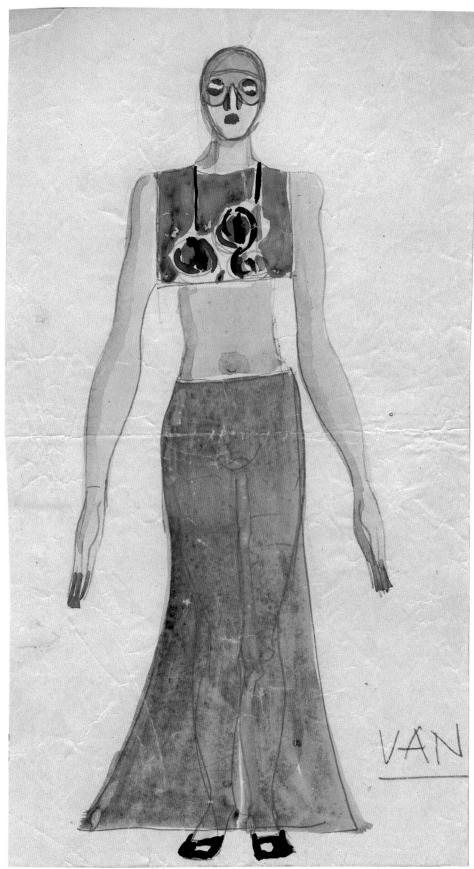

VÅN

THE ARTISTS BALL
COSTUME FOR MY ESCORT

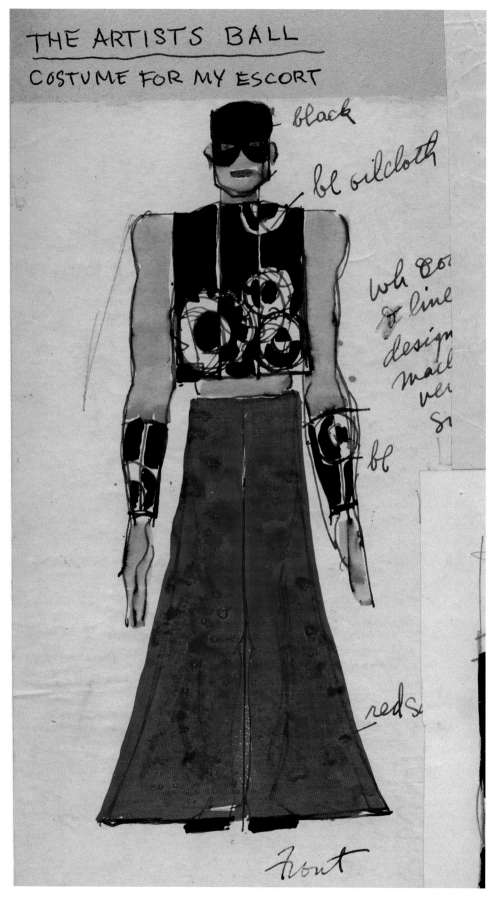

black

bl oilcloth

wh 800
& line
design
mad
ver
S1

bl

red s

Front

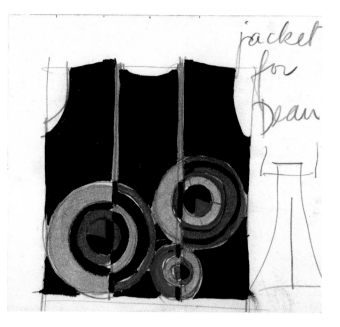

jacket
for
Dean

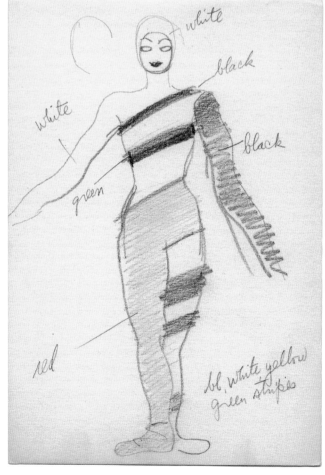

white

white

black

green

black

red

bl, white, yellow
green stripes

ESTELLE REED

Dance Artist

Dorothy Van Gorder

Presents

"An Evening of the Dance"

**TUESDAY EVENING
OCTOBER 15**

COMMUNITY PLAYHOUSE
Sutter and Mason
8:30 P. M.

∞

Management—ALICE SECKELS—Fairmont Hotel

Opposite page: **More 1927 Artists Ball costumes, including one for Dorothy's date and one for the dean.**
Left: **Program design for an Estelle Reed production, circa 1920s.**

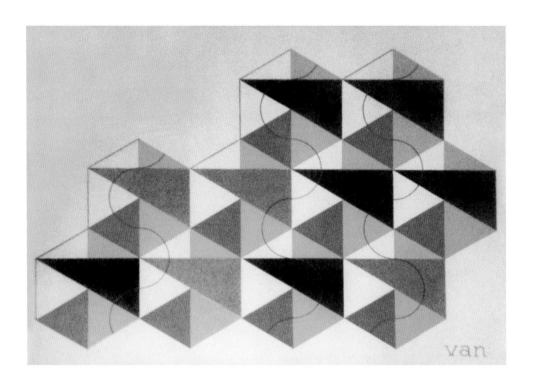

Above and on opposite page:
**Abstract painting
and drawing from the
late 1920s created by
Dorothy, showcasing
her inventiveness with
hard-edged geometric
forms and illusions of
three-dimensionality.**
Right: **Caricatures of
Dorothy by Agnes Boberg.**

d shepard

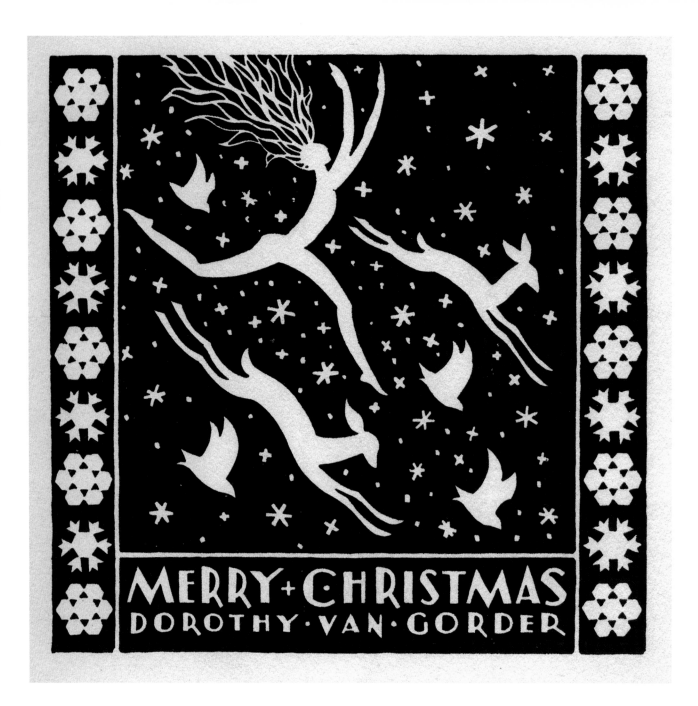

MERRY + CHRISTMAS
DOROTHY · VAN · GORDER

Above and on opposite page:
Two beautiful Christmas cards created by Dorothy in 1927 and 1928. Note the dance figures in the 1928 card, as well as the clever use of minimal linework to evoke the San Francisco streetscape.

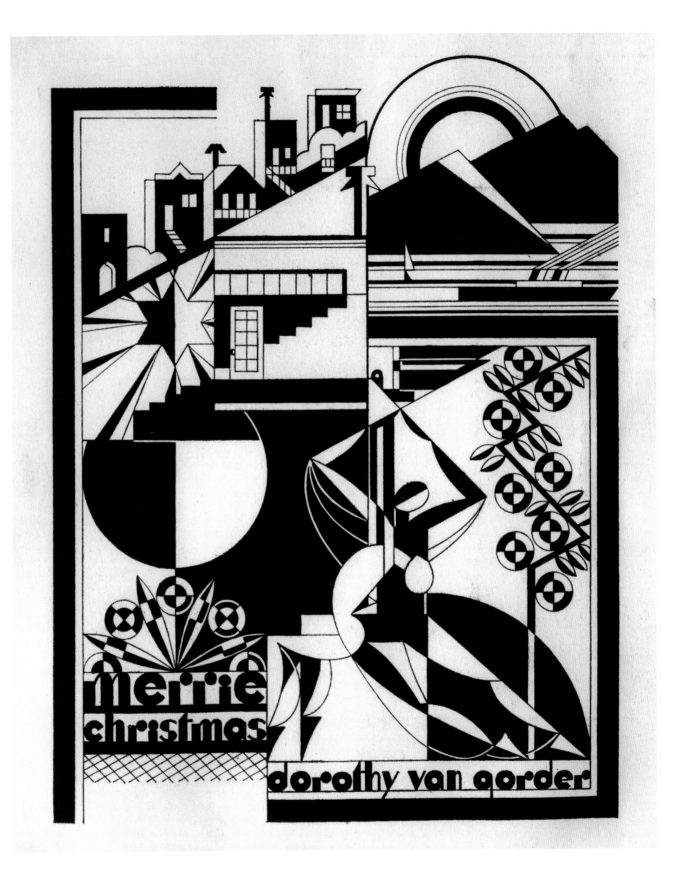

Billboards

Riding high in a new medium,
Dorothy and Otis embark on marriage,
a life in New York, and a fateful trip to Europe

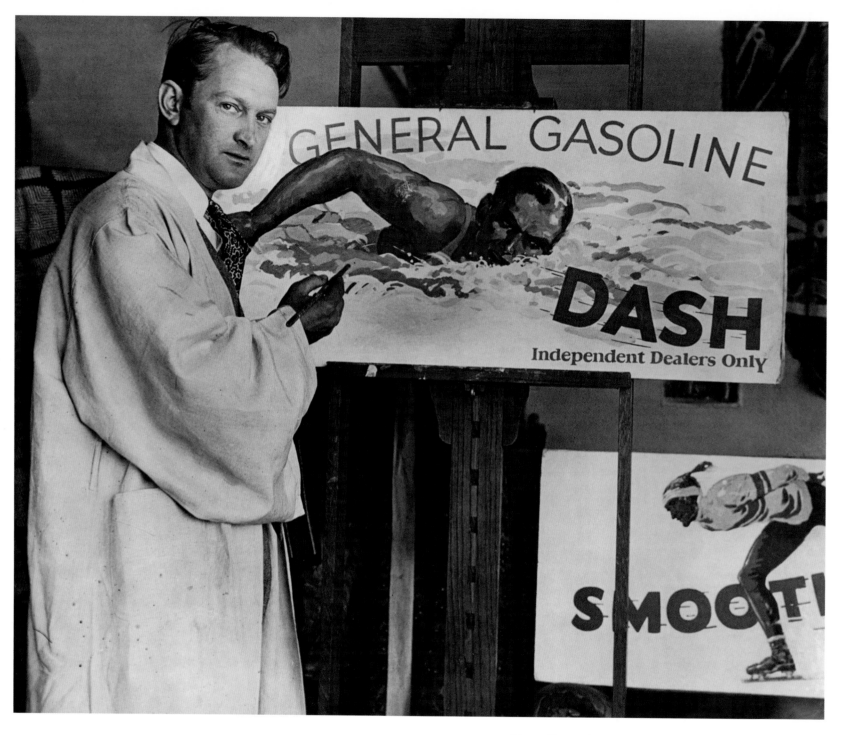

Above: **Shep in his painting smock at Foster & Kleiser, standing before a painterly billboard he created for General Gasoline, mid-1920s.**
Opposite page: **A more officious Shep in his role as general art director of Foster & Kleiser.**

In 1919, after his return from the army, Shep returned to San Francisco and Foster & Kleiser. Still well liked by Charles Duncan, who had remained in charge, Shep was swiftly promoted to art director for the northwest region of the company, at its Seattle branch. He stayed in Seattle until 1923 and then returned to his adopted home of San Francisco, where he was appointed general art director of all eleven branches of Foster & Kleiser. This was considered one of the best commercial art positions in the country. He also began teaching evening classes in commercial art at the California School of Arts and Crafts.

A job at Foster & Kleiser was intrinsically prestigious. The company had been founded in 1901 by advertising salesmen Walter Foster and George William Kleiser; it specialized in advertising campaigns on billboards and buildings. This was a new method of advertising when Foster and Kleiser opened their agency, but with the passing of the Federal Highway Act in 1921, which supplied funding and support for the expansion of the national road system, the method began to boom. Soon after, there were long expanses of road and more automobiles on them. As a result, outdoor advertising became the broadcasting system of its time—and Foster & Kleiser had already monopolized this form of advertising.

Before the boom, most advertisements were in magazines. They were usually in black and white and often suffered from mediocre printing. By contrast, billboards and building artwork were in color, and illustrations on billboards could be lavishly printed. Being given the chance to work on them was the ultimate opportunity to show off one's draftsmanship, color sense, and painterly skill. They were also enormous. Each billboard consisted of twenty-four lithographed sheets totaling 10.5 by 22.75 feet, and was framed by a painted wooden structure. The most successful outdoor advertising companies, like Foster & Kleiser, both owned the structure and created its advertisement for their clients.

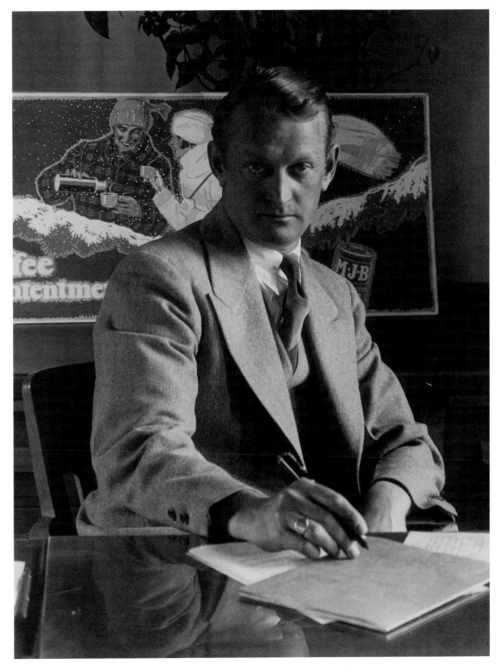

As billboards became ubiquitous, national legislation was proposed to limit the size and scope of them. Foster & Kleiser responded by advocating for the beauty of the billboard—for what it added, rather than detracted, from the landscape. To emphasize this, the company poured money into hiring the best artists it could find—in the process becoming the most renowned outdoor advertising company on the West Coast.

By the early 1920s, Charles Duncan was the "general manager, good will promoter, advertising counselor—anything and everything that the company might need him for."[8] He'd always recognized Shep's flair for theatrics and quick sketching—part of the reasons he'd been quick to hire Shep and give him promotions—and so he would bring Shep along to meetings with potential clients. Shep would draw as Duncan talked. Gradually Shep began to make his own pitches and take client meetings on his own. As both an art director and account manager, he was known as an idea man.

In the 1920s Foster & Kleiser employed twenty-four artists who sat at desks on the second floor of the company's headquarters. The art was sometimes developed by the entire art department.

Glenn Wessels, who was one of the younger artists on the floor, later described the process: "Very often two or three of us would have to work on one piece. For instance, we would have one man who was an expert at painting tin can tops, and another man might be good at something else; we would often combine our talents. A lettering man might put the letters in and somebody else might do the animals and somebody else might do the girls' faces. We had one boy who could do a very chic fashion figure type. And when we had pretty girls in bathing suits, he would always do those. We were specialists."[9]

In the mid-1920s Shep's greatest success was with the national soap brand White King Soap. The image he developed for its billboards was a blond-haired, blue-eyed six-year-old girl and her white terrier going about their everyday lives. Some advertisements featured the two huddled together under an umbrella; some had the pooch watching the girl do her homework; in others they have Christmas together. The tag line: White King Washes Everything. Shep intended that the advertisements would appeal to the perceived audience for White King Soap. He was a pioneer in researching the demographics

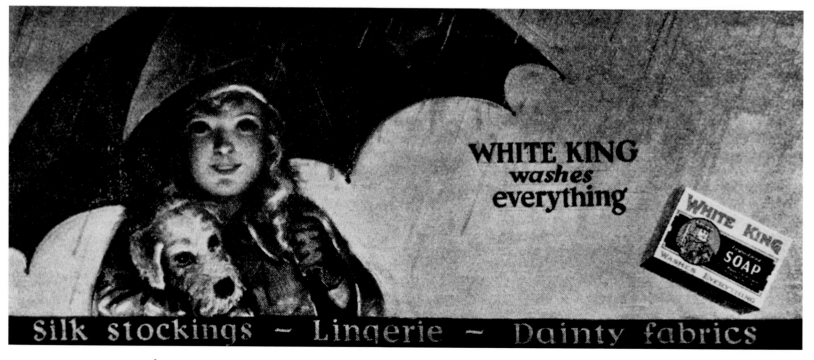

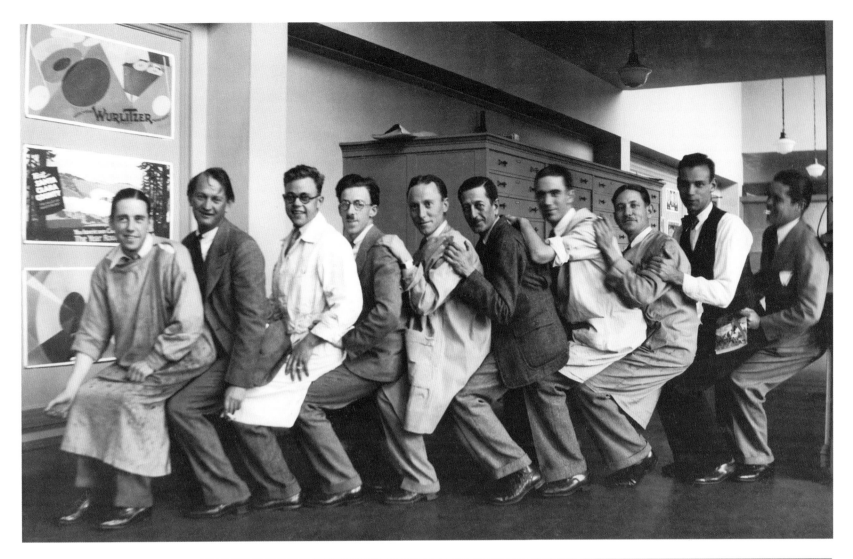

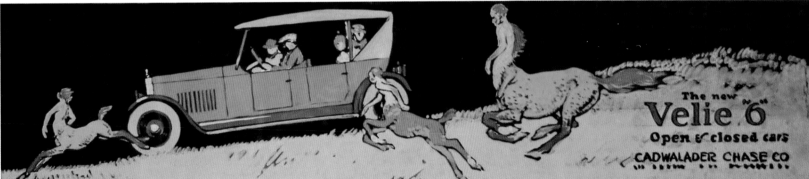

Opposite page: **Shep's great mid-1920s success: White King Soap.**

Top: **Hamming it up in the Foster & Kleiser art studio in the late 1920s. Shep is second from the left.**
Above: **A circa-1922 preliminary drawing for a billboard for Velie, an early American automobile company.**

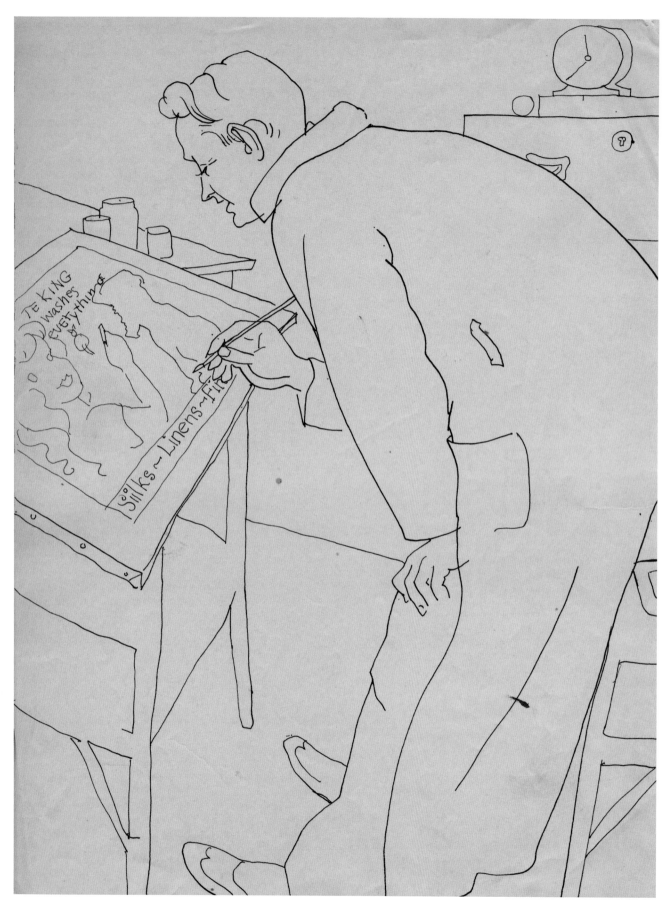

interested in a particular product by collecting data through the mail and at retail stores, and the research showed that White King Soap was primarily purchased by women averaging forty years old. So while the abstractions of modernism appealed to him, he chose a deliberately old-fashioned approach to the advertising campaign for White King Soap—one that was painterly, refined, and pleasing to the eye.

Assessing the field of advertising in a 1929 profile of him for *Poster* magazine, Shep spoke about his conceptual approach to design:

> I am interested in symbolism. The artist who works in the modern style works in symbols of one kind or another, either intellectual, such as words and phrases; literalistic, representations of the photographic kind; or subconscious symbols, getting his effect through an appeal to certain mental reactions without the realization of the onlooker. The modern approach differs from the traditional method in that it makes greater use of the latter kind of symbols. Certain combinations of line and color that speak an almost primitive language, which express dramatic action and appeal to the intuitive emotions— these are the materials used in the symbolic methods today.[10]

This approach evolved with his community at Foster & Kleiser, which also employed notable artists such as Diego Rivera, Maynard Dixon, Fred Ludekens, and Harold Von Schmidt. Together, they looked at the most conceptually advanced graphic work of the day, which meant the abstract art coming out of the Bauhaus, the European poster artists, and the London Transport posters. Outside of the office, intersecting with Otis and Dorothy's social circle, were photographers Edward Weston (who later shot portraits of Dorothy and Shep) and the young Ansel Adams, who used to develop and print film for the Shepards. Joseph Sinel, a pioneering modernist industrial designer, became close friends with Otis.

Opposite page and below:
Dorothy's portraits of Shep at work on the White King Soap campaign, 1927.

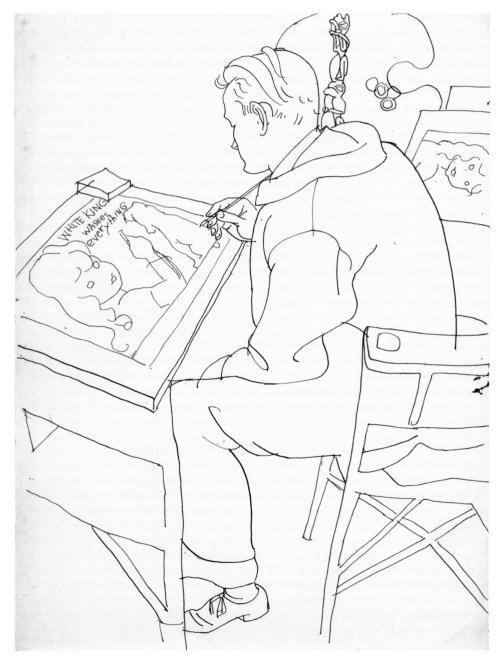

Left and on opposite page: In 1928 or 1929 Dorothy brought Shep home to Morgan Hill to meet her family and spend time doing recreational activities in the area. Dorothy's brother, Hale, recorded their visits.

In November 1929, Shep and Dorothy were married. They honeymooned in Santa Barbara and then Europe, visiting Paris, Venice, Zurich, and Vienna, where they met the modernist designer Joseph Binder. Abstraction was the order of the day in Vienna, and Binder was working as a freelance graphic designer. For the Shepards, Binder's work brought on a revelation. Shep and Dorothy already wanted their work to convey meaning through compositional structure—instead of realism—but Binder took it even further, reducing an image to a series of shapes and forms and integrating typography into his pictures. Binder was also using delicate airbrushed fades from one color to the next. In later years Dorothy and Shep arranged trips to Chicago for Binder, once for him to judge a poster contest and at other times for lectures at the Art Directors Club. Enamored of the modernist European design culture, the couple purchased Bauhaus furniture on this trip, pieces that they later used to furnish their New York apartment.

Dorothy and Shep had followed the modernist developments in magazines, but to see it all in person was invigorating—it meant a greater understanding of the scale and the power of this new language. They returned to San Francisco bursting with ideas.

After their trip to Europe, Shep moved away from painterly realism to a language that was inspired by European modernism yet adapted to his own sensibility. He began to focus on the harmonious interplay of color and form to represent a single salable idea. He was, in a sense, an avant-garde populist in graphic design, bringing the new aesthetic to all regions of the country. The only other American graphic designer widely known for working with a European approach to the American vernacular was Lester Beall, who was based in Chicago and then New York, working on publications and posters.

Helping shape Shep's new style, which carried over to his art team, was his use of the airbrush, a tool that can produce subtle fades and gradients from one color to the next, giving a surface a sheen that it might otherwise lack. Airbrushes were traditionally used for retouching photographs, not rendering forms. Shep's use of the tool was inspired by Binder, and it differentiated his work from that of more illustrative artists, who relied on thick outlines or more overt painterly touches. Shep went sleeker and more reductive, and since Foster & Kleiser always valued innovation, his new work was well received.

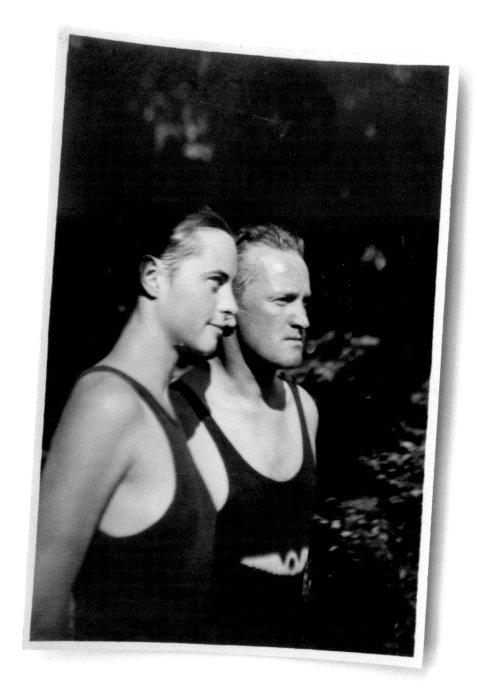

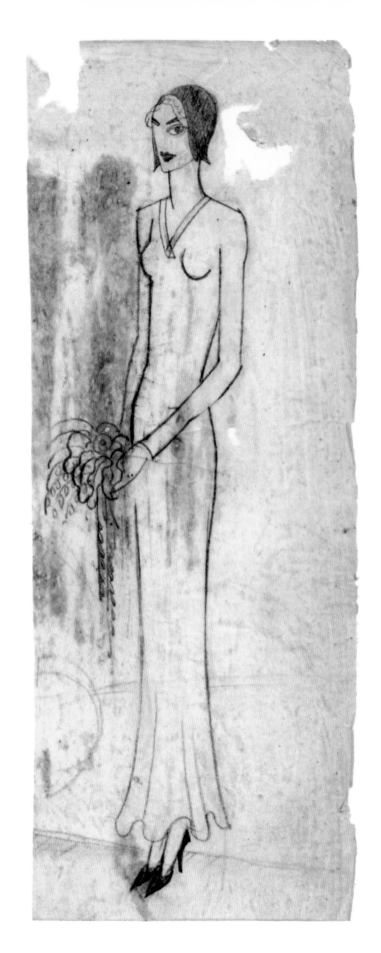

Right: **Dorothy on her wedding day, November 8, 1929, as drawn by Shep.** Opposite page: **The honeymooners in Palm Springs, November 1929. Photographs by Dorothy and Shep.**

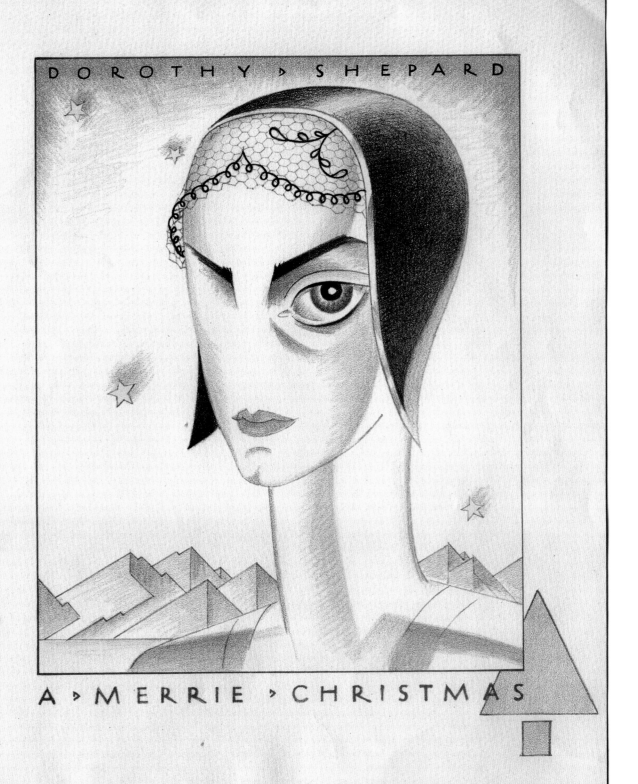

DOROTHY ▷ SHEPARD

A ▷ MERRIE ▷ CHRISTMAS

Dorothy's stunning drawings for the newly married couple's 1929 Christmas card.

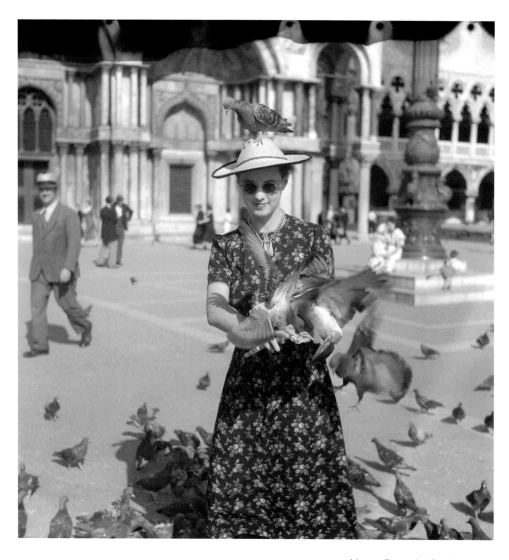

Above: **Dorothy feeds the pigeons in Piazza San Marco, Venice, 1929. Photograph by Shep.**
Right: **Seeing Venice via gondola, 1929. Photograph by Shep.**

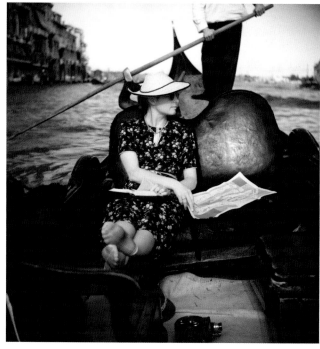

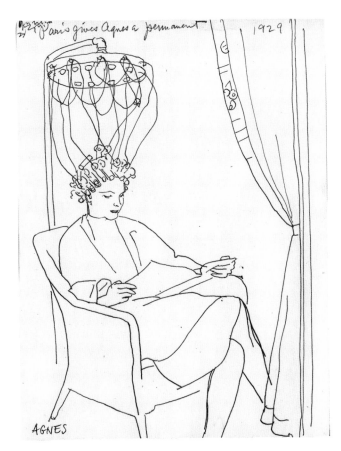

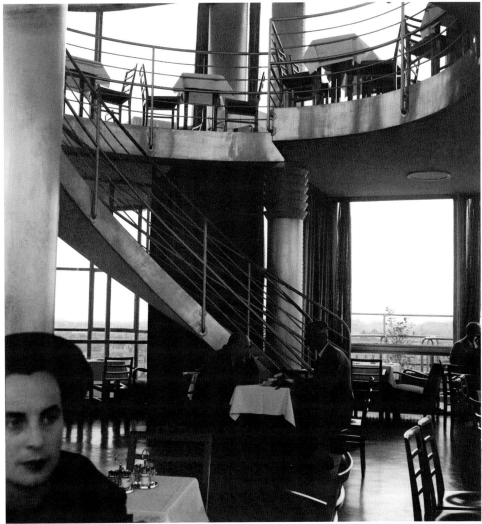

Clockwise from top left:
Dorothy's drawing of her lifelong friend Agnes Boberg getting a "permanent" in Paris, 1929;

Photographs from the European vacation: **Dorothy having a meal in a modernist café in Vienna around the time she and Shep visited Joseph Binder,** 1929. Photograph by Shep: **A building with an ominous new symbol, Germany, 1929; Inspirational modernist posters pasted on the walls, Paris, 1929.**

Shep's new style was exciting for him, but he was also becoming restless with his administrative duties as an art director. Always on the lookout for a new challenge, he began to wonder what life might be like if he was a freelance designer. In early 1930, at the request of a friend in an advertising agency, Dorothy and Otis took a freelance job together (one advantage of being the boss was that Shep could sometimes work outside Foster & Kleiser), designing a poster for Chesterfield Cigarettes.

Chesterfield Cigarettes was owned by Liggett-Meyers, and its executives liked the design so much that the company paid for the newlyweds to go to New York and live and work in a room at the swanky St. Regis Hotel in order to produce the next big Chesterfield campaign. Dorothy airbrushed the lettering and Shep airbrushed the figures. Fifty years later Dorothy picked up the story:

> There were fierce summer thunderstorms that year. A very dramatic time, what with the stock market crash and all. We would get up and go to Park Avenue and then go back and work all day long. We wanted to please these southern gentlemen and they were very sweet and cordial with us, although they were extremely tough when it came to the business of their new campaign.[11]

As Shep told it:

> I had a design in which I drew up a very dramatic sort of background, which was nothing but red and black. There was a big package, which was opened, and the cigarettes were coming out of the top of it. So after three weeks I went down one day and Mr. Toms (the Chesterfield man in charge of the project) said, "Mr. Shepard, we have accepted your poster, but you haven't proved to us yet that you're an artist, because we haven't seen any pretty girls you have drawn." Well, I said, "I don't specialize in pretty girls, myself." "Well," he said, "in our estimation

you're not an artist until you draw pretty girls." So I went back. I was working in the hotel. I had a studio set up there. I had been married that year, and my wife at that time was twenty-three years old, so I used her as a model and I made this stylized drawing of her.

> Then more conferences started. And after another two weeks it looked like the poster and everything was all O.K. We had our reservation to go back to San Francisco. Then they called me down to the office, and Mr. Toms said all the vice presidents were looking glum, not saying a word. "Mr. Shepard, how old is this girl? Is she old enough to be smoking cigarettes?" He said, "You know, Mr. Shepard, we have to be a little careful." I said, "I don't know. My wife posed for it. She's twenty-three. It's stylized. After all, it's not a realistic design. It's purely a vogue-ish thing." But nothing was accomplished. My answer hadn't been satisfactory. About that time the treasurer of the company, Mr. McGinnis, was bringing in some papers for the president to sign. While he was there, Mr. Toms said, "Mr. McGinnis, we're thinking about using this girl, so you think she's old enough to be smoking cigarettes?" Mr. McGinnis looked over his glasses and said, "Well, if she's old enough to be plucking her eyebrows and painting her lips up like that, I guess she's old enough to be smoking cigarettes." Then Mr. Toms said, "Mr. Shepard, your poster has just been accepted."[12]

The final billboard depicts a streamlined beauty, not at all unlike Dorothy, set against a geometric backdrop, her eyes on the cigarette package tilted in the corner. The work links up perfectly to Shep's 1929 theories of composition: it's the symbolic pull of the primary form (in this case a beautiful woman) that attracts the eye, and it's the glamour and mystique, brought to the height of sophistication with those modernist forms, that do the selling.

Dorothy's visage on a street
corner in New York, 1930,
amid less vibrant fare.
Dorothy often said that
the Chesterfield billboard
"changed our lives."

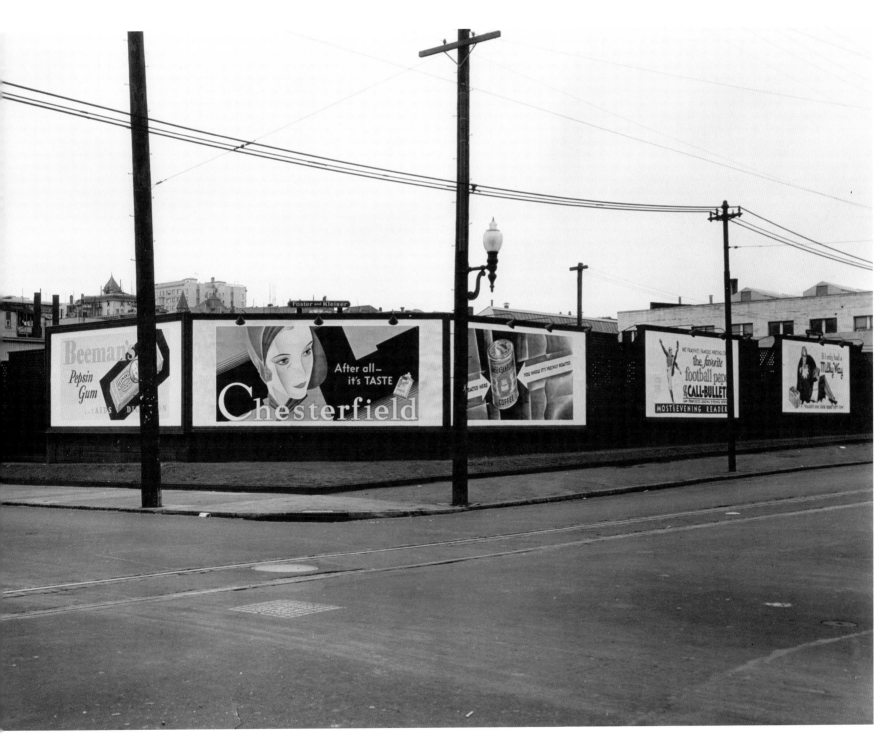

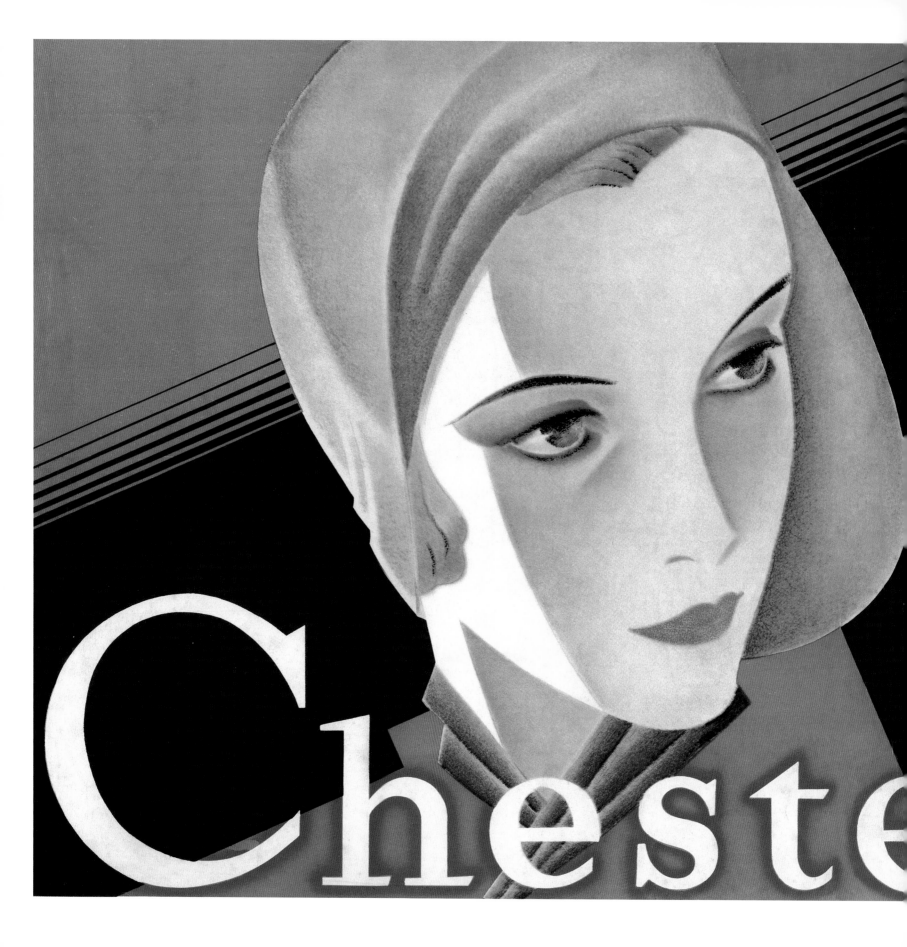

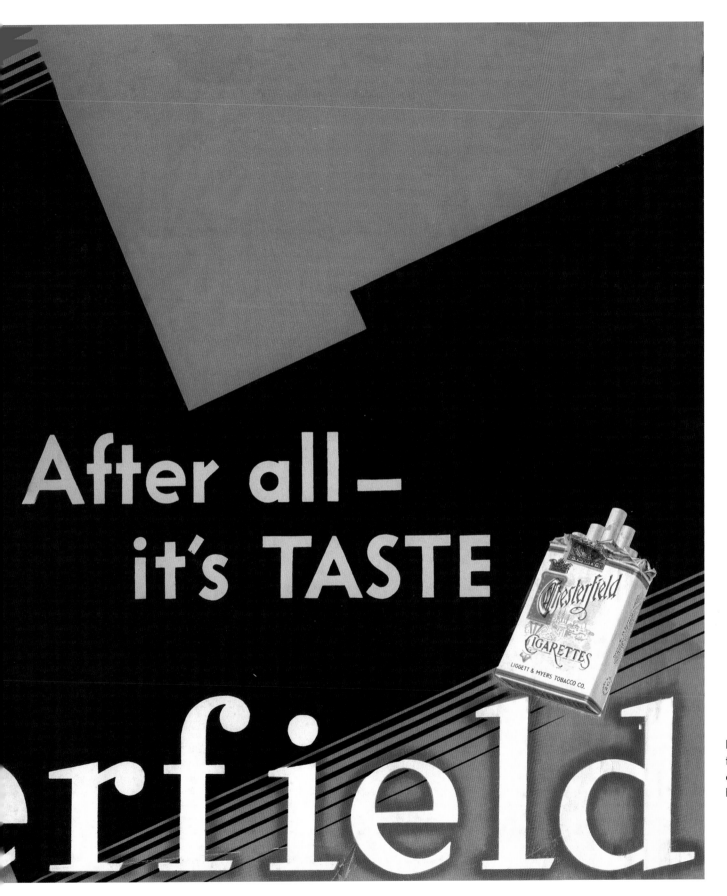

Dorothy and Shep's first freelance billboard, completed in 1930 in New York.

After they completed their six-week residency in New York, the Shepards were in love with the city and decided to take a chance on the money and freedom of the freelance life, figuring they could always go back to Foster & Kleiser if it didn't work out. They returned to San Francisco, resigned from Foster & Kleiser, packed up their belongings, and moved to New York, this time to a sunlit penthouse in a modern, newly built brick building in Greenwich Village. They decorated the house with the furniture and posters they'd acquired in Europe, and each set up a working studio. On the roof of their building, where Dorothy could often be found sunbathing, the Shepards planted a garden next to the water tower. The couple found happiness and financial success during that first year in New York, and Dorothy gave birth to the couple's first child, Gordon. It was a breech birth, and Gordon suffered trauma that would manifest as mental illness as he grew into an adolescent.

During the next two years, working both together and individually, the Shepards produced billboards for Pontiac, Chevrolet, Richfield Oil, and numerous other companies, for which they won awards from the Outdoor Advertising Association. Dorothy's billboards for Folger's Coffee and Underwood Typewriters are bold displays of abstraction and lettering. For Folger's, Dorothy used silhouettes with sweeping curves, and a nearly cubist rose to convey the pleasurable smell of the product. She gave the Underwood Typewriters advertisement a dramatic lighting scheme, emphasizing the modern, geometric precision of its keys. Progressive design was uncommon—and risky—in North America. The developments in Europe were slow to take root on America's shores. But Dorothy's style of illustrating was even rarer. She had a flair for hard-edged geometrically constructed forms and could arrange multiple forms harmoniously on a single plane. She was a woman who adapted the modern language of abstraction to suit her own needs, and she did so fearlessly and with style.

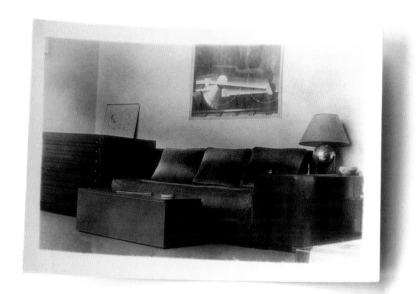

Life in (and on top of) the Greenwich Village penthouse in the early 1930s. In the photo at left, note the wedding announcement pictured on pages 54–55 propped on top of the flat files, and the A.M. Cassandre Nord Express poster above the sofa.

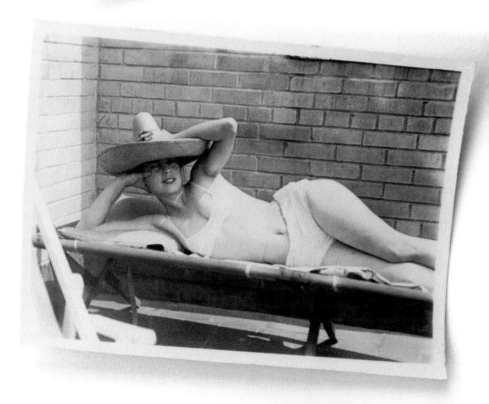

235 E. 22 - NYC

64

Opposite page: **Rooftop drawing by Dorothy.**
Left: **Life drawing by Dorothy.**
Below, left: **Another rooftop view, this time by Shep.**
Below, right: **Dorothy nursing their new son, Gordon, painted by Shep.**

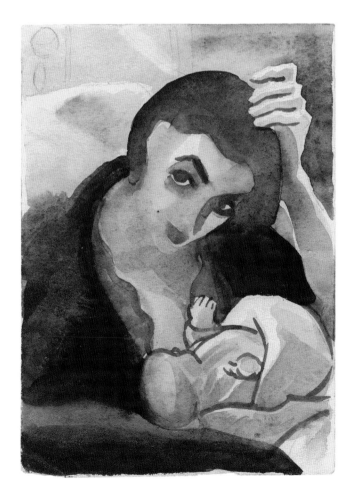

POPPER GIVES HIS MOMMER A LA PAN
WINTRY WINDS DO BLOW
TO WARM HER HEART · AND LITTLE HANDS
POPPER LOVES HER SO!

Opposite page, above: **One of Shep's beautiful birthday cards for Dorothy, which mentions a gift for Dorothy.**
Opposite page, below: **Shep in the New York apartment, circa 1930; Dorothy with her birthday gift.**

Below: **View from the penthouse, painted by Shep.**
Pages 68–71: **Dorothy's billboards for Folger's Coffee and Underwood Typewriters.**

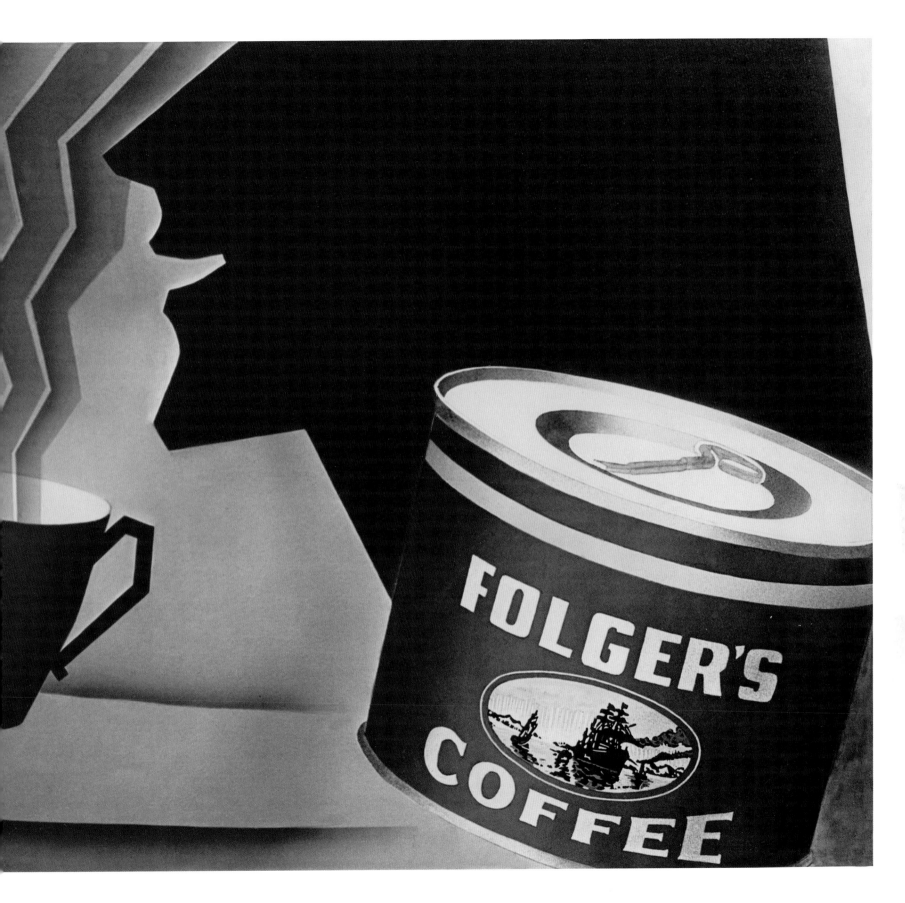

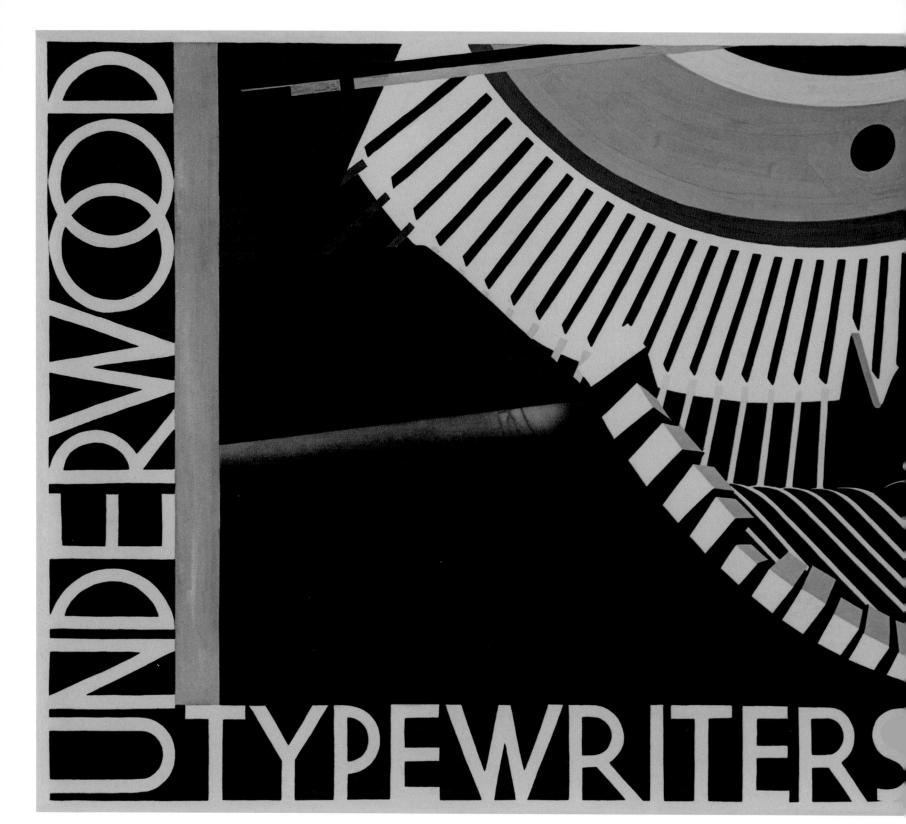

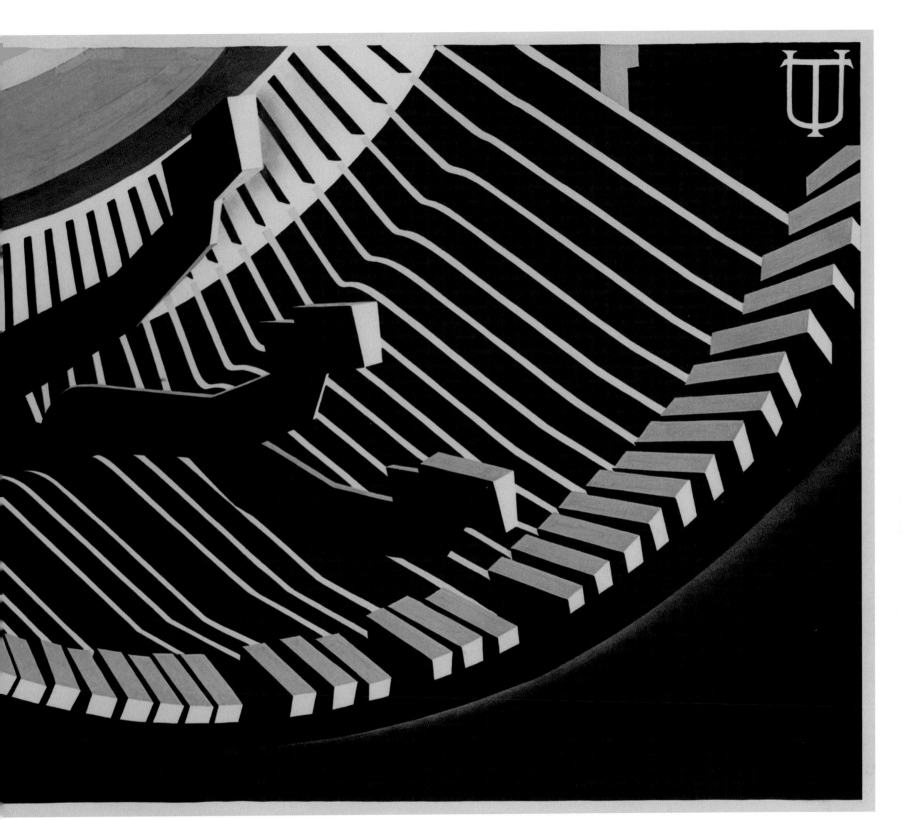

In 1930, Dorothy completed a series of labels for Mannings Tea, which was owned by Mannings & Co., a chain of cafeterias on the West Coast. Dorothy's work for the Mannings Sun-dar and Jo-to brand teas exemplifies her style. Different from Shep's more sparse designs, Dorothy's compositions were more intricate, filled with details for the eye to linger on—like the repetition of diamonds in her Sun-dar label, or the flower motif that unites her Jo-to label. This style ran through her later interior and clothing design work. She understood that every aspect of a composition needed to be compelling to the eye, and she never relied on a single element for the success of the whole.

The work Dorothy produced in the 1930s made her the earliest established and successful female modernist graphic designer in North America—though the social mores of the time prevented her from rising to the top of what was generally a men's club. There simply wasn't a place for women in advertising and graphic design at the time. Dorothy even downplayed her work in her scrapbooks and sometimes referred to herself as having ridden on Shep's coattails. She scrupulously documented Shep and his work in scrapbooks but saved little of her own.

By the early 1930s, Shep and Dorothy were considered by their peers to be the king and queen of the advertising field. They worked constantly, enjoying their new life together even in the midst of the country's financial chaos. And in 1932, Shep would meet the man who would change his and Dorothy's lives: P. K. Wrigley.

Above, left: **Self-portrait by Dorothy.**
Right: **Dorothy and a friend out for a fashionable stroll.**
Opposite page: **Shep's drawing of Dorothy toiling away in their Greenwich Village penthouse, early 1930s.**

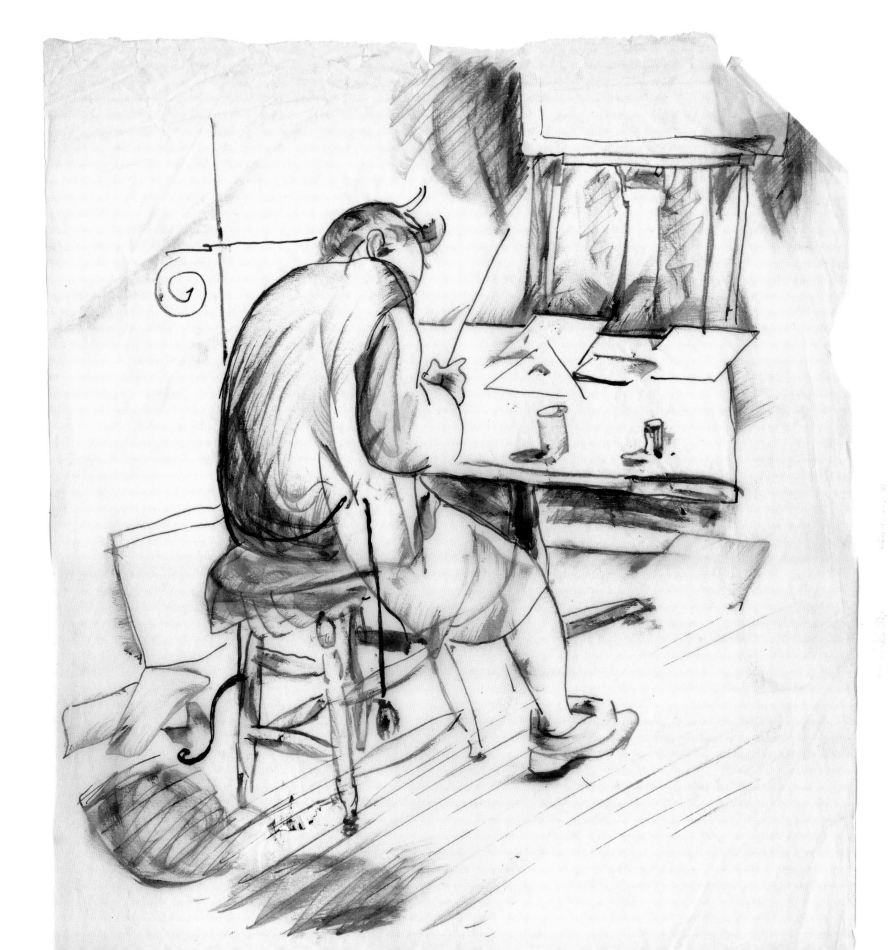

One of Dorothy's major freelance commissions, of which she was very proud, was for the West Coast–based Mannings & Company café and store chain. Shown here and on the opposite page are Dorothy's preliminary design sketches, along with more finished pencil presentation drawings. These 1930 drawings highlight her love of geometric shapes and her strong black-and-white design sense.

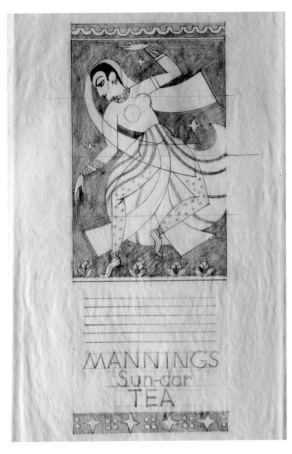

MANNINGS
Sun-dar
TEA

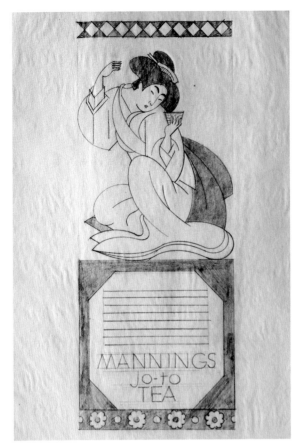

MANNINGS
Jo-to
TEA

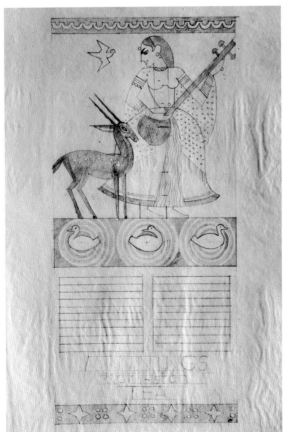

MANNINGS
TEA

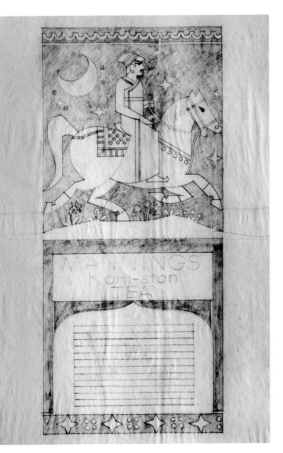

MANNINGS
Roh-ston
TEA

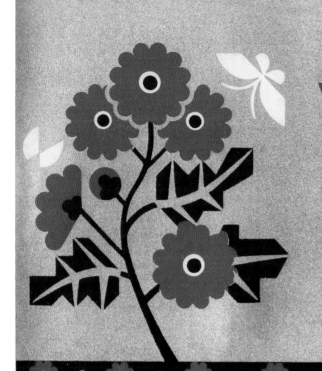

MANNINGS
Jo-to
TEA

GREEN 4 OZ. NET.

COPYRIGHT 1930
BY MANNINGS INC.

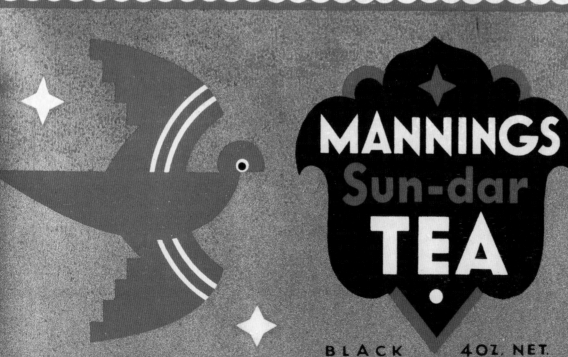

MANNINGS
Sun-dar
TEA

BLACK 4 OZ. NET.

COPYRIGHT 1930
BY MANNINGS INC.

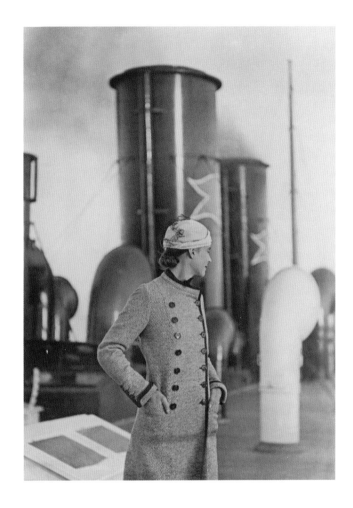

Left: **Two of Dorothy's finished label designs for Mannings & Company. The bottom label includes a bird design she would revisit for both Wrigley and Catalina Island.**

Above: **The stylishly dressed and successful designer en route to Boston for a vacation, 1932.**

Basic Symbolism in Modern Design
Unpublished manuscript, Otis Shepard, 1928

In advertising design, the artist who works in the modern style does not approach his task with the desire to be extreme, bizarre, or merely "different." His purpose is to present a message which will infallibly grasp the attention of the fickle public. He must work in symbols of one kind or another—either intellectual symbols, such as words or phrases; literal representations, of the photographic or illustrated kind; or subconscious symbols, which produce an effect by giving rise to certain moods or mental impulses.

The modern approach differs from the traditional approach in that it makes increased use of subconscious symbols. Its compositions often feature combinations of lines and colors which speak an almost primitive language, which express dramatic action, which appeal to the intuitive emotions.

When the artist succeeds in making use of these materials, he produces a "language of advertising" that silently carries its message. He has gone below the superficial and has reduced advertising to a universal language.

Consider some examples: Suppose our subject for advertising is a motor truck. We want to tell of its strength, its speed. We may letter boldly on our design: "It's strong!" or "It's speedy!" Or we may prefer to show the truck heavily laden, or in swift travel. In the literalistic interpretation, however, it is difficult to create the sense of tremendous strength or rapid movement that we need. Those things come through a mental process in which the thinker substitutes himself for the truck. They are associated with a feeling of resistant shoulder muscles (in the case of strength) and exhilarating flight through air (in the case of speed). Therefore the artist resorts to fundamental symbols of dynamic action to suggest these ideas. He creates the sense of movement through abstract forms. In order to convey the *strength* of the truck, he depicts abstractly the ideational representation of *pull* or *push* in which a form that the reader associates his own body with the force of the mechanism. In order to show *speed* he uses a combination of lines which inevitably bring to the mind a dynamic suggestion of kinetic force.

In an entirely different field, suppose the artist wishes to suggest for a retail store the idea of "vogue"—impeccable smartness and modernity. Shall he depict a charming woman in a gown of the latest style? Perhaps the literal interpretation would be something of this kind, but obviously the store offers many styles of gowns, many garments in addition. Using the symbolic appeal, then, the artist prefers to show only a head, or a shoulder, or perhaps an earring, but presented in such a manner, and in such an atmosphere, that the idea resulting is inescapably the one sought, but generalized, and made immediately applicable to anyone who sees it.

A study of the various classifications of dynamic action or static moods which may thus be dramatically presented in abstract forms will reveal a large number of them, each associated with a symbol of design.

Most of these are dynamic motifs, expressed in dramatic movement. In order to make clear the general—almost universal—application of the symbols, they have variously been used to express different qualities of one product, an automobile.

There is "flash," which suggests the quick movement of lightning; "pull," which carries the idea of irresistible power; "sublimity," an expression of luxury and elegance; "pathos," accompaniment of the quiet mood; "happiness," which stimulates thoughts of gaiety; "thrust," which generates a motor response expressive of the exertion of strength; "strength," in a different sense, characterized by mass and solidity; and finally "confusion," suggested by a design which produces a chaotic reaction.

Below: **Shep in his studio with European posters acquired on vacation hanging behind him, 1930.**

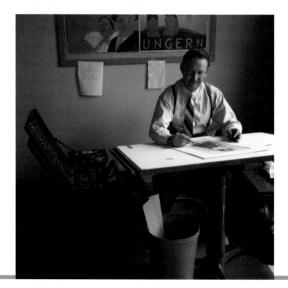

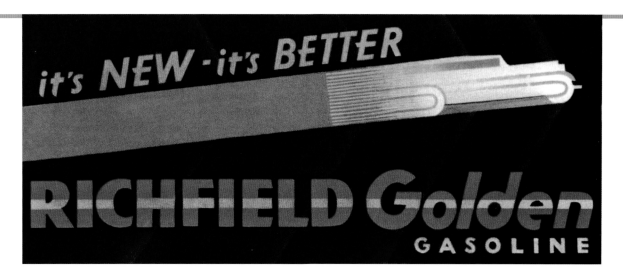

Above: A circa-1931 Richfield Gasoline billboard by Shep, showing his early use of the airbrush. This and all the billboards on this page were hand-lettered by Dorothy. Image courtesy of Duke University David M. Rubenstein Rare Book & Manuscript Library.

Right: Shep's award-winning campaign for Chevrolet, employing his much-touted symbolic approach to engage the viewer quickly and with a minimum of forms, 1932.

Below: Shep's cartoonish 1932 billboard for Pontiac, complete with delicate airbrush fades. Image courtesy of Duke University David M. Rubenstein Rare Book & Manuscript Library.

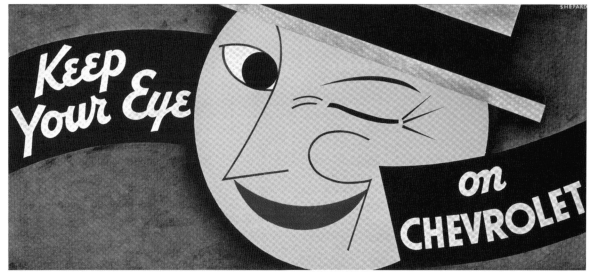

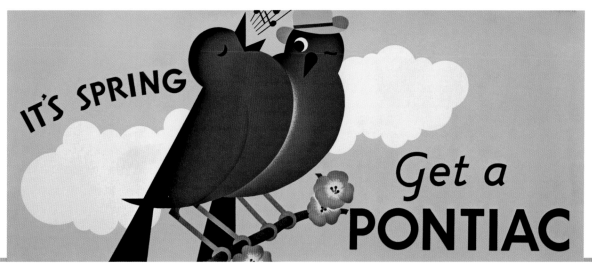

Wrigley

The ideal client appears and Dorothy and Otis
help make chewing gum into an all-American pastime.

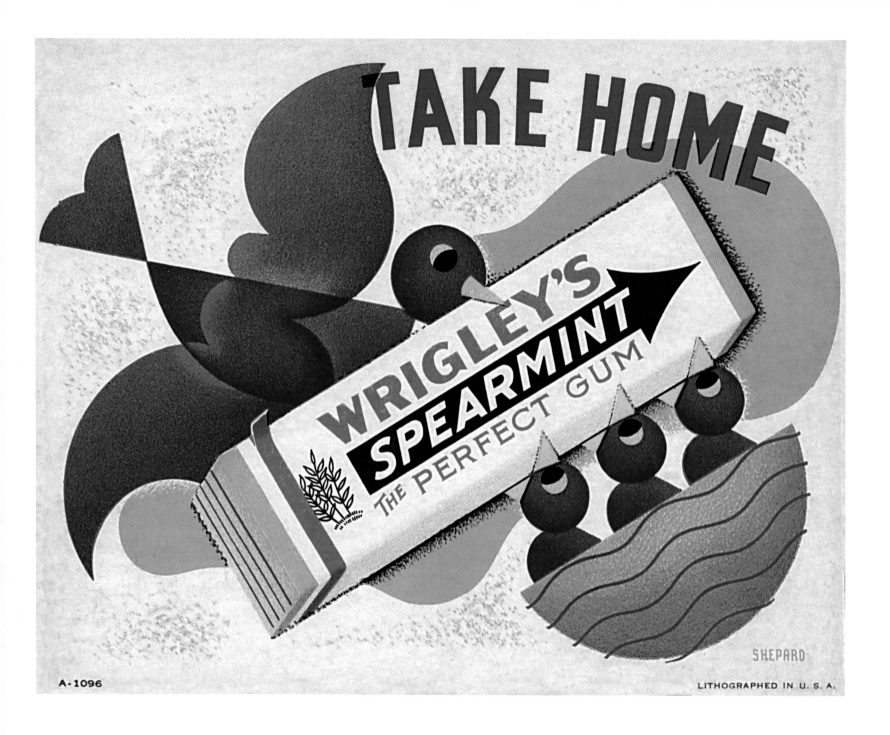

Above: **Shep and Dorothy's mid-1930s design for a Wrigley's spearmint gum counter display used one of Dorothy's favorite motifs: a modernist cartoon of a bird.** Opposite page: **P. K. Wrigley in his office, mid-1930s.**

Philip Knight Wrigley was the owner of the Chicago-based Wm. Wrigley Jr. Company, which by 1932 was the largest chewing-gum maker in North America. It was founded in 1891 by P.K.'s father, William, a boisterous, P.T. Barnum–esque figure. When it first opened, the company sold scouring soap, and—as incentive for vendors to carry his products—William offered free baking powder for each soap purchase. Soon the baking powder was more popular than the soap, so he began selling that instead. In 1892—as incentive for vendors to carry the baking powder—he began offering two packs of chewing gum for every can of baking powder bought. Soon the gum was in greater demand than the powder, so that became Wrigley's primary product. William went wherever the money was, adapting his industrial capabilities as needed. He also set about building a small empire. Like many industrialists, he bought a baseball team, the Cubs; built his own building to house his company; and eventually acquired Catalina Island.

In 1932 William Wrigley died, and P.K. assumed the reins of the company. P.K. was quiet, ambitious, and, according to a 1943 profile in *Fortune*, a proponent of communication as an art form. He went about his work meticulously; he had once said he wanted to be an auto mechanic, and his leadership showed his skill in making the company's whole engine run smoothly. He was also a believer in the importance of having a relationship with consumers, and he would hire researchers to advise how he could improve the public's opinion of his company. This is somewhat ironic, since P.K. rarely gave interviews and usually refused to be photographed. But it was the product, not the man, which he wanted the public to know.

Dorothy described the first meeting in New York of Shep and P.K., who would become lifelong friends.

> Shep said he wanted to submit something to P.K. Wrigley, who he'd heard was coming to town. They were introduced with the understanding that Shep had "five minutes."

We made up dummies of some of Shep's ideas and he showed them to P.K. right off. He loved them. Much more so than the work the Outdoor Advertising Association men had prepared. He wanted to buy one or two of Shep's pieces. "Not for sale!" insisted Shep. "The only sensible thing to do is to have continuity," he says. "You can't get a job like this even started with a piece here and a piece there," Shep explained to him. They worked up a letter right there that Shep would come to Chicago for half of his time and remain in New York the rest of the time.[13]

In his meeting with the Wrigley company, Shep wasn't just trying to get a one-off gig. He believed in long-term visual plans for maximum effectiveness. P.K. likely connected with Shep for this reason: they both thought about the big picture, long-term sales and revenue. In speaking about his first job for Wrigley, Shep later recalled:

I'll never forget the first poster design I made for the Wrigley Company. Mr. Wrigley looked at it and said, "I don't like it." And I said, "Mr. Wrigley, what has that got to do with it?" I said, "Are you selling chewing gum or are you going to hang this in your parlor?" He looked at me for a minute, and then he said, "I think you've got something there." I think that cemented our relations right there and then. I don't think I've ever made one since that he did like. As long as the sales curve went up, that was all that was necessary.[14]

Opposite page: **Shep's first design for Wrigley, a 1932 billboard. Image courtesy of Duke University David M. Rubenstein Rare Book & Manuscript Library.**
Left: **Shep on Michigan Avenue during his first visit to Chicago.**

Below: **An original wall sign that still exists in Texas.**

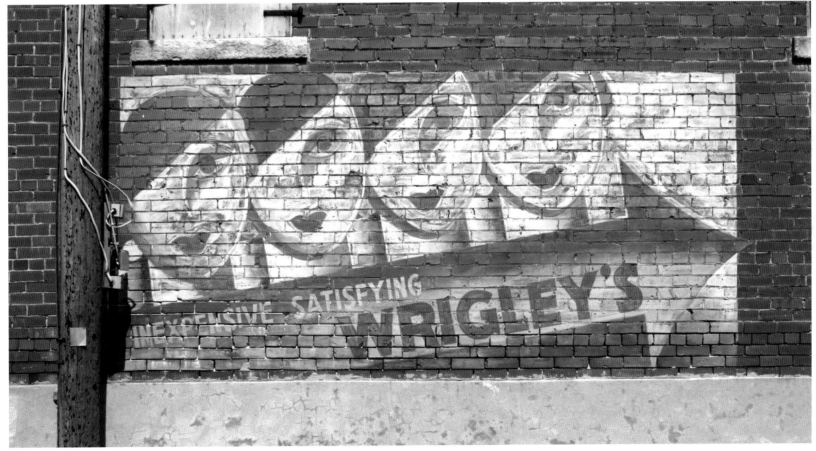

Otis gave up his freelance work and went full-time with Wrigley, while Dorothy did uncredited assists and continued her freelance work. Five years after that first job for Wrigley, a journalist caught up with Shep on the sixteenth floor of the Wrigley Building in Chicago. He described the scene in a 1937 issue of *Art and Industry*:

> At least 12 hours a day he thinks, talks, and chews Wrigley's. He sketches almost continuously throughout the day. Perhaps it's a poster, a new package wrapper, a box design, or an electric spectacular. Sketch—sketch—sketch—on tablecloths, telephone pads, important letters and even smoky office windowpanes.... Throughout the vast Wrigley offices wherever Shepard goes, invariably there is a trail of pencil sketches (his cigarettes, tie, coat, or hat), for with Shep the idea comes first. His personal belongings will catch up with him. But an idea—that is something to hold on to.[15]

Shep was charged not only with creating outdoor advertising for Wrigley but with running the entire art department, which in the beginning consisted only of himself. His assignment was to design everything Wrigley-branded from top to bottom. He had 9,500 salesmen, one million retailers, and countless consumers to please, and for them he produced counter displays, chewing gum boxes, retail pamphlets, a salesman's pamphlet, and advertising images for billboards, streetcar cards, newspapers, trucks, and posters.[16] At the height of Wrigley's 1930s market penetration, Shep's designs appeared on twenty thousand billboards across the country in a single year. Every visual element of these objects was created or approved by him. This even extended to the décor of the Wrigley building's restaurant and its menu, done in glowing modernist forms in bright red and white.

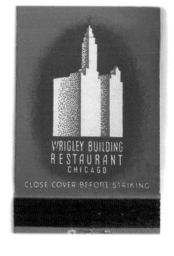

Left: **Consumer magazine ad.**
Above: **Wrigley Building Restaurant matchbook.**
Below, left: **Interior design for the Wrigley Building Restaurant.**

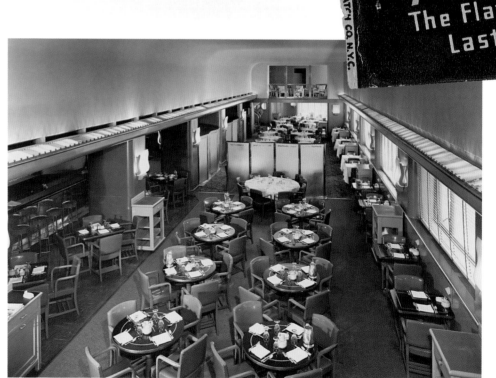

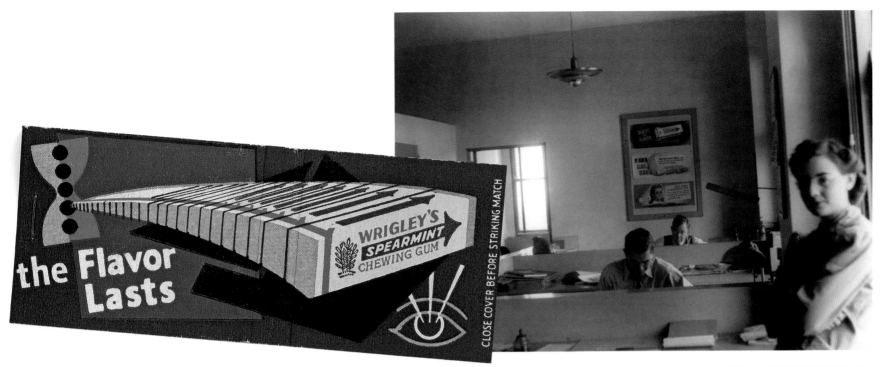

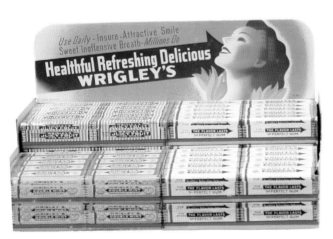

Left, top and middle:
Two abstract matchbook covers.
Left: **Gum counter display.**

Top: **A view of the Wrigley art department, circa late 1940s.**
Above: **Hubert Nelson in Shep's office.**

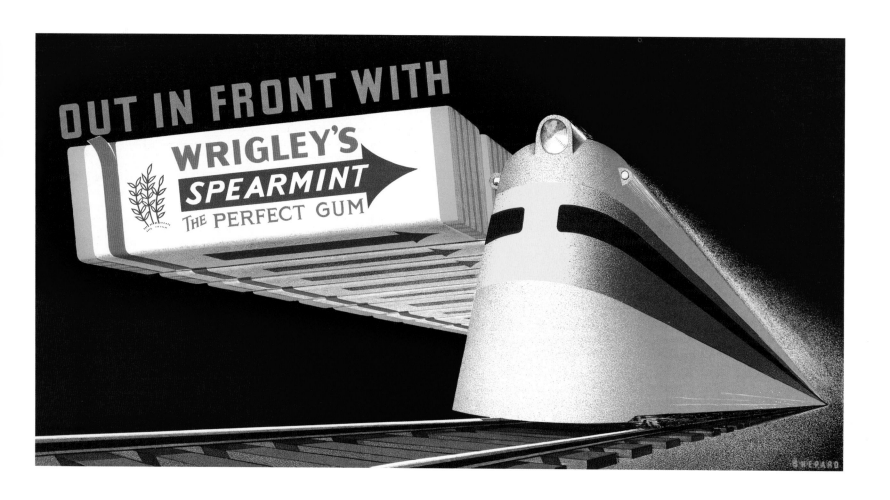

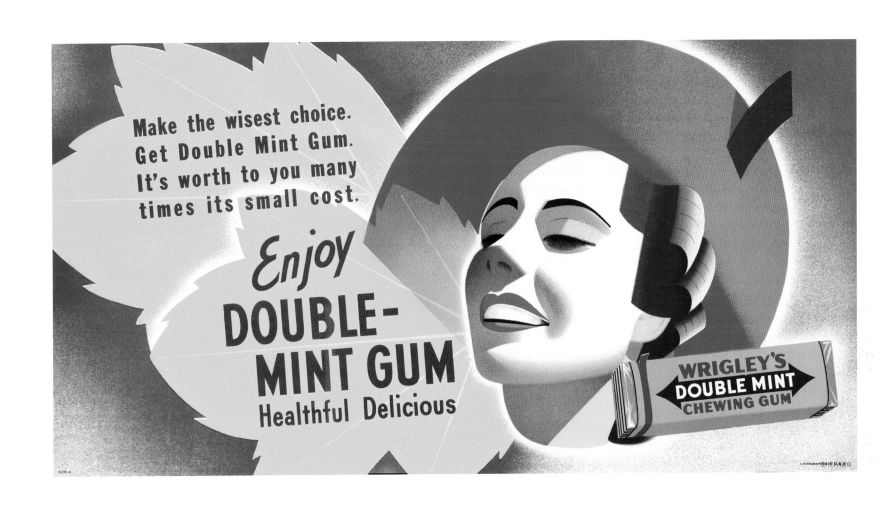

Above and on opposite page: Wrigley billboards by Shep from 1937 and 1938. These are strong examples of both Shep's airbrush technique and his emphasis on quickly grasped symbols of the boisterous energy of Wrigley's gum.

Attractive Smile
Healthful Delicious
DOUBLE MINT GUM
Use daily..Millions Do

SHEPARD

LITHOGRAPHED IN U. S. A.

Early 1930s billboard by Shep, emphasizing the homespun appeal of Double Mint gum.

Shep's criteria for a successful advertisement was that its meaning should be grasped by the viewer in five seconds or less. He used prodigious areas of flat color, which he felt made an image look clean, and he airbrushed details to make them look luminous. His figures possessed generic features so that anyone could see themselves or their friends in the characters. He also insisted on minimal verbiage. If he had it his way, he said in 1952, there would be no words at all.[17] Shep refused to use photography at Wrigley, insisting that it was too literal and didn't allow the imagination of the viewer to take flight. In his opinion, the openness of the handmade image and the continuity between campaigns that it afforded made it superior to photography.

Shep's innovative designs were both celebrated for their imagery and successful in their results. An article in the August 2, 1937, edition of *Time* noted that, "Helped by the modernistic chewing gum advertising designed by Artist Otis Shepard, William Wrigley Jr. Co. showed profits of $4,354,000 for the first half of 1937, compared to $3,428,000 in the same period of last year."[18]

In 1939, Shep introduced the Doublemint twins to go with the gum brand: two elegant women beaming out from his posters, their faces rendered as smooth, nearly abstract planes of color, each just about to bite into a stick of gum. In the beginning, in keeping with the fashion of the time, the characters wore wide-brimmed, stylish hats. They were so popular in their first year that they inspired the trade newspaper *Millinery Research* to proclaim Shep's ads a seller of hats—even more so, in their opinion, than gum. "After all," the article read, "a hat is certainly more dramatic, more dynamic, more desirable than a stick of chewing gum. A woman may give five cents for a package of gum, but she would give her soul for an intriguing hat."[19] Nonetheless, with this advertisement, Wrigley chewing gum sales again soared.

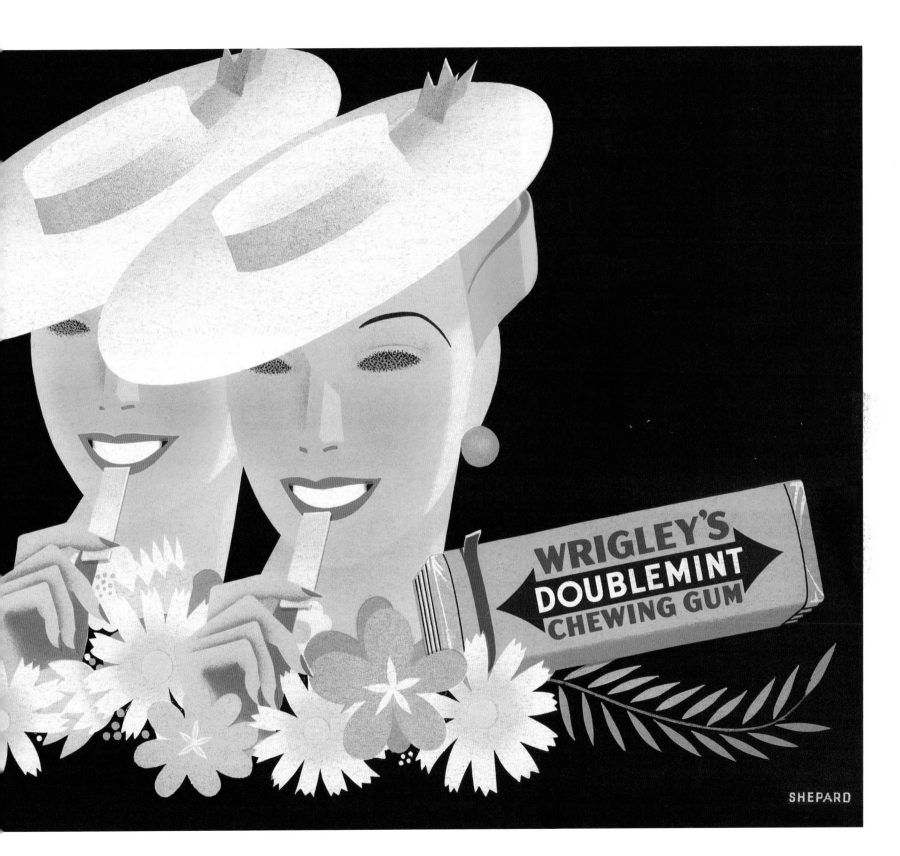

Below: **A 1939 billboard by Shep featuring the Doublemint twins.**

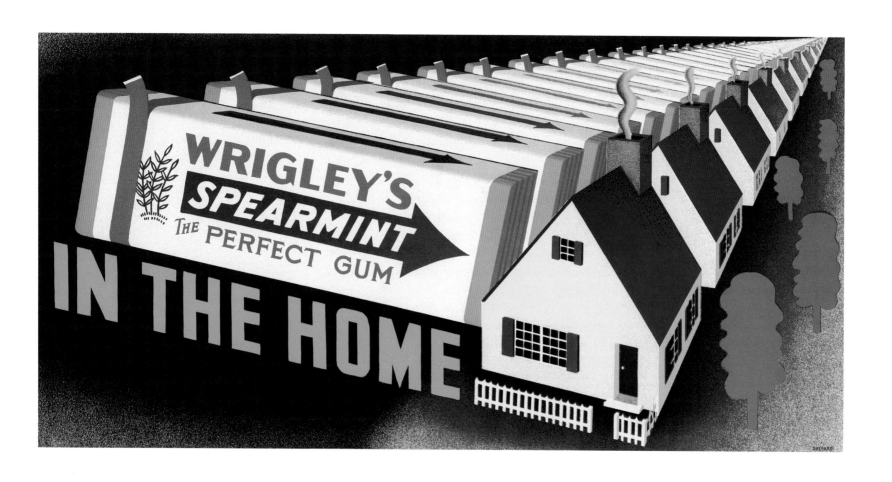

Above and on opposite page:
Late 1930s Wrigley designs appealed to suburbanites across the country.

Dorothy's Spectacular

On March 28, 1936, Dorothy's largest work was unveiled: the Wrigley's Times Square Spectacular. At the time it was the largest neon display in the world: eight stories tall and one block long, running up Broadway from Forty-Fourth to Forty-Fifth Street on the east side of Times Square. Gigantic abstract tropical fish in orange, red, yellow, and blue flashed continuously, their tails and fins undulating as though they were in ultramarine electric water, while white bubbles would appear at the mouths of the fish and then woozily blink to the top of the display. At the center of it all, sitting atop a package of spearmint gum, was the Wrigley's Spearman Elf, whose arms spouted alternating slogans, including "Steadies the Nerves" and "Keeps the Taste in Tune." The scale was immense: The elf was twenty-three feet tall and thirty-nine feet wide. The eleven fish varied in size from fourteen to forty-two feet long. Dorothy's design was based on unused drawings of hers that Shep spotted in her studio on Catalina. He recommended that she pitch it to P.K. for the Spectacular and she went for it. The Times Square Spectacular had all of Dorothy's trademarks: multiple forms and colors arranged harmoniously to gently bring an idea to life. Water and fish had no literal relationship to Wrigley, of course, but Dorothy was expressing the idea of pleasure as she was then experiencing it on Catalina Island. It was less about selling and more about the joy of life. Dorothy received a tremendous amount of publicity for the work and also won the National Advertising Council Award, which consisted of a very heavy plaque and the then-large sum of $4,000.

Right: **A postcard image of Dorothy's Times Square Spectacular.**

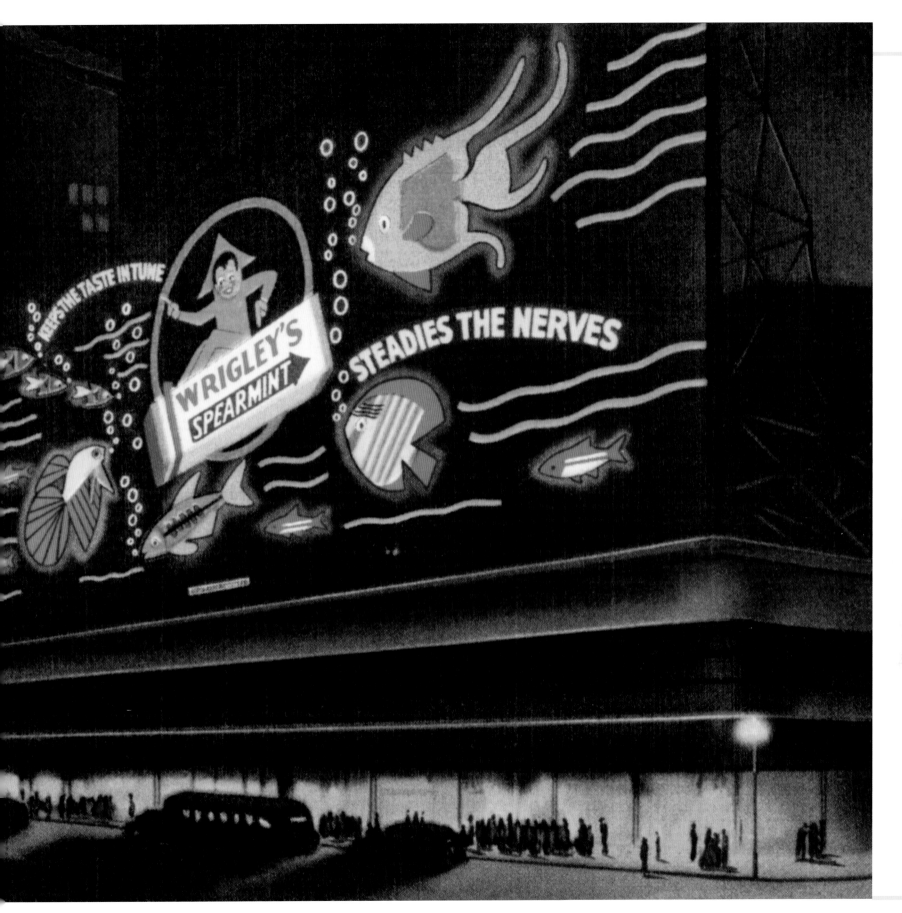

In the 1940s, Wrigley contributed to the war effort by supplying G.I.'s with enormous amounts of chewing gum for free, packed into their ration kits, which were largely packaged in Wrigley plants at a reduced rate. Before the war, gum was considered déclassé; but when the men returned home with chewing gum habits, it became widely accepted. Shep's posters from this time called to mind the shortages the nation was experiencing—particularly aluminum, which was used in the gum wrapper. His haunting image of an enormous empty wrapper floating in a dark space became an icon. It was also his most avant-garde billboard design. The wrapper is radically foreshortened and crinkles in a forbidding manner. The dark gradient behind it emphasizes the seriousness of the matter. Even a chewing gum wrapper, the ad implied, could make a difference. In one image Wrigley reinforced its market dominance and its patriotism.

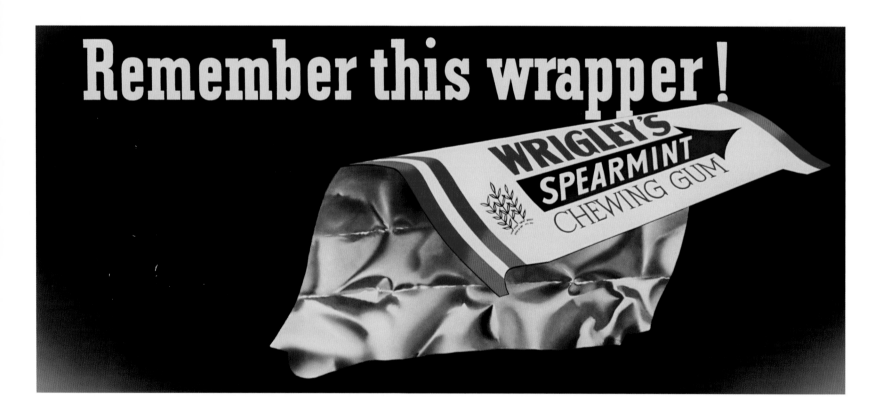

Opposite page: **Shep's memorable World War II empty wrapper billboard design, 1945.**
Below: **Shep frowned upon the lengthy text on these wartime billboards, but it came from P. K. and he could only argue so much.**

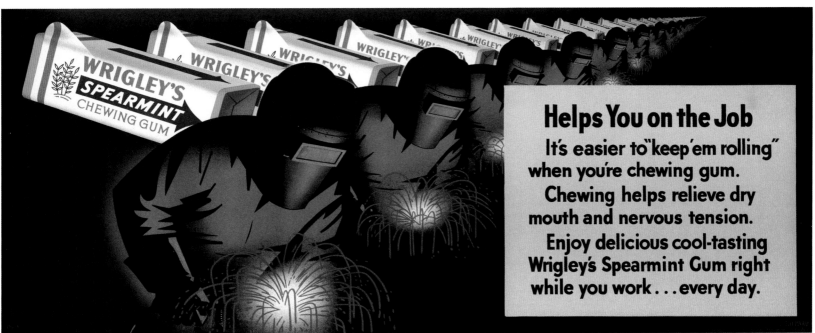

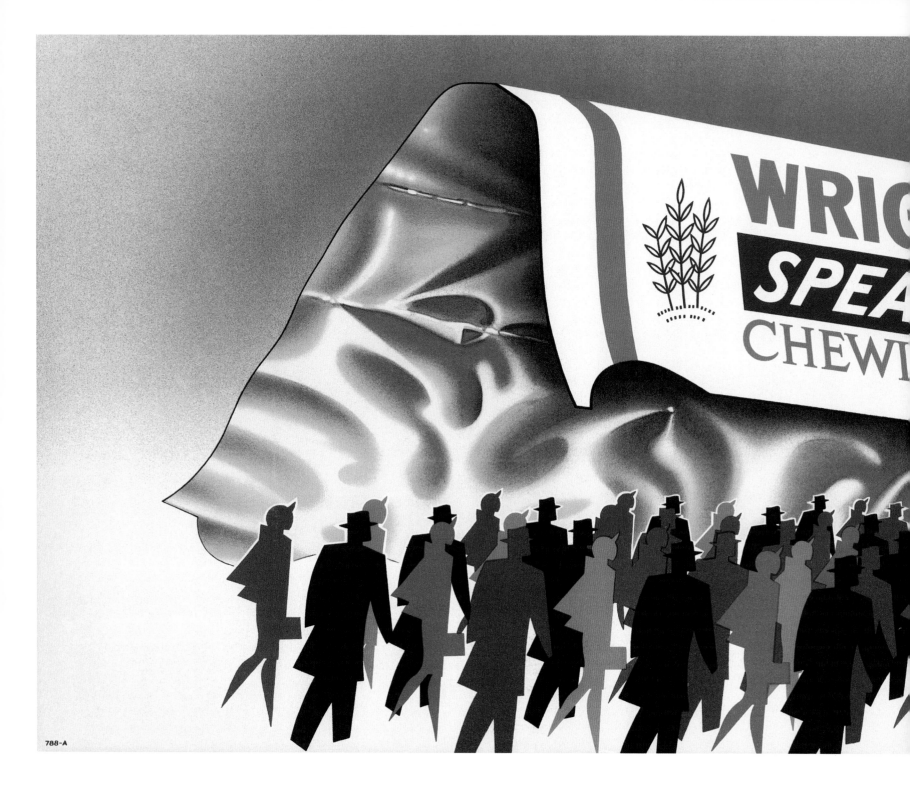

788-A

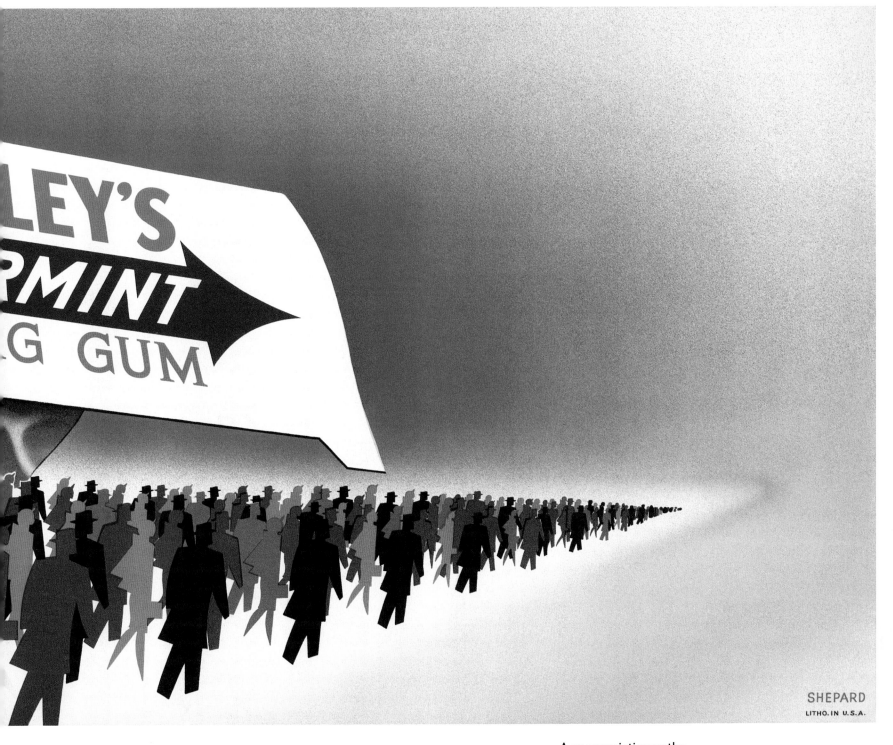

LEY'S
PMINT
G GUM

SHEPARD
LITHO. IN U.S.A.

A 1945 variation on the
empty wrapper theme.
Shep brilliantly used
hard-edged abstractions
of people against the
softer, glowing wrapper to
emphasize the importance
of the community in the
wartime rationing effort.

Top: **In this 1943 billboard, Shep emphasizes the wartime industry of America, particularly the women who worked in factories while the men fought overseas.**

Above: **The daydreams of a factory worker, as envisioned by Shep in this 1943 billboard.**

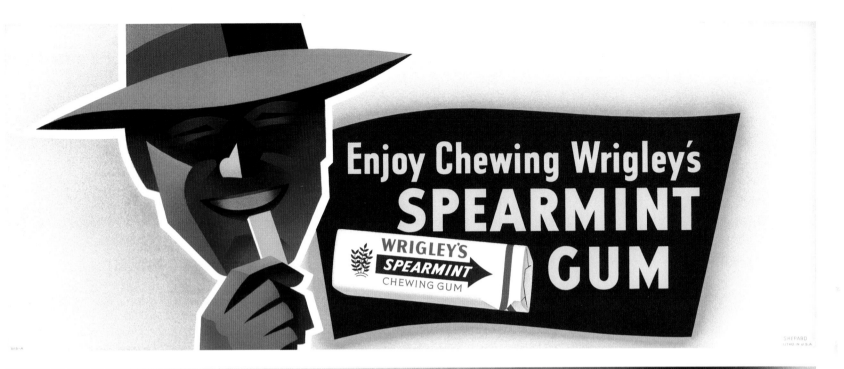

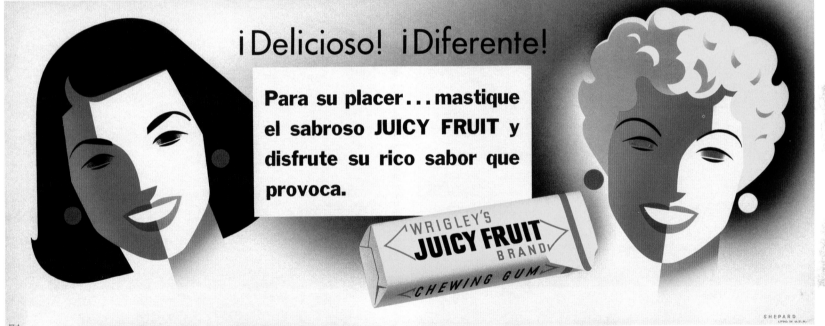

¡Delicioso! ¡Diferente!

Para su placer...mastique el sabroso JUICY FRUIT y disfrute su rico sabor que provoca.

Above: **After the war, Shep shifted into a bright optimism characterized by the sunny faces of his dream America, which was also exported around the world.**
Right: **Shep working with the model for the above 1953 billboard.**

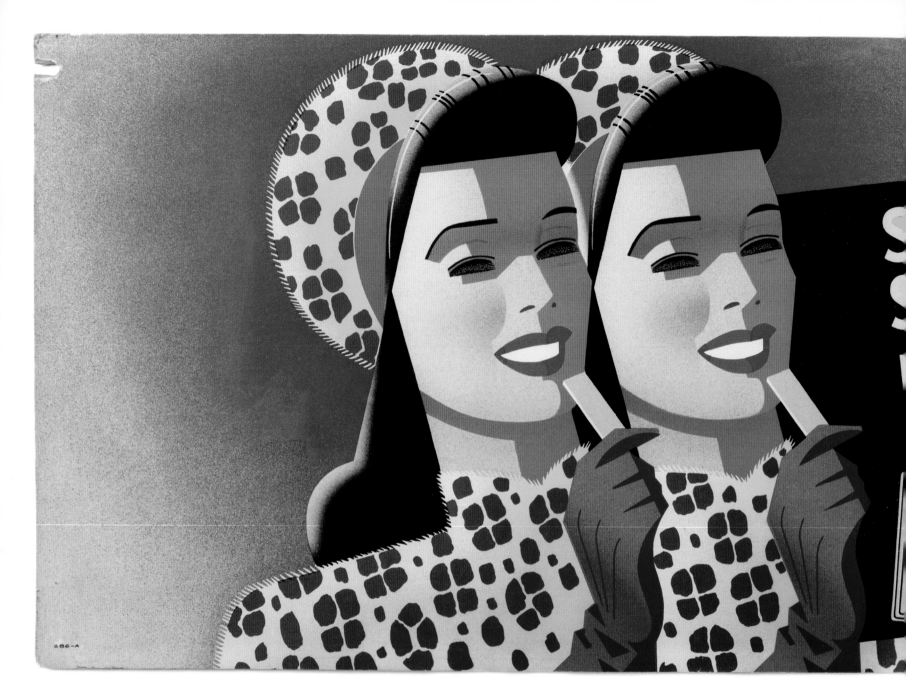

686-A

A mid-1950s Doublemint billboard by Shep, featuring period hairstyles and fashion.

Not just advertising

The most important of Shep's designs for Wrigley was, of course, the gum packaging. When Shep redesigned the gum packaging, he went, as was his style, to theatrical lengths to present it. He hired a teenager, dressed him as a pasha complete with a turban and slippers, and had him bring out a box on an ornate cushion. Shep lifted the lid of the box and there, before P.K., was the new gum packaging. Against the overly ornate, text-heavy packaging of Wrigley's competing brands, the new design was a model of aesthetic economy. It consisted of horizontal stacked words: the company name, the brand name, and "Chewing Gum." Those words were offset by an arrow form. Taken together, it was a modular and uniform structure. The company name could shift as needed based on the shape of the brand word and the arrow could assume different positions and shapes, but the basic elements would remain consistent. This was a step into modernism and would become a classic American design.

Right: **The presentation box designed by Shep to reintroduce Wrigley's gum line after its wartime absence.**
Opposite page: **The family of redesigned packages.**
Overleaf: **Shep's archetypal design for the spearmint gum stick.**

FOR YOUR ENJOYMENT

Wm. **WRIGLEY** Jr. Company

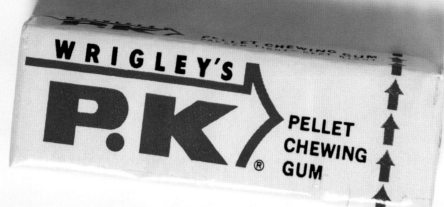

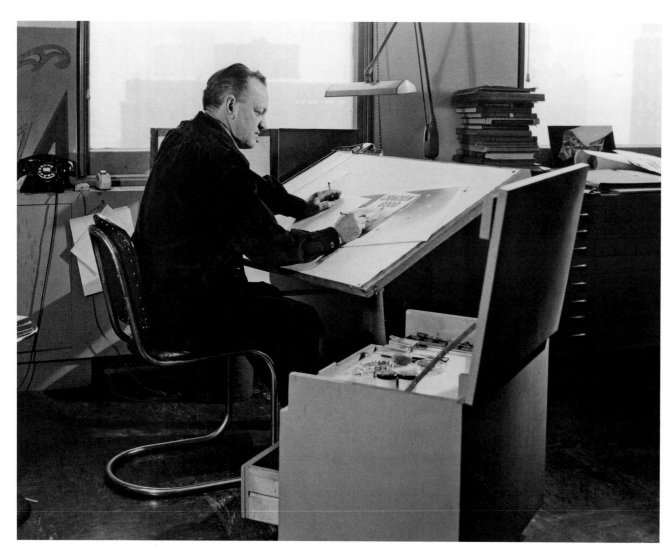

Left: **A rare photograph of Shep at work on an illustration. Sadly none of his original art survives today.**
Below: **One of many awards given to Shep for his graphic design work.**
Opposite page: **More recreational optimism from Shep, with the focus on couples enjoying gum and fun in the late 1940s.**

After the war, Shep used Wrigley advertisements to project American optimism. From snowball fights to swimming to horse wrangling, his cheerful, colorful, and all-American images came to represent the Wrigley brand. As always, the posters embraced form and continuity. Each featured no more than two figures, always in motion, with the gum package seeming to collide in midair with that motion—making it integral to whatever fun was happening. His delicate airbrush blends made the figures and background colors gently glow.

Shep and P. K. Wrigley had an unusual relationship. They were born the same year, both served in World War I, and both rebelled against outlandish fathers. More than just the art director

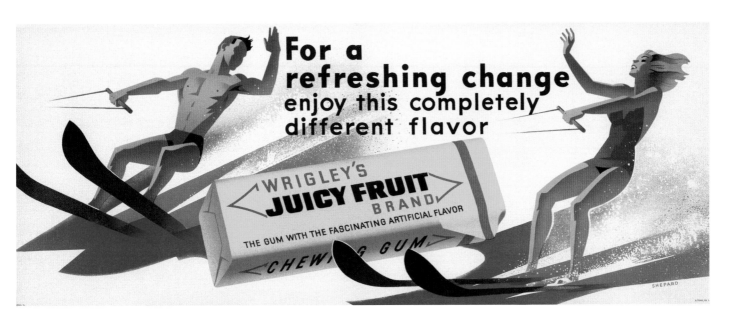

For a refreshing change
enjoy this completely different flavor

WRIGLEY'S JUICY FRUIT BRAND
THE GUM WITH THE FASCINATING ARTIFICIAL FLAVOR
CHEWING GUM

SHEPARD

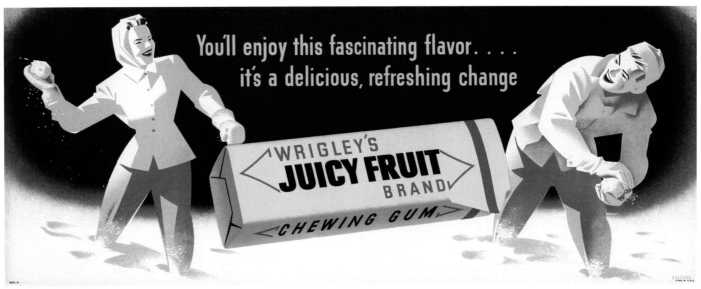

You'll enjoy this fascinating flavor.
it's a delicious, refreshing change

WRIGLEY'S JUICY FRUIT BRAND
CHEWING GUM

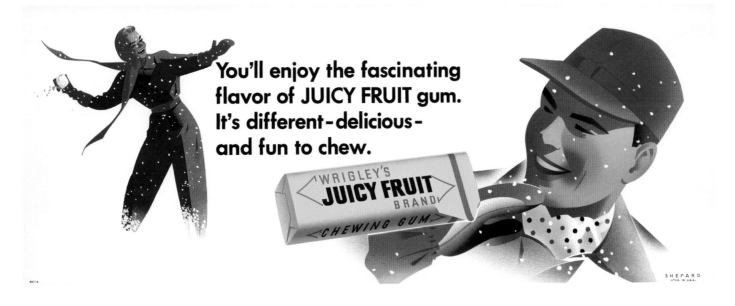

You'll enjoy the fascinating flavor of JUICY FRUIT gum. It's different-delicious- and fun to chew.

WRIGLEY'S JUICY FRUIT BRAND
CHEWING GUM

SHEPARD
LITHO. IN U.S.A.

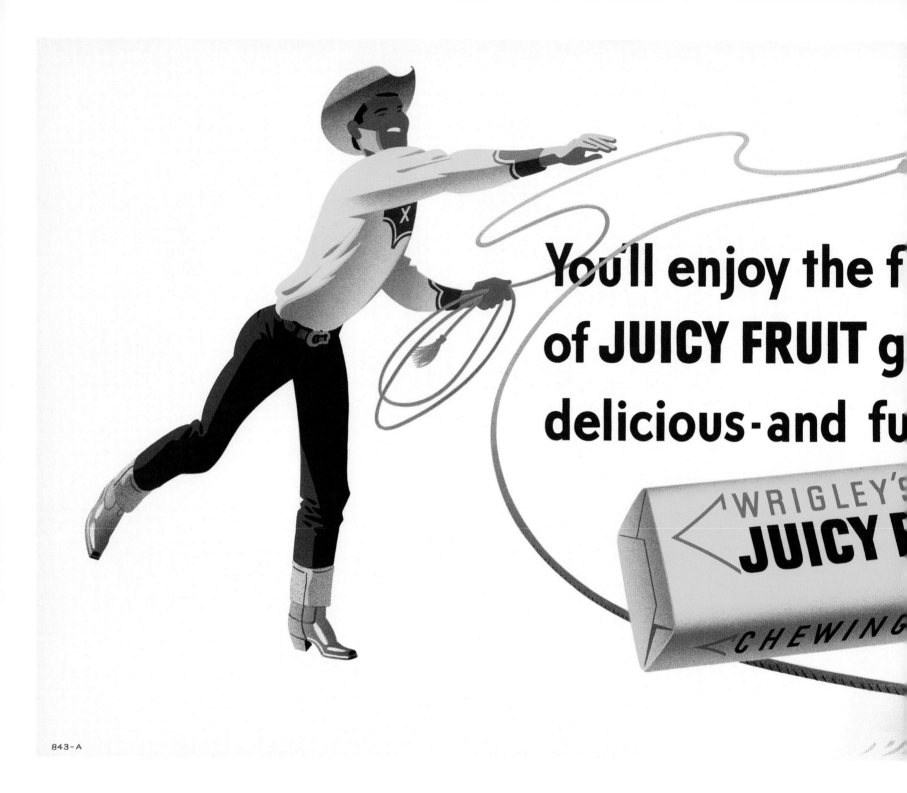

843-A

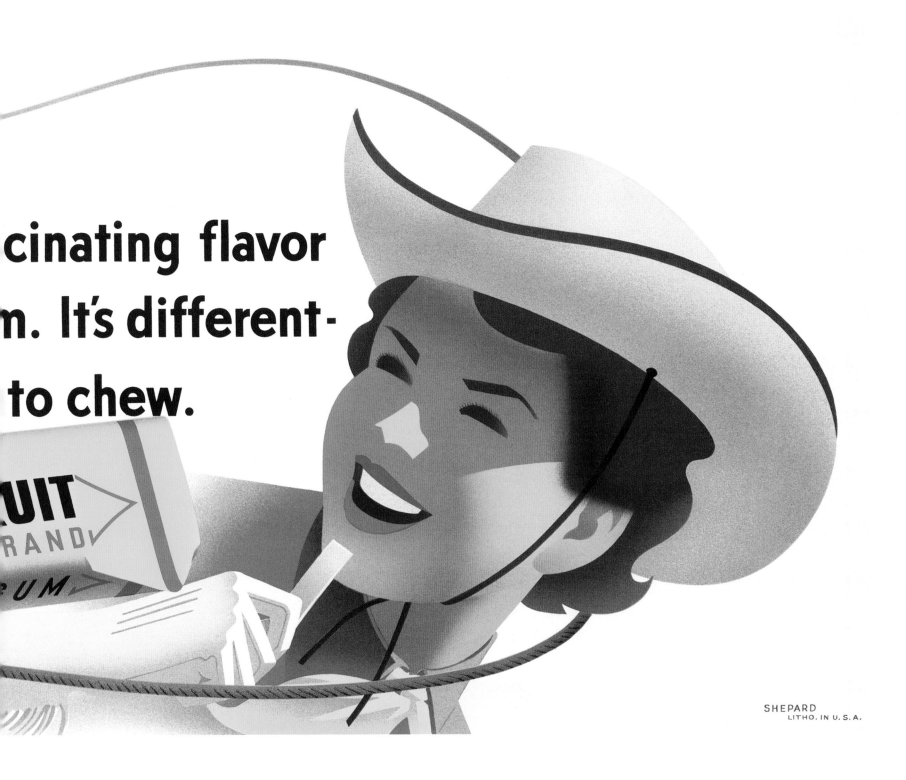

cinating flavor
m. It's different-
to chew.

SHEPARD
LITHO. IN U.S.A.

A mid-1950s image of
all-American fun by
Shep, calling to mind his
own horseback days on
Catalina Island.

for a differe

WRIGLEY'S JUICY FRUIT BRAND CHEWING GUM

t taste treat

An abstract mouth awaits
a Wrigley treat in this late
1949 billboard.

of the company, Shep became a close adviser to P.K. and the man in the company whom Wrigley sought out for an honest opinion. In return, Shep brought P.K. out of his shell and set him at ease. One day, while Shep's son Kirk was visiting the office, a man came in and asked Shep a question, and Shep gave an answer the man didn't like. They argued furiously, cursing horribly at each other until the man stormed out. Kirk, understandably shaken, asked his father who the man was. Shep casually responded, "Oh, that's Mr. Wrigley."

Wrigley also relied on Shep for a good laugh. The two were out for dinner one night with a group of Wrigley executives. When the waiter arrived, the other men, as they tended to do, waited to order what Wrigley ordered. But Shep intervened, insisting that the whole table have the restaurant's special. Dinner was served on a silver tray with a domed lid. The waiter lifted the lid to reveal a plastic dog turd in a bed of parsley. The room was speechless until P.K. began to laugh.

Outside of work, they also had a close, personal relationship. P.K. owned an airplane, and when the pilot complained that it was too slow and old hat, Shep and P.K. got up on the scaffolding and painted zoom lines on the plane's tail. They also shared a love for big, flashy cars. After they attended an automobile show together, P.K. bought Shep a 1942 light-blue Lincoln Continental with red leather upholstery. This was not Shep's first extravagant ride. His previous cars included a white Cord Roadster and a Packard Roadster, so beautiful that Dorothy used to joke that she married Shep for the car.

P.K. and Shep's friendship was built in Chicago, furthered later on Catalina Island, and continued for the rest of their lives, with Wrigley bringing Shep and often Dorothy as well into all the visual aspects of his businesses. As Shep put it to *The Sporting News*, "Phil is the 'WHAT to do' man and I'm the 'HOW to do it' feller."[20]

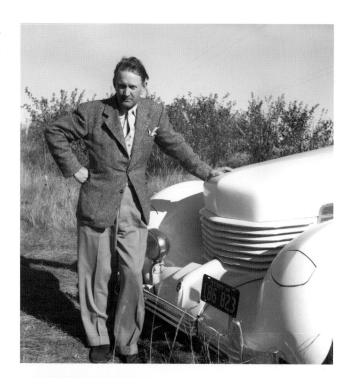

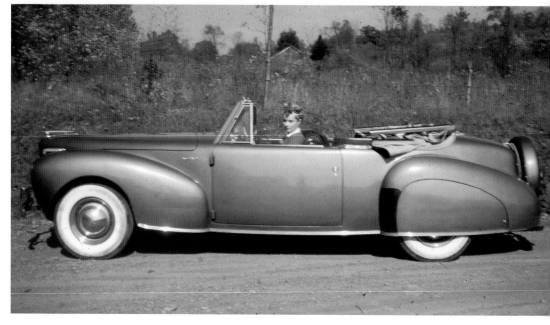

Top: **Shep in front of his 1938 Cord convertible.**
Above: **Dorothy in the Lincoln Continental convertible given to Shep by P.K. Wrigley in 1942.**
Opposite page: **Shep's photo of Dorothy sitting on the bumper of the Lincoln.**

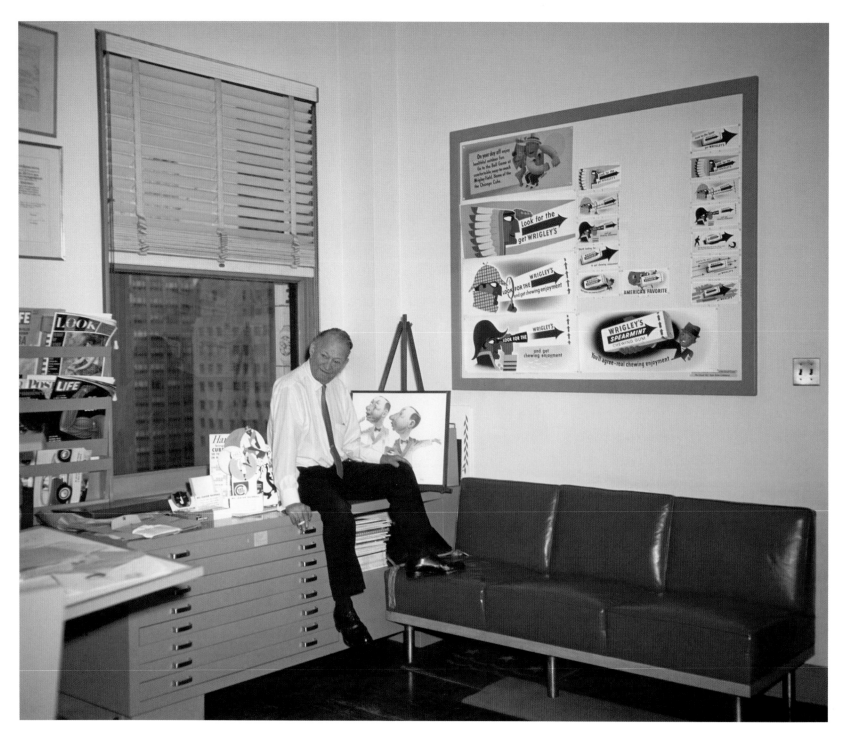

Above: **Shep in his office in 1962, the year of his retirement. On the bulletin board are mock-ups of a new transit card campaign. Beside him are Cubs game schedules adorned with his graphics.**

Opposite page: **At the drawing table surrounded by tools and awards. On top of the filing cabinet stands Shep's sculptures of Cubs players arguing with an umpire.**

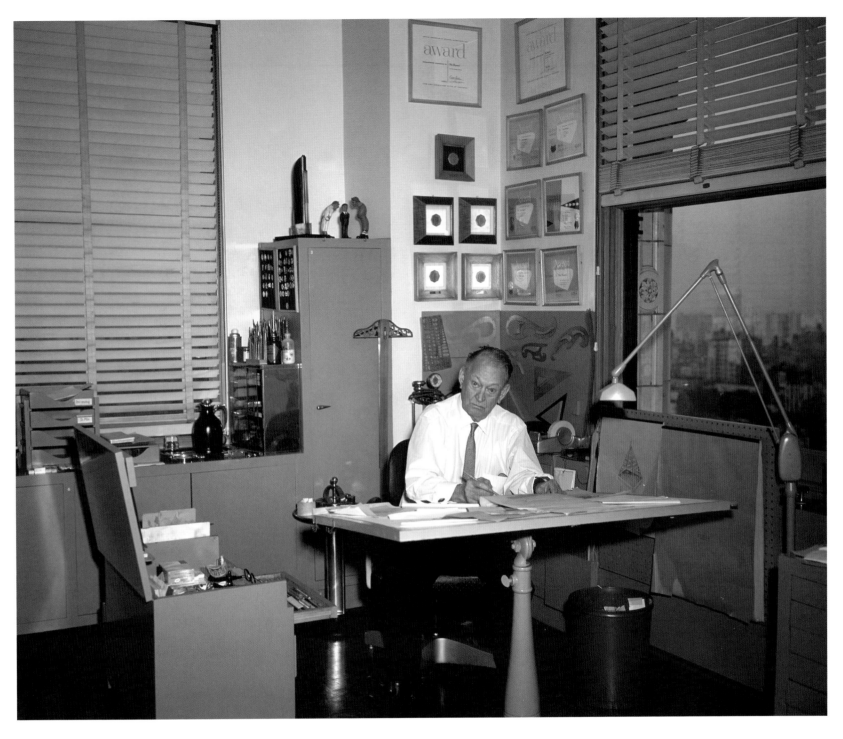

RP 58-11

Above: **A transit card from 1958, done in a more cartoonish style.**
Opposite page: **One of a range of promotional posters created for the foreign market, 1950s.**

Double delicious—double smooth, too...
that's why Doublemint's doubly
delightful to chew.

Try double-good Doublemint today

Double your pleasure with Doublemint.
So smooth—so satisfying—so
good to chew.

Get double-good Doublemint today

Top: **An example of how Shep's style transitioned from softer, modeled airbrush work to a more reduced style, 1960.**

Above: **An unusual piece from 1960 with a complete lack of rendering or shading, yet with a design still unmistakably made by Shep.**

Above: **Completely abandoning the airbrush, Shep embraces a hard-edged pop style to keep up with the visual-culture trends of the day. These were among Shep's final pieces for Wrigley, printed in 1963.**

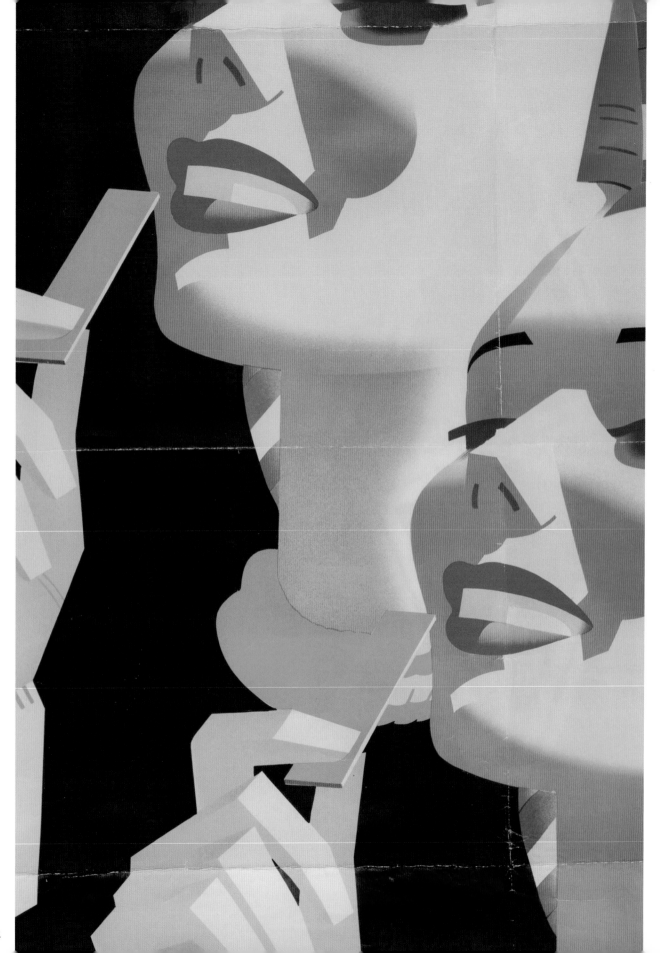

Right: **A rare fragment from an actual printed panel of a Wrigley billboard. Wrigley transit cards and billboards were printed in custom color lithography, as opposed to today's more limited four-color offset printing. Lithography allowed for perfect color matching and faithful imitations of Shep's airbrushed original artwork.**

Shep worked very closely with all of his printers, developing new techniques in order to achieve the highest-quality printing at an unprecedented scale.

Below, left and right:
Many New Year's Eves, Shep would dress up like the New Year's Baby, cloth diaper and all. He would gather bottles of liquor and, starting at the sixteenth floor of the Wrigley Building, work his way down, pouring booze for staffers along the way. It was quite a ways to the ground, and he could never make it all the way down without getting too drunk, at which point he was packed into a car and sent home.

Catalina

Four marvelous years
creating an island dream

Selling gum was only one part of P.K. Wrigley's vision for this company. In 1932 P.K. summoned Shep to California from Chicago, ostensibly to "ride the paints"[21] (meaning, evaluate the hand-painted signs, rather than the mass-produced billboards, adorning buildings). But after a quick bit of business in Los Angeles, Shep found himself twenty-six miles southwest of the city off the coast of Los Angeles with P.K., riding a horse up a dusty trail in a backwater island called Santa Catalina. Shep was rough enough—he'd ridden and climbed and fought and drank—but now he was on some kind of newfangled corporate retreat. "If I'd known that wrestling with a strange horse on the side of a mountain was a part of making Wrigley chewing gum posters I'd have gone in training by having someone jump on my head while I was doing a split; hit me on the back with a sledge hammer, burn me with matches and stick a flock of pains in my body."[22]

With P.K., Shep built a barn and worked the Wrigley ranch. Atop one of the craggy peaks, the men looked across the eight-mile-wide island and began to toss around ideas for how they could turn it from a humble space into a money-making tourist destination—one complete with a solid infrastructure and nightlife.

They were not the first to entertain visions of glory for the island. Santa Catalina was first settled around 7000 B.C. and was claimed by the Spanish in the sixteenth century. The viruses the Europeans brought with them were deadly for the indigenous population, and by 1830 the natives had been eradicated. In their place gathered a rowdy crew of smugglers, fishermen, and Chinese immigrants under very loose Spanish governance. In 1821 Mexico won control of California from Spain and declared ownership of Catalina; but in 1848, with the close of the Mexican-American war, the state and island were claimed by the United States. In the years that followed, the island was ruled by miners, squatters, smugglers, and everyone else who could carve out a living in its steep hills and survive its grueling winters.

In 1887 the island was bought by an American real estate developer named George Shatto, who began to develop it into a resort. His sister-in-law named the island's only town Avalon. This was a short-lived affair, and the entrepreneurial Banning family bought the island and continued Shatto's getaway vision. But most of their work burned to the ground in a massive blaze in 1915, and Catalina stagnated once again. In 1919 William Wrigley visited, fell in love with, bought, and began an earnest push to elevate Catalina. Wrigley was a very wealthy man at the time of the purchase—his international consortium of gum brands generated seventy-five million dollars in revenue annually—but he had become restless in Chicago, so he had been growing his portfolio of businesses. He dreamed of having his own empire—just as William Randolph Hearst had dreamed of and built his in Northern California.

Catalina offered a way to refine the idea of the rugged West. Wrigley brought cosmopolitan ingenuity and industrial techniques to the island. He built a power plant and a fresh-water reservoir, and vastly improved the sewage system. He created a furniture factory and several rock quarries that served the island's inhabitants and also brought money in by exporting furniture and minerals. He established Catalina Clay Products in the early 1920s to make use of the island clay for both building materials and decorative arts. In order to draw wealthy Californians to his resort, Wrigley spent two million dollars to construct an entertainment complex. It included a casino and an eighteen-hole golf course, and it opened in 1929. And in 1927, to bring more attention to the island, he moved his Chicago Cubs' annual spring training to Catalina, building them a playing field and clubhouse.

Through Catalina, William Wrigley built himself a fiefdom. He made the island function and publicized it. But he lacked an eye for design. It was a mishmash of architectural and design styles without a fully realized aesthetic.

Opposite page: **Shep riding with P.K. Wrigley, in full Western regalia.**

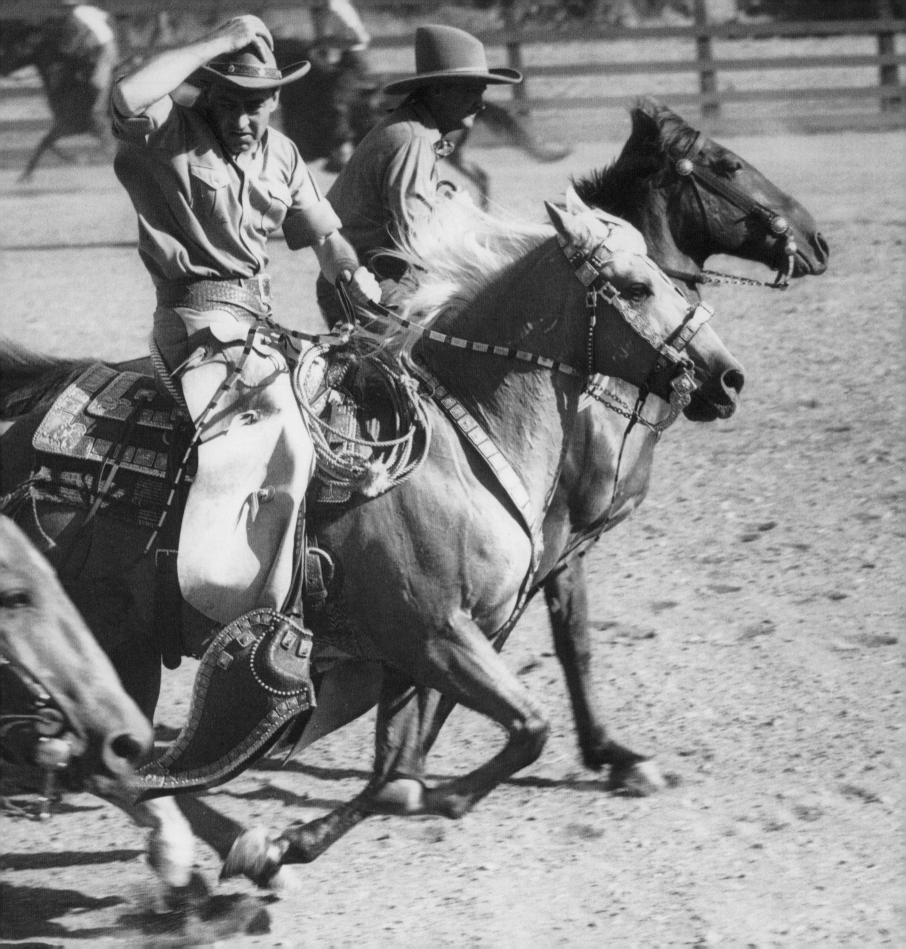

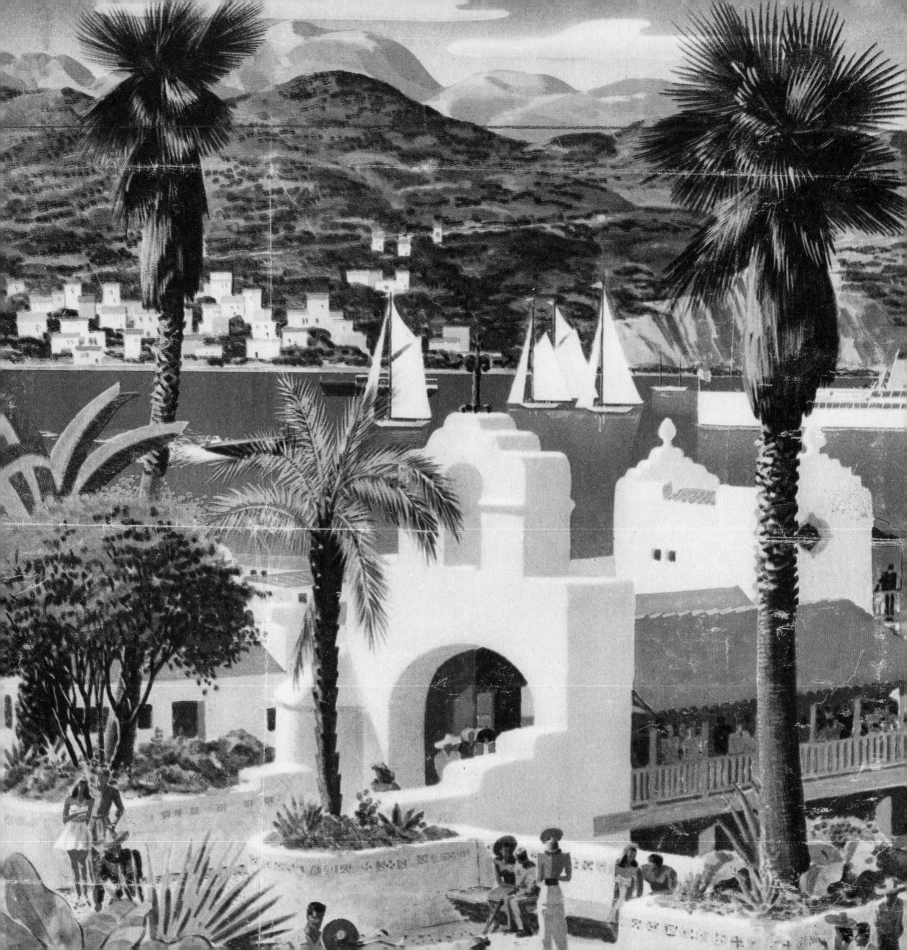

In 1932 when P.K. inherited the island, he wasted no time getting to work on this transformation. His first step was to hire Shep. Neither had experience with city planning or environmental design, but they shared a belief in the power of design to communicate ideas—a lifestyle or a sentiment—and the need for a seamless mix of art and commerce.

In conversation fifty years later, Dorothy, who joined Shep on the island, would rhapsodically summarize the Catalina era:

> There was no real schedule and yet the activity was endless and the progress was very apparent each day. It was an endless California dream. Shep played with everything he could get his hands on. There were serpentine walls, color schemes, and the well-known rustic street lamps. To this day the posters for Catalina bear his original designs. He loved playing with the big spaces that affected lots of people, and this was part of the glory and potential he saw in the billboards and bus posters. We had four marvelous years there on Catalina. I did some work for other clients while Shep kept the Wrigley [gum] affairs moving forward. While I had often felt that as a commercial artist I rode on Shep's coattails, on Catalina there was great freedom and I did some good work on my own. We all—Otis, Philip K., and I—did some very elaborate jobs together as well. We transformed the place. We entertained with the greats of Hollywood, and people from around the world enjoyed our rebuilt paradise.[23]

Opposite page: **The paradise of Catalina, as depicted by Shep in a 1934 full-page advertisement in** *Fortune*. **Right: As stylish as they'd been as urbanites, the Shepards would sometimes adapt their sartorial style to one more fitting for island life.**

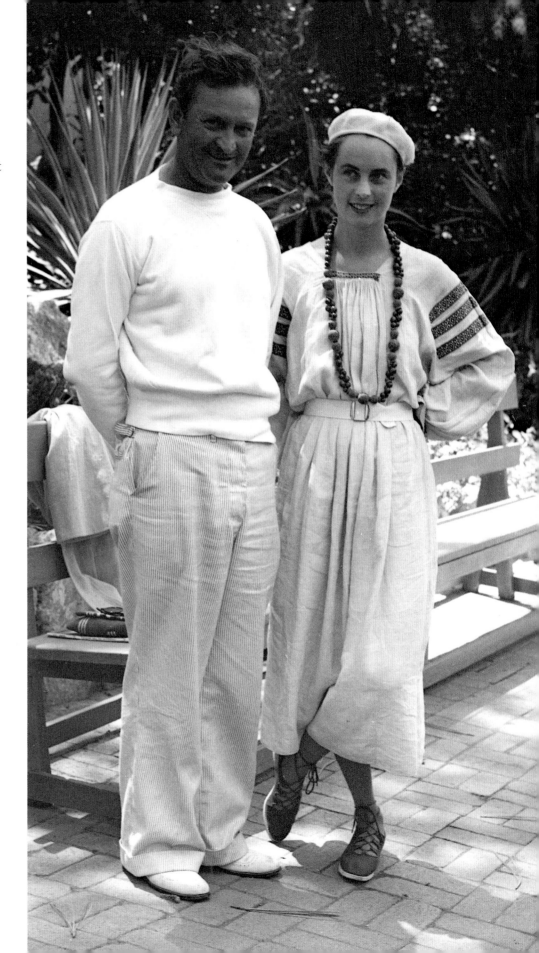

In April 1934, after nearly two years of planning, Shep presented his and P.K.'s master plan for the look of the island to a "special meeting of Avalon businessmen" at the island's City Hall. It was a comprehensive scheme to unify all of the architecture, signage, promotional materials, and even city workers' uniforms under a single "Early California Plan," an aesthetic that blended nineteenth-century Mexican and Native American turquoise and magenta-dominated patterning with streamlined modernist sensibilities.

Catalina's newspaper, *The Islander*, published Shep's pitch in its April 26, 1934, issue:

> What can bring business from the mainland is the creation of a unique Avalon, a little town whose fame for beauty, charm, and

Below, left: **William Wrigley Jr. in the world's largest exotic bird park, which was his own creation.**
Below, right: **At home with a feathered friend in 1929.**

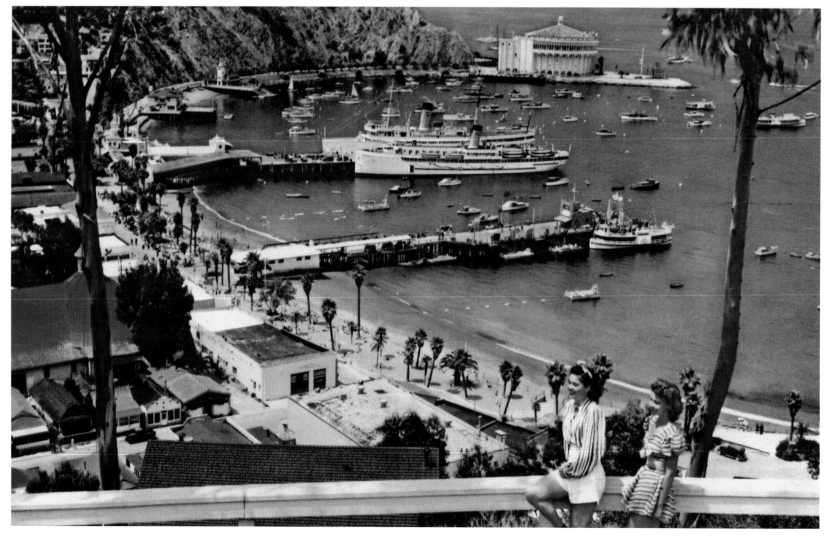

Opposite page:
A circa-1930s postcard
of the Catalina primary
waterfront, as designed by
Shep and architect
R. M. Schindler.

Above: **Not one to overlook**
a detail, Shep not only chose
the palm trees but then
supervised their placement
and planting as well.

individuality will travel around the world; a place that will be written about by noted writers, and painted by famous artists; be talked about as a place different from any other, but with a restfulness and allure that makes those who come want to stay longer and come back again and again.

With his audience primed, Shep had then gone on to recommend to them how best to run their businesses to accomplish this:

It is a horrible mistake if we attempt to do business on the island as it is done on the mainland. We lose a golden opportunity to cash in on what is immeasurably more valuable than anything the mainland can accomplish with expensive sales methods. We want to make people feel far removed from the atmosphere of high-powered selling. We want to get them intrigued by our spirit of courtesy and hospitality, to drink in the unique atmosphere and restfulness of our shops. We want to avoid the resistance that high-powered salesmanship naturally builds up. In other words, get them eased up. A relaxed purse is much easier to open.

In this speech, Shep described how Catalina should be designed according to its unique scale and needs, and said that approaching the island like this could make a great deal of money for everyone involved. He gave an example and then a conclusion that sounds like a dispatch from a contemporary marketing company: "Americans spend millions in Europe each year that they do not spend at home merely because the shopkeepers in Europe employ a different sales psychology. They buy there what our high-powered selling methods have driven them away from. The charms of their shops sell themselves to the customer. That is what we can do here."

Shep's speech emphasized the importance of intimacy and lifestyle—that Catalina should sell itself through charm and grace, not hucksterism, to attract people to the island. He gave his vision of how shops could make a consumer's purchase an experience, not simply a transaction. He drove the point by positing that the lifespan of "usual" amusement destinations is short, that "cheap signs and cheap selling methods kill the average resort."

"Santa Catalina Island has everything of natural beauty to capitalize on," he said. "However, all this beauty and charm can very readily be spoiled by just a few manmade incongruities—

Below: **Shep and Dorothy strolling on the Avalon Quay.**
Opposite page: **An island flower seller wearing one of Dorothy's costumes, in front of a kiosk featuring a** **Shep-designed poster for Wrigley's as well as a movie poster. Engaging the public visually and personally was part of Shep's plan for Catalina to attract—and keep—tourists.**

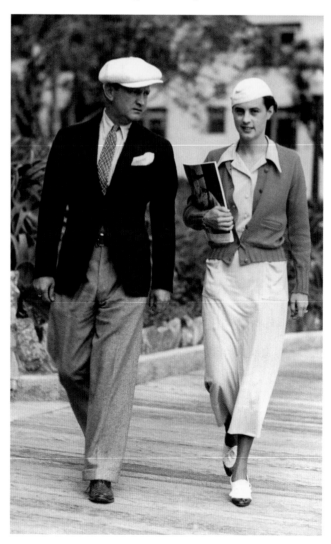

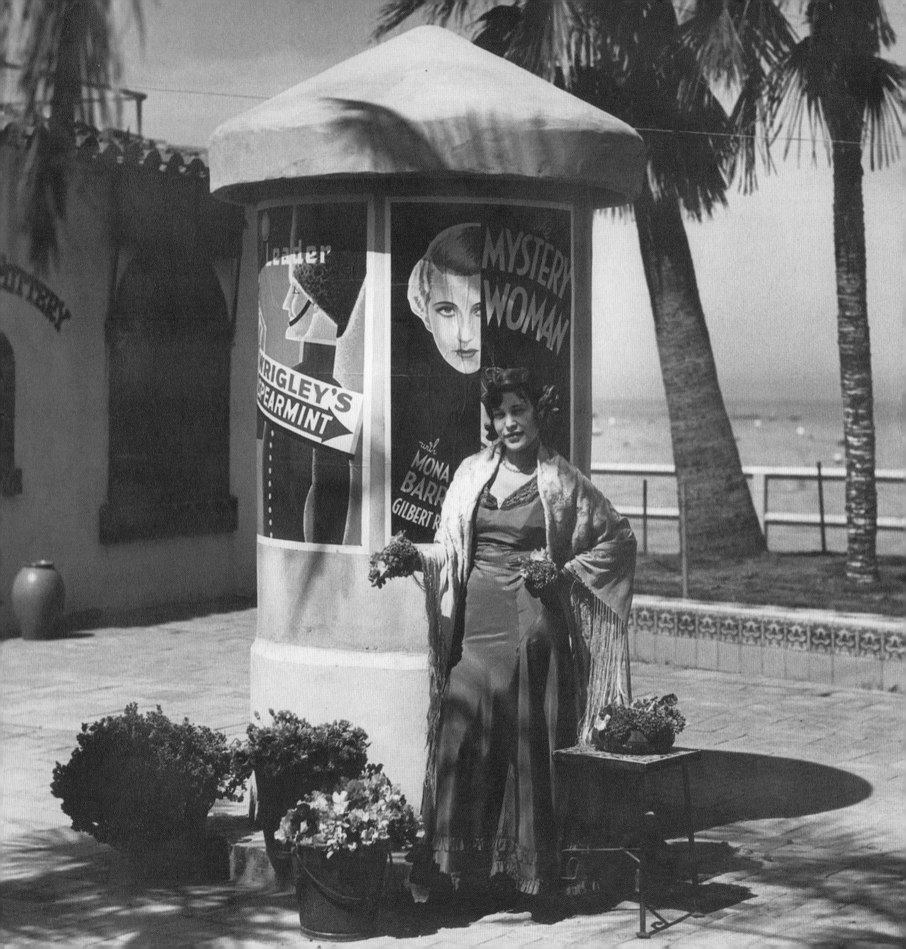

trying to employ commercialism that may have its place on the mainland, but not here." No, Catalina would be a place where business was done, and done well, but it would be done without any urban hustle-bustle or crass salesmanship. It would be pleasant. Purses would be opened, but gently and under a richly decorated awning across from a brightly tiled fountain. Shep continued, "We can do here what it took thousands of years to create in Europe. With new scientific knowledge at our disposal, we are transplanting palms and olive trees fifty and sixty years old. With paint and clever design, [we are achieving] effects that bring the feeling of romance and cultural background that only the passing of centuries has heretofore been able to give."

Shep created baseline palettes, graphic systems, and forms upon which local artisans could expand to execute his vision for the island. Shep even established an office that offered free support and design services to local business owners. Nothing would be imposed, Shep stressed, but rather the Early California Plan would provide the tools to build a consistent, but not stuffily uniform, vision. According to *The Islander,* Shep "fired the enthusiasm of everyone present and drew instant response of 100 percent cooperation with the suggestions advanced."[24]

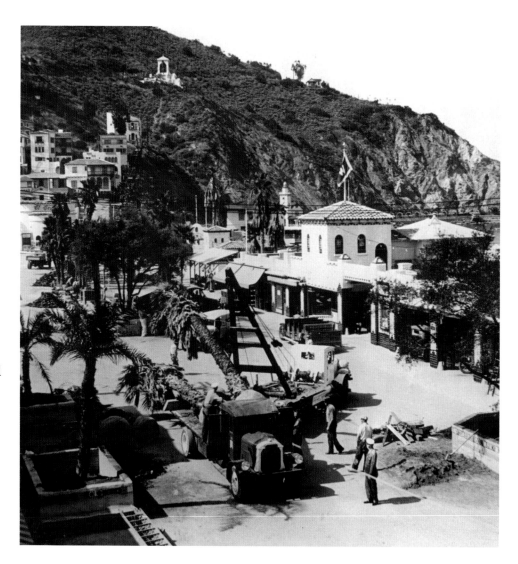

Dorothy's island studio

When Shep was out in the field, Dorothy would work from her personal studio in Avalon. To a deep grounding in early modernism and abstraction, she added an immersion in the Native American and Spanish visual traditions of the island. She researched the indigenous clothes, patterns, and jewelry of the island and made sure that, like the physical structures of the island, the décor, whether worn or gazed at, was visually organic to the place.

In addition to the work on Catalina that Dorothy did for Shep, she also ran a successful interior design business, decorating newly built cottages and hotel interiors for the steady stream of wealthy homeowners buying a bit of her paradise. This, along with the continuation of the work she did for billboards and freelance clients, provided her with a sense of career independence, a feeling she would lose in her later pursuits.

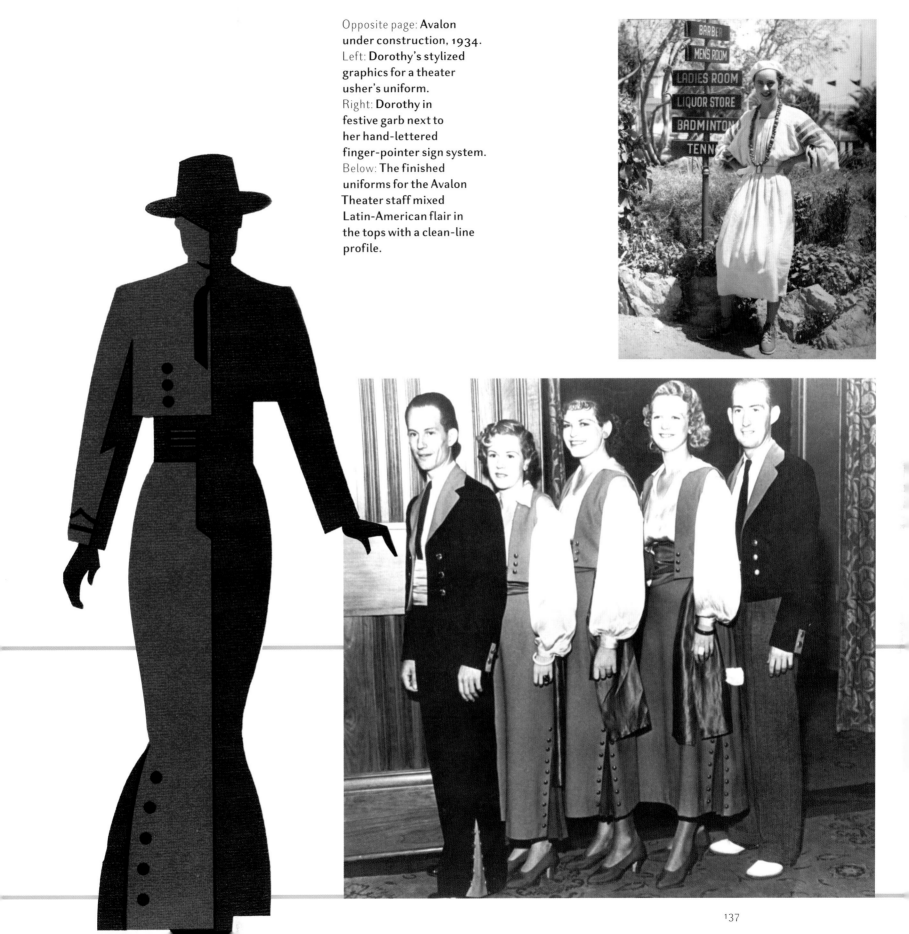

Opposite page: **Avalon under construction, 1934.**
Left: **Dorothy's stylized graphics for a theater usher's uniform.**
Right: **Dorothy in festive garb next to her hand-lettered finger-pointer sign system.**
Below: **The finished uniforms for the Avalon Theater staff mixed Latin-American flair in the tops with a clean-line profile.**

BARBER
MEN'S ROOM
LADIES ROOM
LIQUOR STORE
BADMINTON
TENN

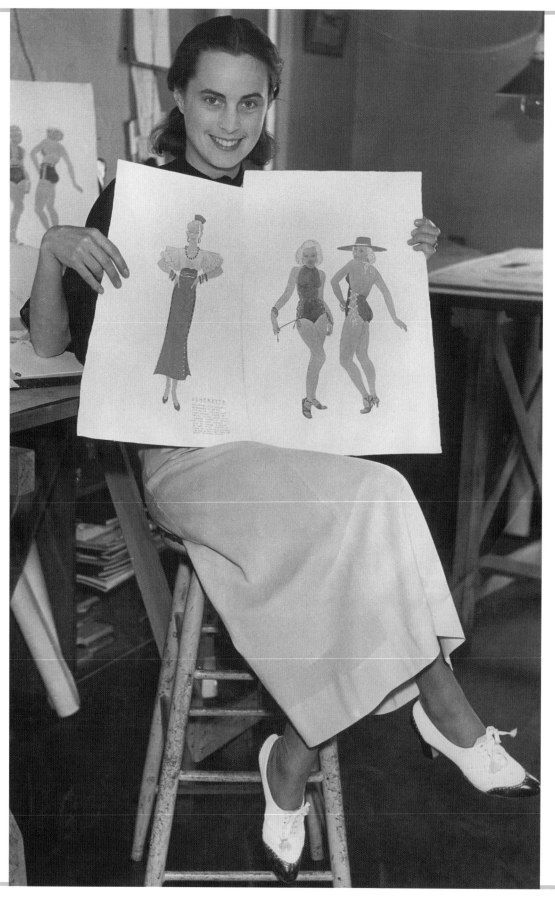

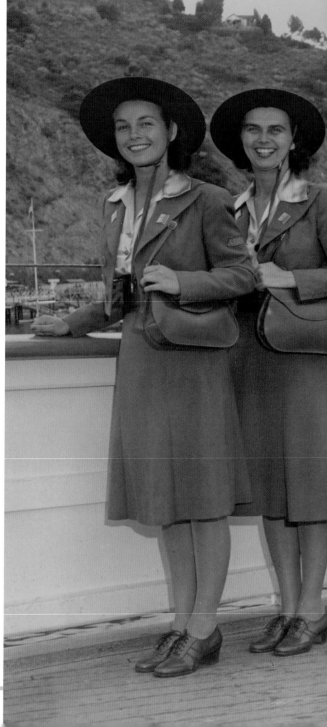

Opposite page: **Practical but always possessing a flare for the theatrical, Dorothy's design sense here is a perfect marriage of historical clothing and contemporary fashion.**

Below: **Everyone from postal workers to theater ushers to lifeguards wore Dorothy's uniforms.**

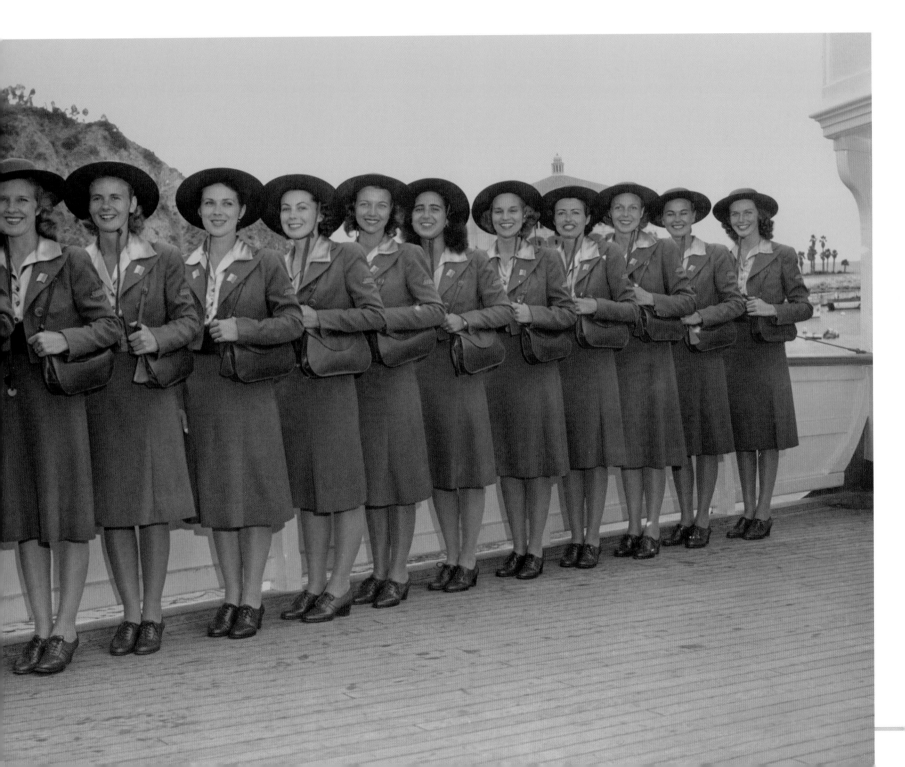

Right and on opposite page:
Courier, theater usher, and bus driver uniforms.

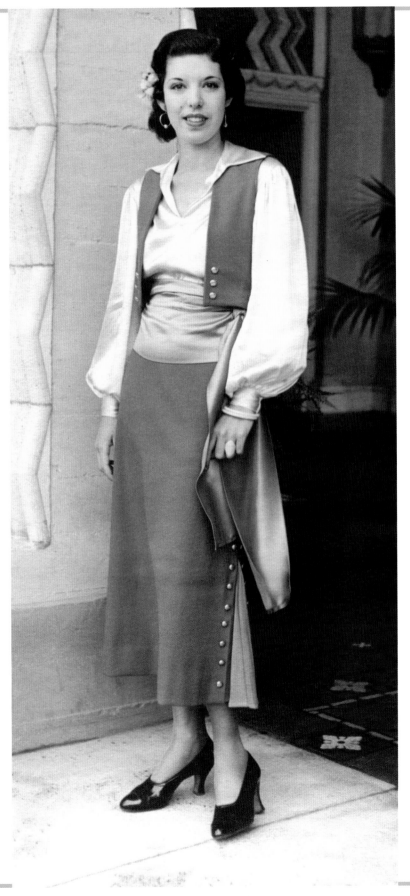
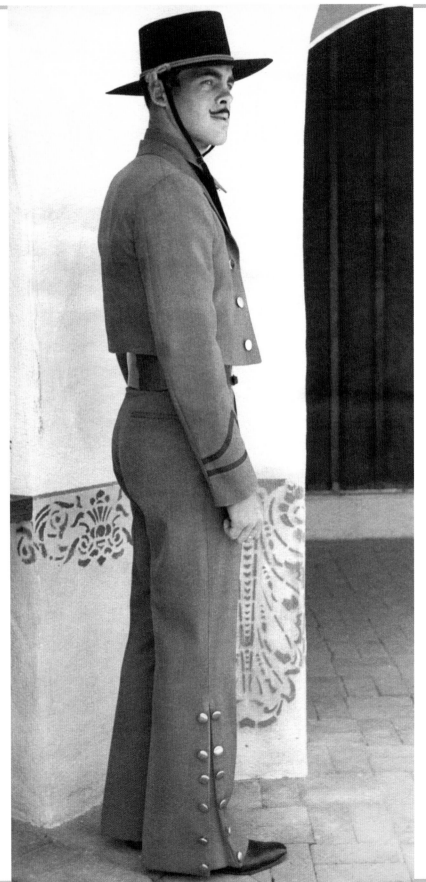

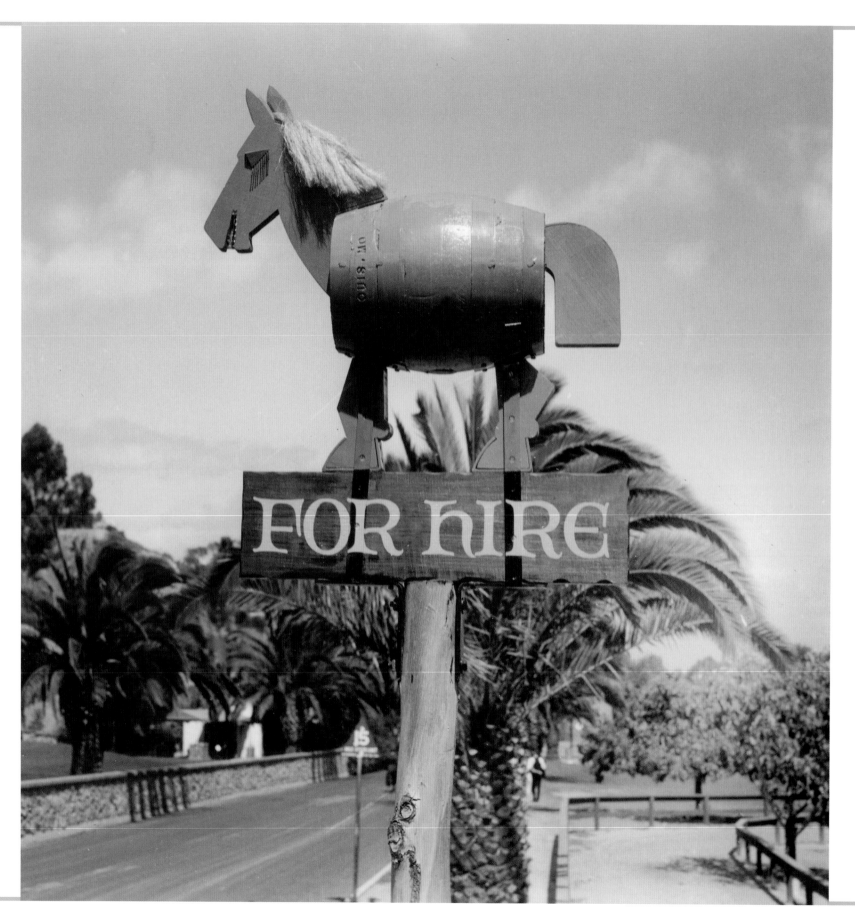

Dorothy's clever,
dimensional signage system.
Opposite page: **Horses for hire.**
Right: **The way to the Flying
Fish tour.**
Below, left: **Various road
signs. Image courtesy of the
Catalina Island Museum.**
Below, right: **The entrance
to the Bird Park.**

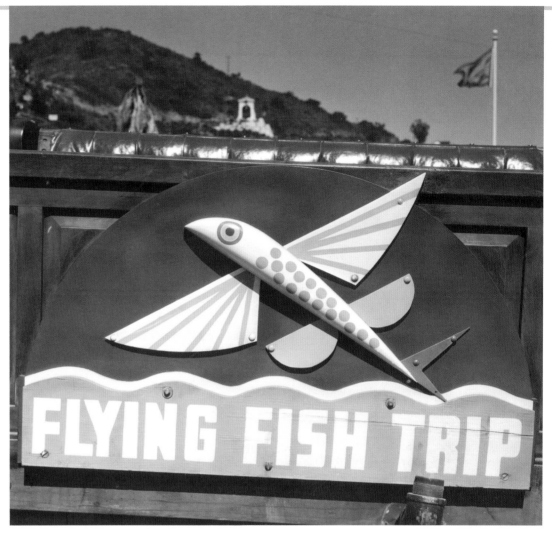

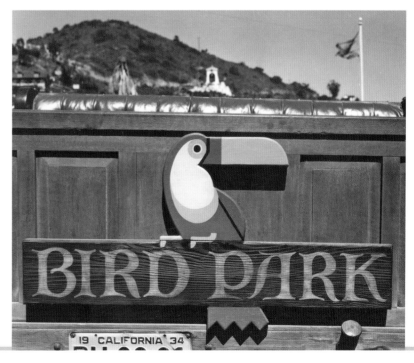

Having gained notice for her design work for everything from the St. Catherine Hotel interiors to the Catalina ferry, Dorothy hung out a shingle for her own interior design company.

THE INTERSTATE DECORATING CO

STUDIO BUILDING · AVALON · CALIFORNIA

DOROTHY SHEPARD · VICE PRES

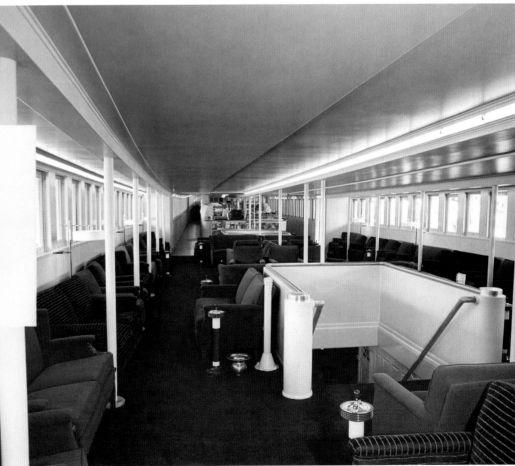

Above: **A mural designed by Dorothy for a playground.**
Below: **Her 100-foot-wide sea life–themed mural for the Casino's Marine Bar.**
Opposite page: **Dorothy at work in the studio, airbrushing one of her award-winning billboard designs for Pabst, an account she kept even amid all her work** on the island. Note Shep's wall painting of dancers just above a photograph of him astride a horse. Behind Dorothy is Shep's drawing of Johnny Weismuller.

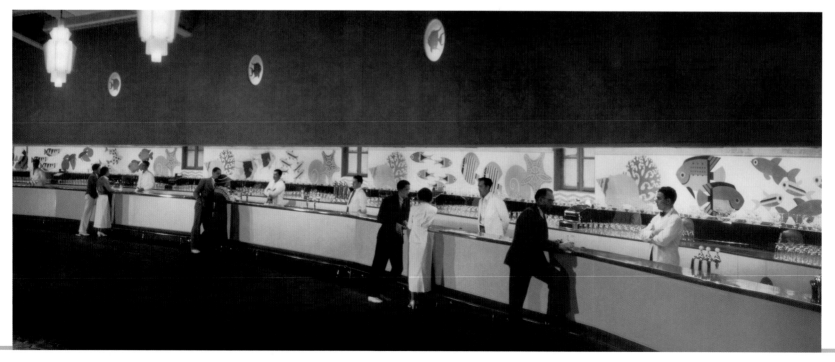

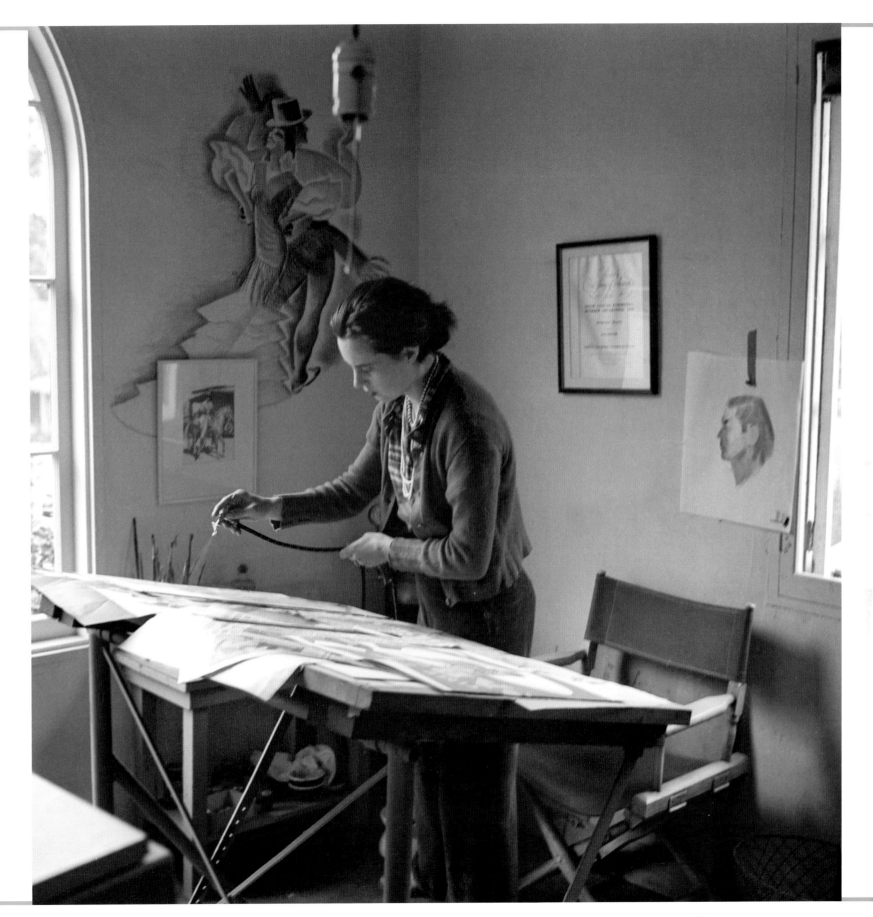

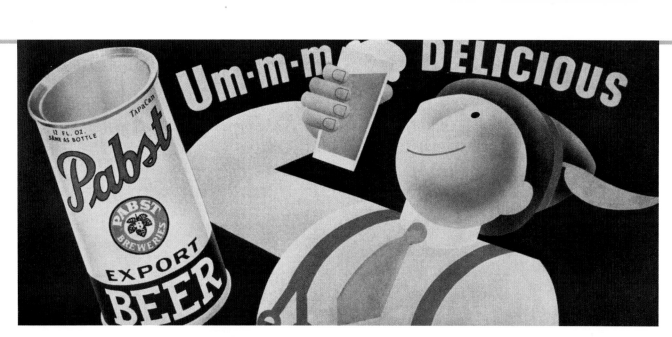

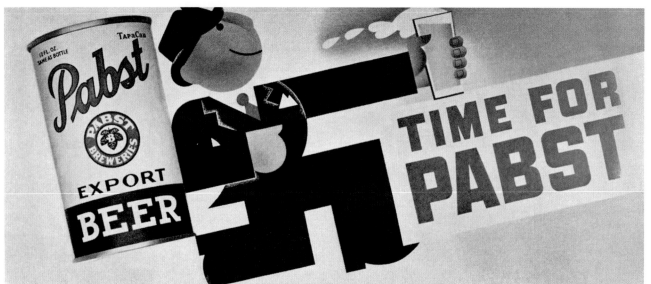

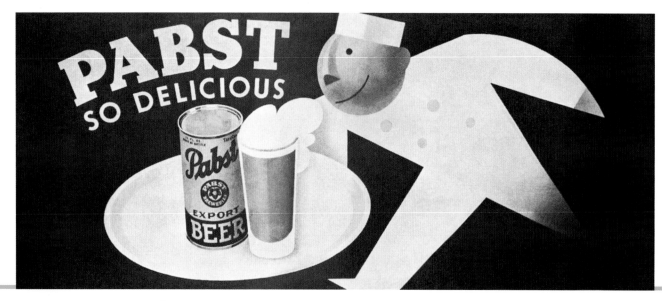

Left: **Dorothy's 1936** Outdoor Advertising Art Award. The inscription on this art deco plaque reads: "The Nation's Art Gallery", reflecting the idea of billboards as public art.

Opposite page and below: Dorothy's award-winning Pabst billboards, completed while she lived on Catalina. She continued to sign her work "Van." Images courtesy of Duke University David M. Rubenstein Rare Book & Manuscript Library.

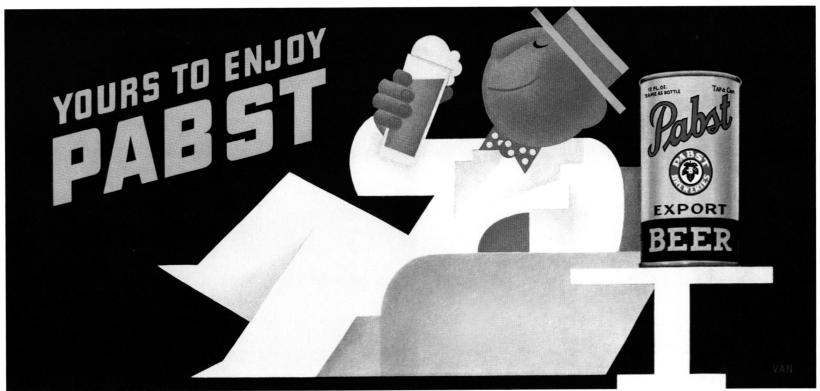

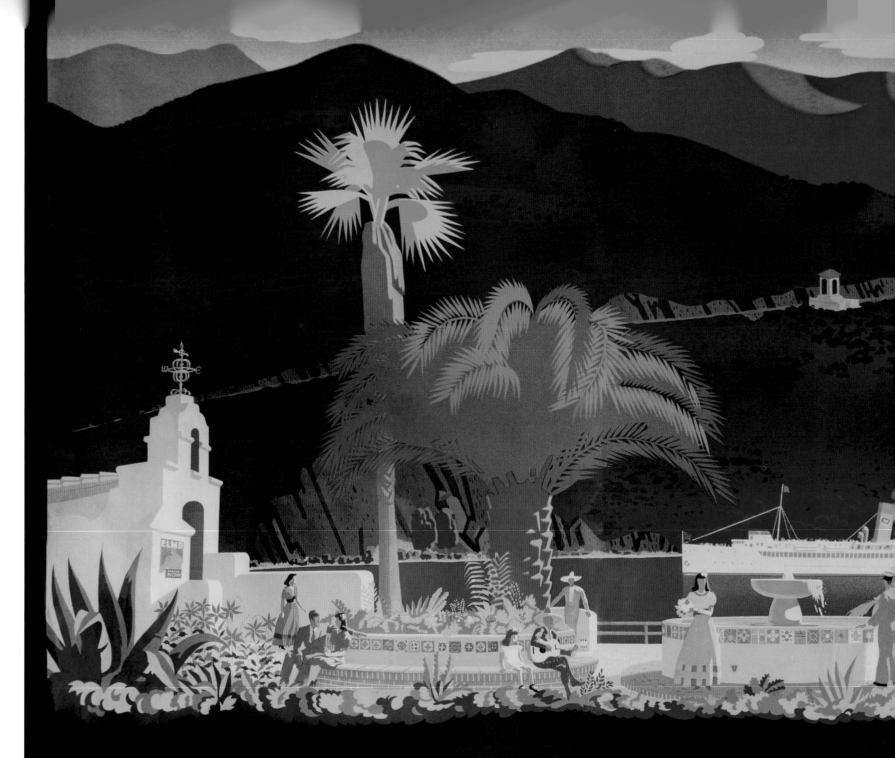

CATALINA Now see Santa Catalina

of the U.S.A. . . . yet only a short delightful voyage

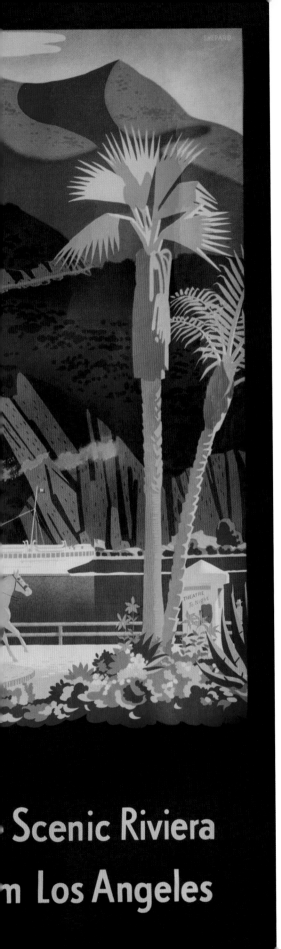

Scenic Riviera

m Los Angeles

The Early California aesthetic was in keeping with the rest of Shep and Dorothy's work: modern but never cold; optimistic but not over-the-top; handcrafted but not "crafty." It was also, in keeping with modernist philosophy, meant to address the totality of the project: all aspects of the island would be addressed. Shep designed the Catalina Island typeface; Dorothy devised the signage system for streets and attractions and painted the murals for the L.A.–Catalina steamship and the local hotel. She also designed uniforms for everyone from theater ushers to refuse collectors to tour guides. The kiosks, fountains, and walls were adorned with locally fired tiles of the Shepards' design, and even the menus in the restaurants were garnished with a design and typeface made by Shep. In addition to visuals, they devised promotional taglines like "the Scenic Riviera of the U.S.A. ... yet only a short delightful voyage from Los Angeles."

In the late 1970s, Dorothy recalled the process as all-consuming:

A large-scale poster by Shep, designed in the style of English railway posters. Many of Shep and Dorothy's actual designs and motifs for the island are apparent in this image—tiles, uniforms, and even a cowboy.

> Shep would do anything. Landscaping, palm trees, Mexican colonial design. He'd get on his knees with the laborers in the hard sun and lay pebble and rock in the hot street all day long. I really think they were all intoxicated with the Early California look, and laying patterns on the street was an obvious medium to work with. He hated neon; had it removed. The wooden signs in their distinctive style are still in use to this day. I knew then that this was the closest thing we'd get to paradise. We'd look at the pots as they came out of the pottery and tile shops by the thousands, all following our various designs.... We'd look until we were tired of looking.[25]

Through Shep's vision, Catalina became everything the mainland in its recession was not, a place of bright prosperity—a symbol of the American Dream.

151

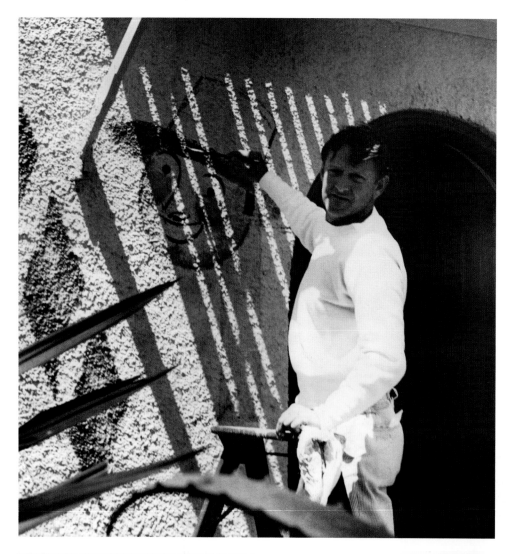

Above, left: **Shep executing the sign for the island barbershop.**
Above, right: **Shep conceived a custom typeface for use on Catalina's signage, and Dorothy executed this artwork for the finished style guide.**
Left: **Shep's mural for the St. Catherine Hotel bar.**

Left: **Shep at work** in the Catalina studio.
Right: **Dorothy's** wonderfully abstracted design for the Marine Bar's drink menu, autographed by big band leader Kay Kyser.
Below, left: **The *SS Catalina*** pulling into the dock, which featured the Shepards' aqua color scheme and one of Shep's lamps.
Below, right: **This** serpent-wall construction on Crescent Avenue was designed and built by **Shep.**

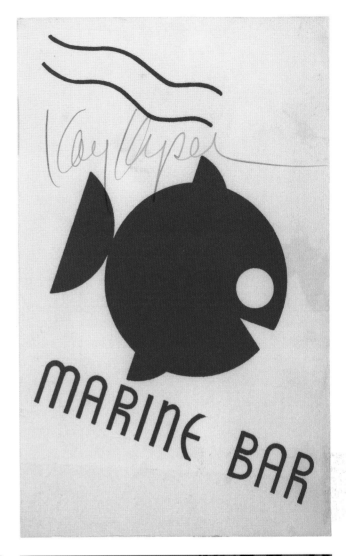

MARINE BAR

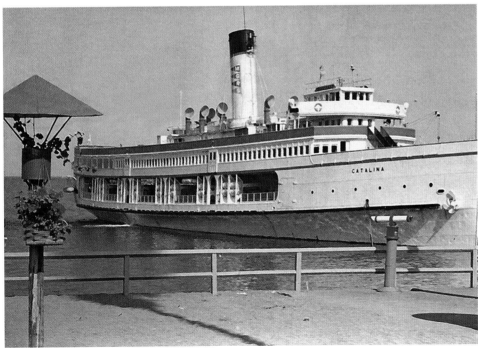

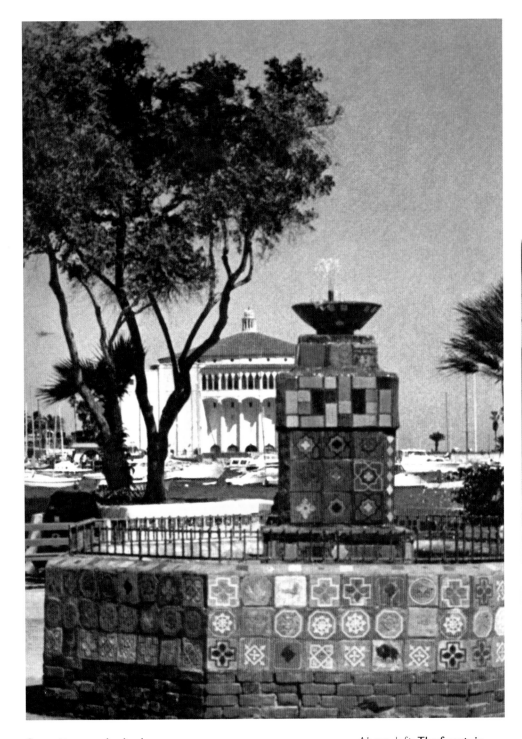

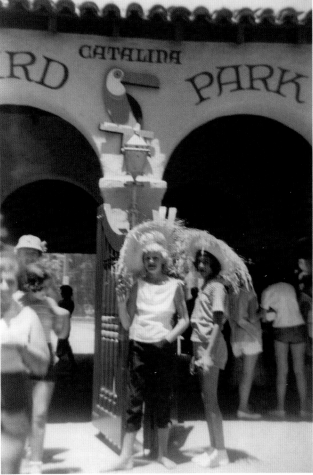

Opposite page: **An Avalon street featuring two of Dorothy's signs, a ziggurat wall, and an uplighter "Shepard light."**

Above, left: **The fountain Shep built with his own hands.**

Above, right: **One of Dorothy's signs at William Wrigley's Bird Park.**

Catalina was more than just a landscape. The people who worked on and inhabited the island were as interesting as the place itself. The Shepards knew this and enjoyed sketching their fellow residents.

Left: A drawing by Shep of Jack White, the island's resident cowboy, who attended to the horses and livestock and served as an unofficial lawman.

JACK WHITE

Right: **P. K. Wrigley's wife, Helen, who was a close confidante of, and frequent model for, Dorothy.**

Helen Wrigley

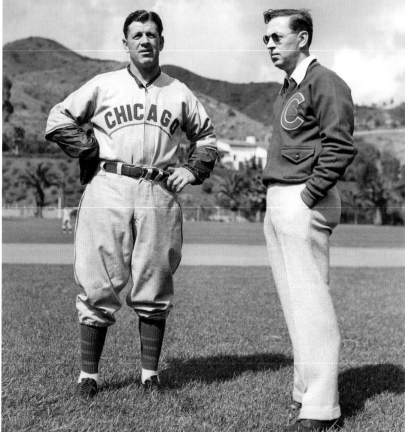

Above: **Cubs players posing during a spring training practice.**
Left: **Charlie Grimm and P. K. Wrigley on the field.**

In the 1930s, the Chicago Cubs were one of the nation's top baseball teams. Led by the gregarious Charlie Grimm, they won the National League Championship in 1932 and 1935 and became heroes of the American public. Shep, being a friend of P.K.'s and a man who enjoyed his evening entertainment, quickly met and befriended the Cubs at the local watering holes, and they embraced Shep as the charismatic and fun-loving artist he was. He was a constant presence in their clubhouse, joshing with them and cavorting with them in photo ops.

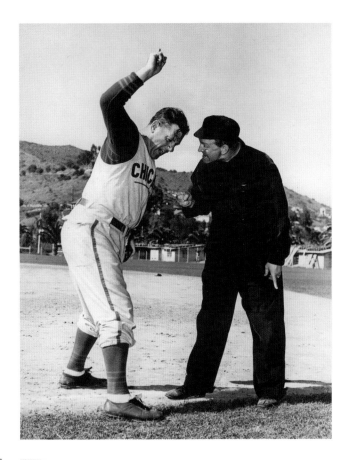

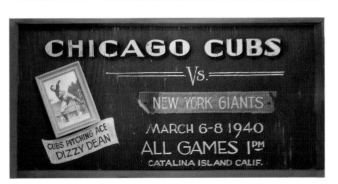

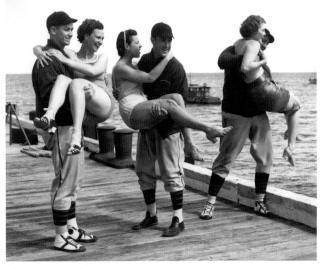

Top: **Shep hamming it up as an umpire with the "furious" Cubs manager, Charlie Grimm.**
Above, left: **Shep joshing around at the Cubs commissary.**

Above, right: **A few of the players taking a photo op with some models.**
Left: **Anonymous hand-lettered sign for a 1940 exhibition match on Catalina.**

Right: **Shep's Tuna Club membership card.**
Below: **Shep's hunting license, designed by the man himself.**
Opposite page: **With Gordon and Dorothy and a prize tuna catch.**

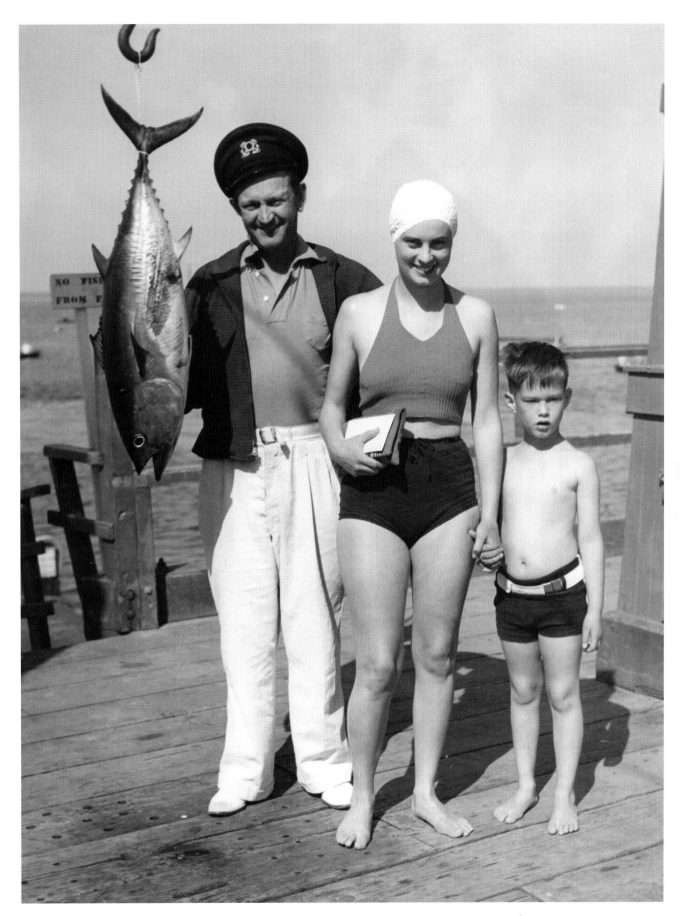

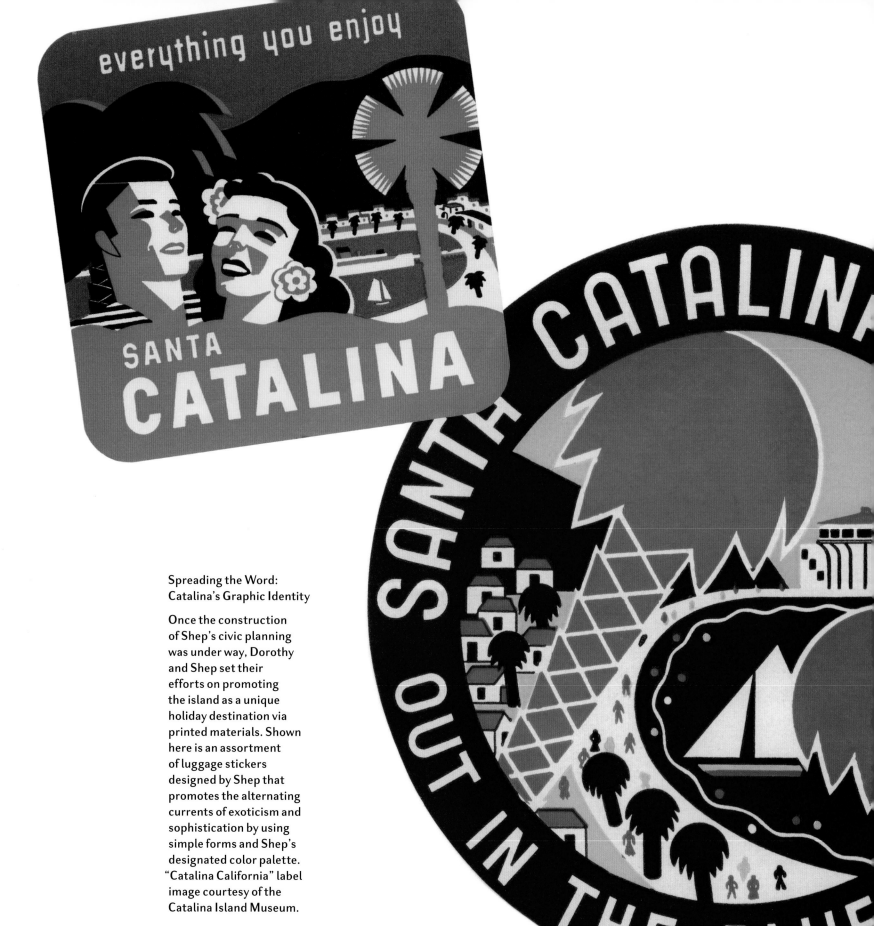

everything you enjoy

SANTA CATALINA

SANTA CATALINA CATALINA

OUT IN THE BLUE

Spreading the Word:
Catalina's Graphic Identity

Once the construction of Shep's civic planning was under way, Dorothy and Shep set their efforts on promoting the island as a unique holiday destination via printed materials. Shown here is an assortment of luggage stickers designed by Shep that promotes the alternating currents of exoticism and sophistication by using simple forms and Shep's designated color palette. "Catalina California" label image courtesy of the Catalina Island Museum.

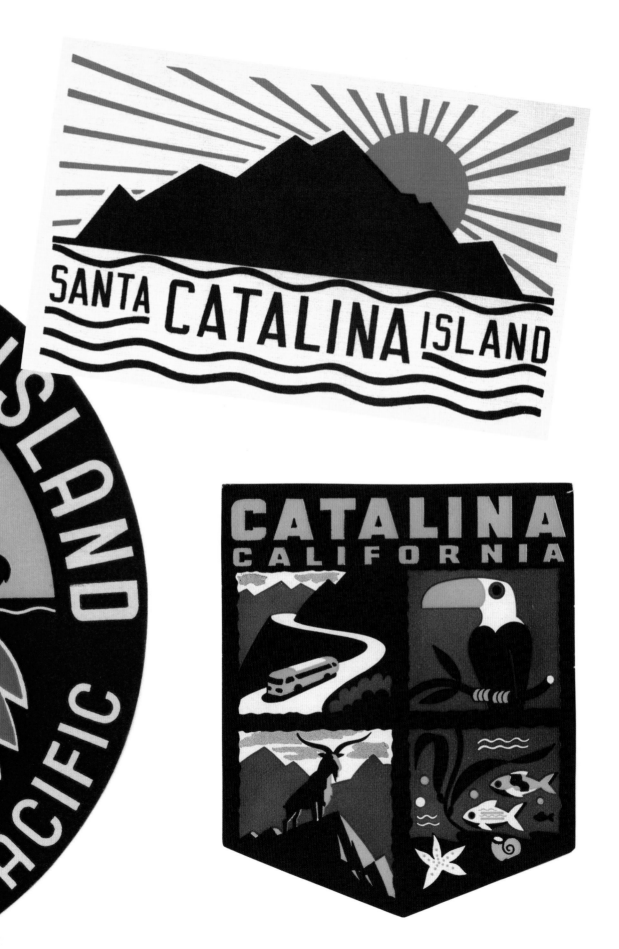

Overleaf: **An unusually restrained European-inflected billboard for Catalina by Shep, circa 1934.**
Pages 164–169: **Promotional brochure covers designed by Shep and Dorothy.**

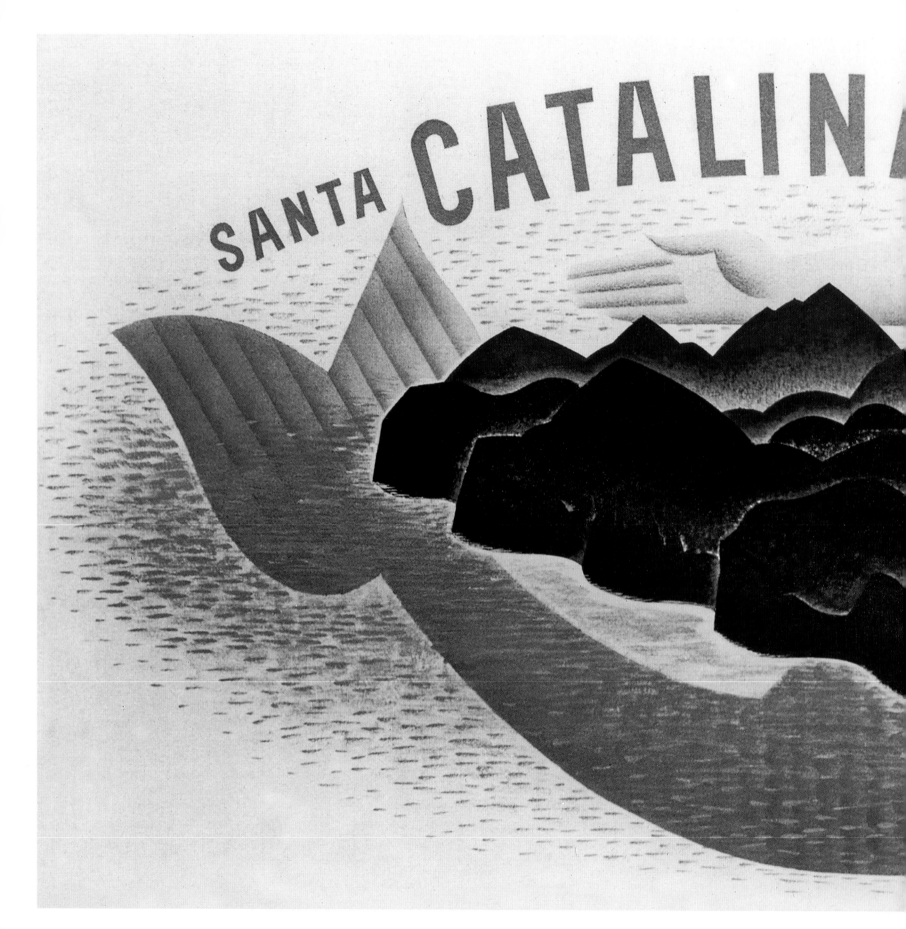

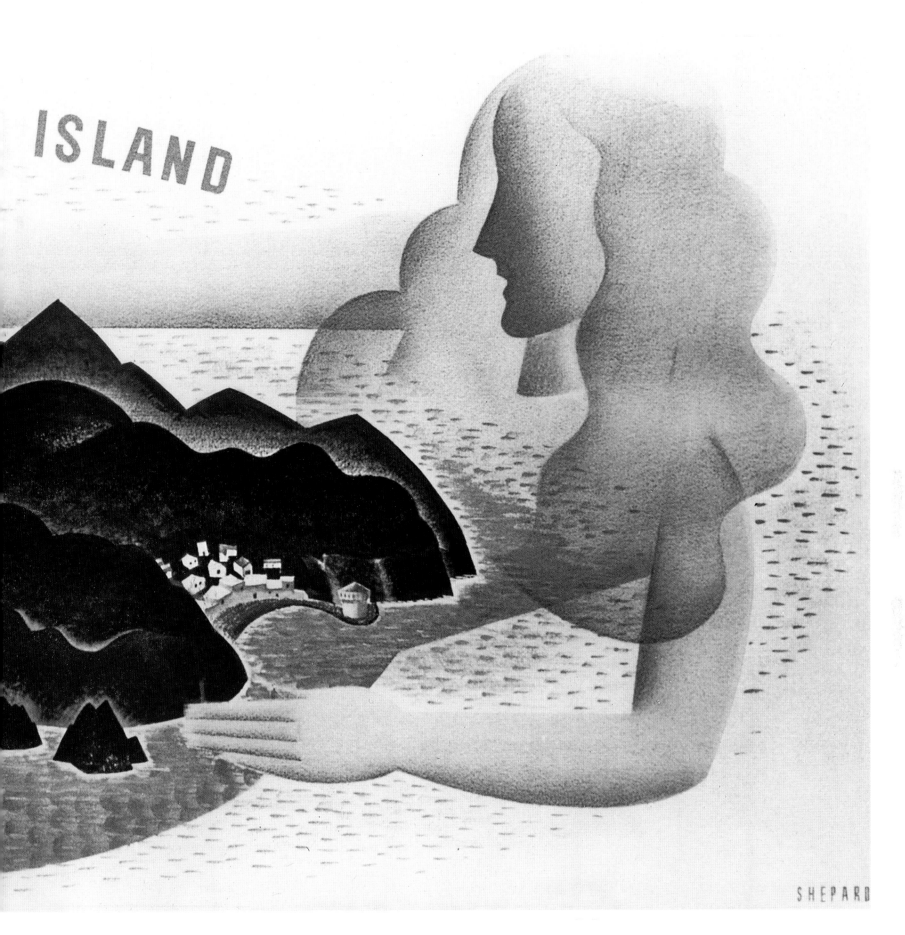
ISLAND

SHEPARD

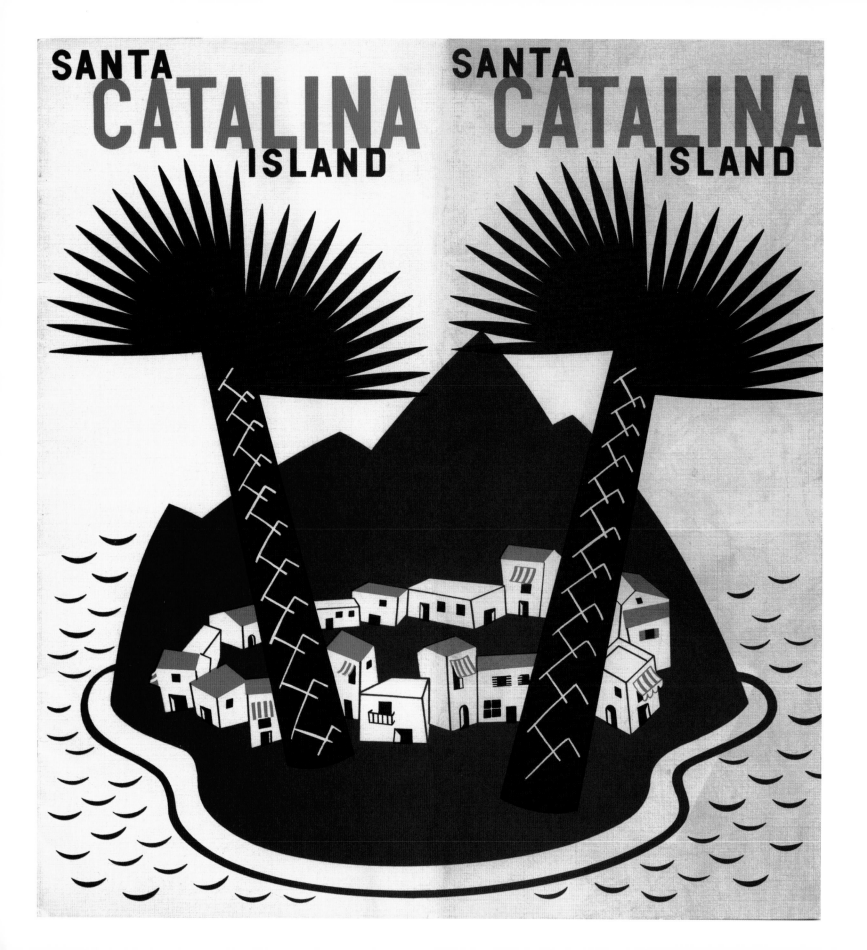

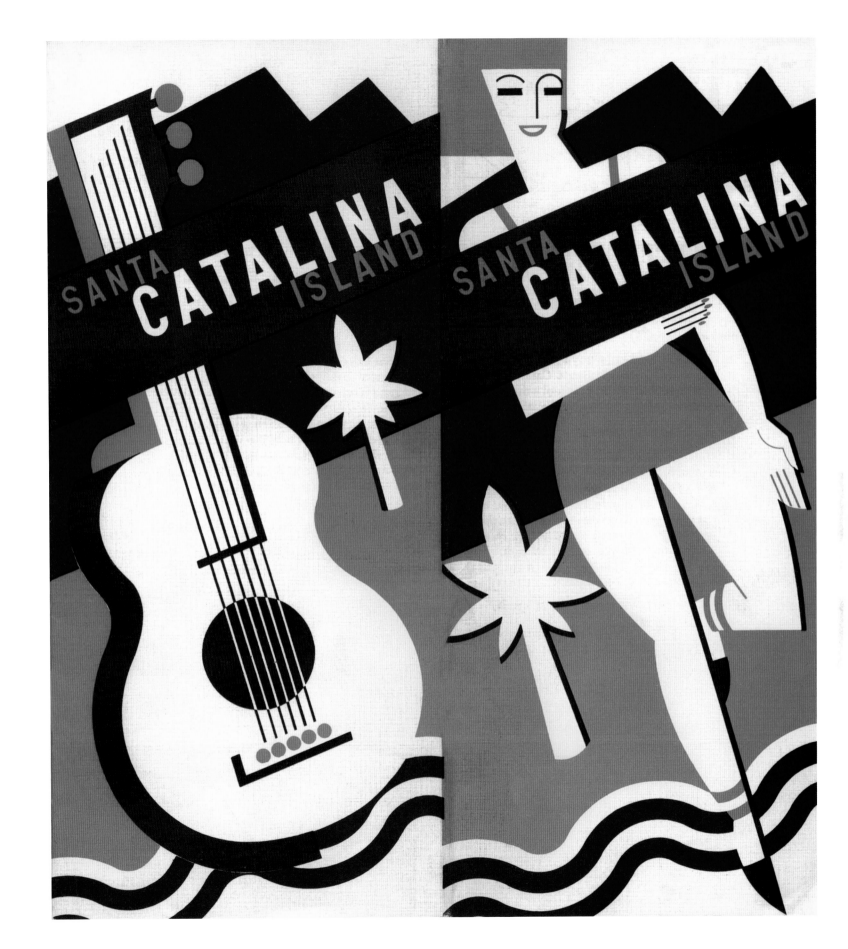

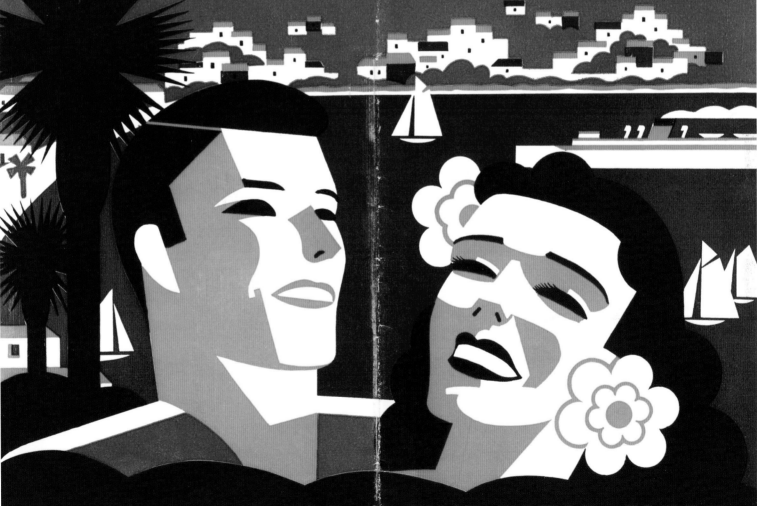

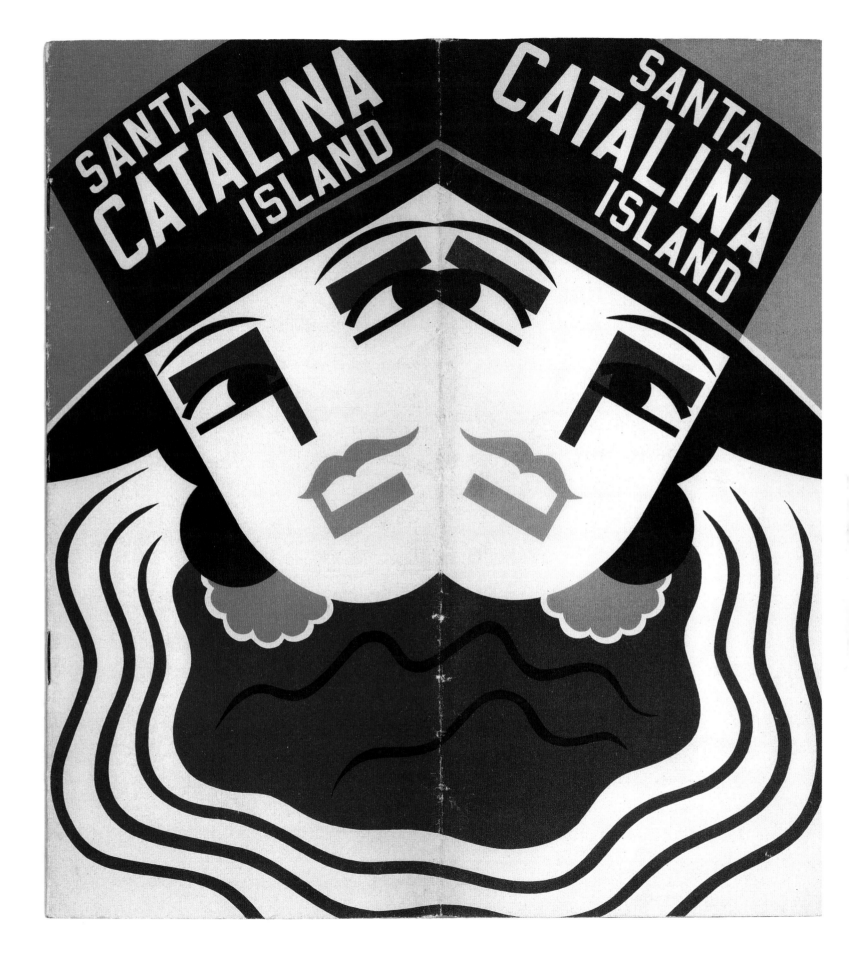

CLUB LA CIMA
COCKTAIL
MENU
SANTA CATALINA ISLAND

Left and on opposite page:
Cocktail menus bearing line-based design work and lettering by Dorothy. Club La Cima menu image courtesy of the Catalina Island Museum.

ST CATHERINE HOTEL

SANTA CATALINA ISLAND

COCKTAIL
MENU
AND WINE LIST

Above: **A travel brochure for The Isthmus, located in the western region of Catalina.**

174

CATALINA

FLYING FISH · TASTY DISH · MOUNTAIN GOAT

ISTHMUS BOAT · PLEASURE PIER · STEIN OF BEER

CASINO KATE · NIFTY DATE · COOLING DIP

SUMMIT TRIP · OCEAN BREEZE · B.V.D'S

EAGLES NEST · HAIRY CHEST

Right: A collaboration by Shep and Dorothy promoting the island's various activities. Image courtesy of the Catalina Island Museum.
Overleaf: Detail of a matchbook designed by Shep.

While America slumped, baseball engaged the public; so did the booming movie industry. The island, with all its privacy, became a stomping ground for those in the business who needed a bit of discretion in regard to their spending habits and lifestyles. From 1934 to 1938, the island's entertainment complex was open every night for dancing. On many of those nights, Shep would take the bandstand and introduce Glenn Miller, Harry James, or other big and small names taking up residency in the ballroom. He would also shamelessly—and to much laughter—vamp, playing the MC to the hilt. In the audience were the likes of Charlie Chaplin, Joan Crawford, Clark Gable, Betty Grable, Irving Thalberg, Johnny Weismuller, Stan Laurel, Oliver Hardy, Jimmy Cagney, Cecil B. DeMille, and John Wayne. Sometimes the stars were there to get away and other times they were working; *Mutiny on the Bounty*, among other movies, shot water scenes on Catalina. Dorothy and Shep visited the sets and mixed with the actors. They were especially friendly with Stan Laurel and Oliver Hardy and their wives. Shep, it is rumored, cuckolded Johnny Weismuller by carrying on an affair with his wife, the entertainer Lupe Vélez.

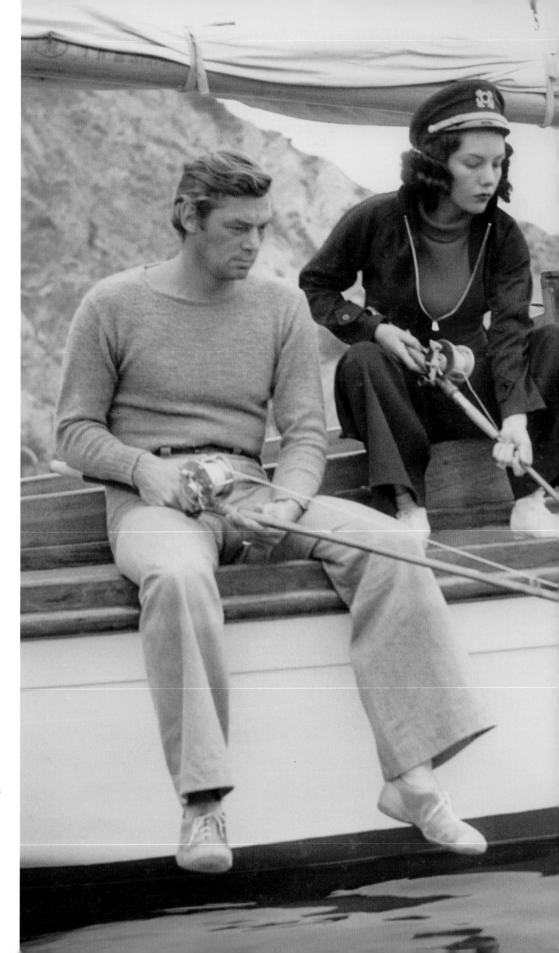

Right: **Johnny Weismuller and his then-wife Lupe Vélez were habitual visitors to the island. Both were in the prime of their careers and found a haven where they could cut loose. Here they play at fishing in the cove.**

Opposite page, below: **Dorothy's poster promoting a big band dance on the island.**

Left: Shep acting as the master of ceremonies during one of the island's many parties. He loved to be out in front, playing the host or the fool. Or both.

Below: Ladies' day out: Lois Laurel, Dorothy, Helen Wrigley, and Myrtle Hardy.

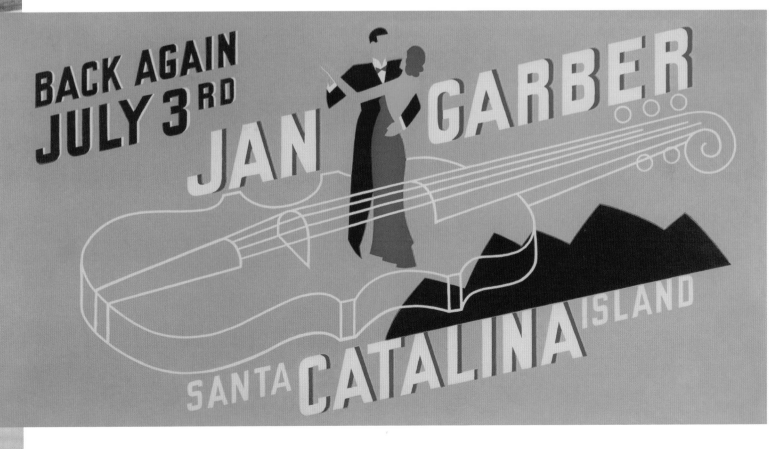

BACK AGAIN JULY 3RD JAN GARBER SANTA CATALINA ISLAND

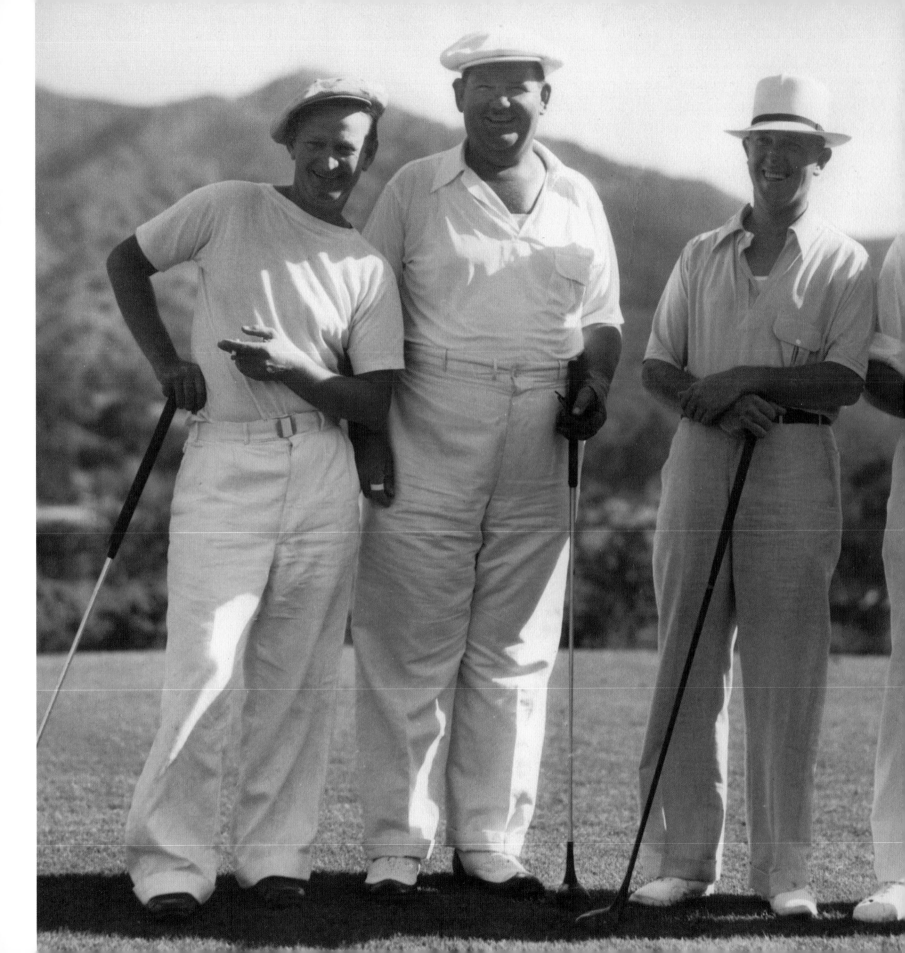

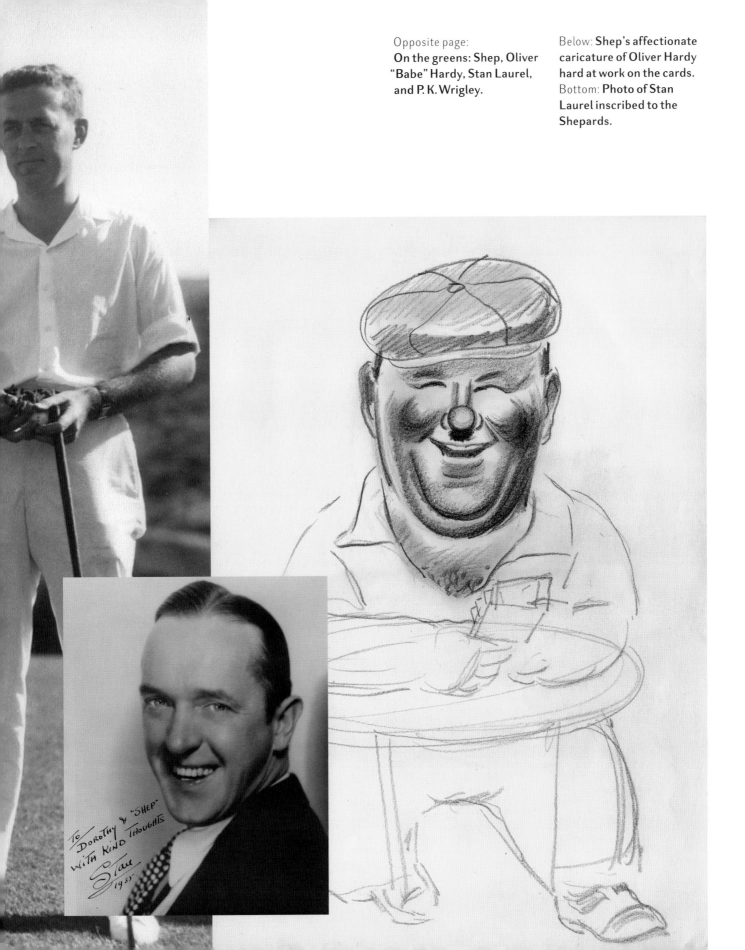

Opposite page:
On the greens: Shep, Oliver "Babe" Hardy, Stan Laurel, and P. K. Wrigley.

Below: Shep's affectionate caricature of Oliver Hardy hard at work on the cards.
Bottom: Photo of Stan Laurel inscribed to the Shepards.

To Dorothy & "Shep" with kind thoughts Stan 1935

In the midst of all this hoopla, the couple took a break from Catalina. Dorothy had become pregnant in 1935, but the child, a boy, died at birth. To get away, the couple decamped from Catalina to Europe for a few weeks in 1936. There they rented a red Austin and toured Germany and France with their friends Fred and Eva Ludekens. Catalina, as Dorothy would later say, was four glorious years; but they were not without strain. In 1938, with the implementation of their plans completed, the couple returned to Chicago.

In 1942, during World War II, P.K. turned over Catalina to the U.S. government, and it was used as a naval base because of its strategic position. When the war ended, the island reopened to the public, but it would never again be a stomping ground of the rich and famous. The Early California Plan was still in use—and Dorothy even returned with her second son, Kirk, in 1946 for another three years—but the place was rough and dark, harkening back to its pre-Wrigley days, and after 1949 she would visit only briefly every summer, whereas Shep never saw the island again.

Left: **Dorothy on the Avalon beach in later years.**
Opposite page: **Another dreamy tourism advertisement airbrushed by Shep.**

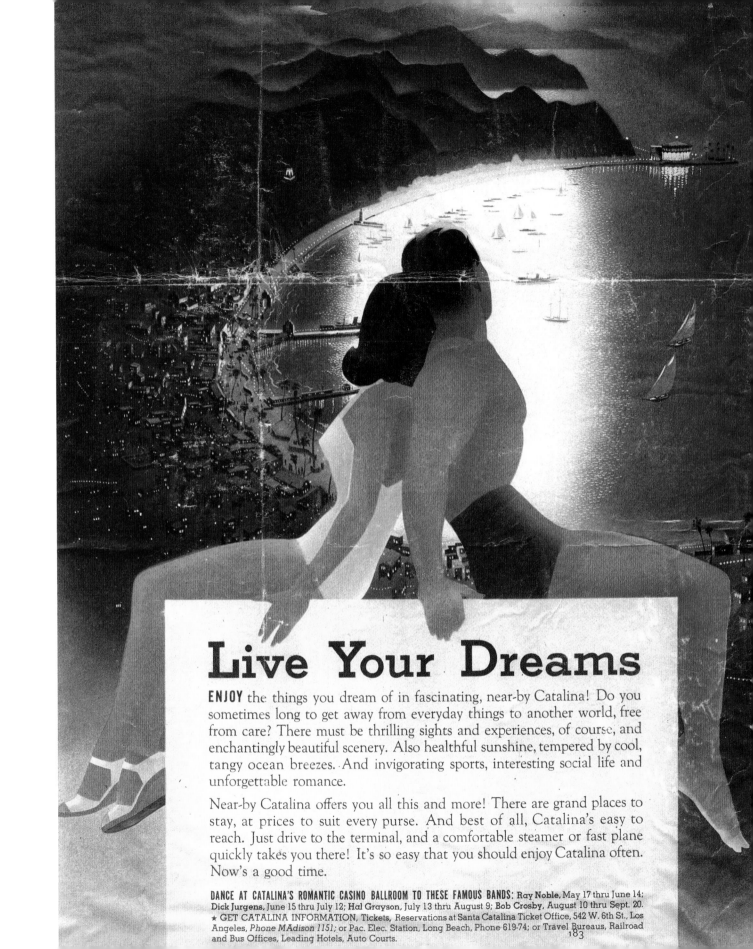

Live Your Dreams

ENJOY the things you dream of in fascinating, near-by Catalina! Do you sometimes long to get away from everyday things to another world, free from care? There must be thrilling sights and experiences, of course, and enchantingly beautiful scenery. Also healthful sunshine, tempered by cool, tangy ocean breezes. And invigorating sports, interesting social life and unforgettable romance.

Near-by Catalina offers you all this and more! There are grand places to stay, at prices to suit every purse. And best of all, Catalina's easy to reach. Just drive to the terminal, and a comfortable steamer or fast plane quickly takes you there! It's so easy that you should enjoy Catalina often. Now's a good time.

DANCE AT CATALINA'S ROMANTIC CASINO BALLROOM TO THESE FAMOUS BANDS: Ray Noble, May 17 thru June 14; Dick Jurgens, June 15 thru July 12; Hal Grayson, July 13 thru August 9; Bob Crosby, August 10 thru Sept. 20. ★ GET CATALINA INFORMATION, Tickets, Reservations at Santa Catalina Ticket Office, 542 W. 6th St., Los Angeles, *Phone MAdison 1151;* or Pac. Elec. Station, Long Beach, Phone 619-74; or Travel Bureaus, Railroad and Bus Offices, Leading Hotels, Auto Courts.

183

The Cubs

Shep transforms the Cubs and Wrigley Field
into institutions of fun, sun, and family

In the 1930s, baseball was hugely popular, but the look of the game was rooted in its Victorian past. Its colors were drab. The uniforms bore names written in fulsome script lettering. The ballparks were dingy, not a place for families. P. K. Wrigley was determined to change this, and as was his wont, he turned to Shep to liven things up. In the winter of 1936–1937, Shep set about overhauling the Chicago Cubs' uniforms. Catcher Gabby Hartnett and third baseman Stan Hack served as his models, and Shep designed six different home- and away-game uniforms.

A 1937 article in the *The Chicago Daily Tribune* read, "Everything Mr. Shepard has done for the Cubs is in the cause of art and beauty. ... He has a wide reputation as one of the leading authorities on the commercial application and the psychology of color reactions." Supporting text from Shep explained his designs and methodology:

The first principle I applied in evolving the new Cub uniforms is that color has more value in solid areas than strips. Solid color areas carry greater distances and can be seen as the color they are at greater distance. For instance, Cub uniforms of the past have been trimmed with narrow red and blue stripes. At a distance of a few feet, the strip appears purple, and a few feet farther it can't be seen at all.

Colors have been used that can be seen from the stands in all their vivid richness. Insignia, too, can be seen from the stands, and there are no more hemstitched or embroidered teddy bears to perplex and strain the eye.

The necks are bit with a deeper V then ever before. These V's were studied very carefully on the mannequins and had no feminizing effect whatever. In fact, the boys looked more athletic than heretofore. There won't be any button in the entire wardrobe, except the bright red ones atop the caps.

For some reason sock manufacturers have always made socks long enough to reach 10 or 12 inches above the knee. A ball player wears a thin white cotton sock under his costume sock. After he has rolled both down to his knees, he naturally has a knock-kneed appearance. And this distortion establishes an optical contrast, which, combined with the misplacing of stripes, destroys the athletic appearance of a player's calf. The new Cub socks will be less than knee length and the stripes will be placed around the ankle, not the calf.

Six years ago the Cubs started the use of uniform sweatshirts, then, after others had taken up the plan, went back to the rag-bag for their tattered and greasy private ones. The sleeves of the former uniform sweatshirts were such a dark blue they looked black. The new Cub sleeves will be a brilliant electric blue.

The uniforms will be tailored differently than heretofore. The elimination of the sock roll has resulted in a different design for the pants, including a re-draping of the conventional drooping seat. There will be a half-inch stripe on each trouser leg. There will be no ornate flaps on the hip pockets, in fact, no flaps of any kind.

The predominant color notes in both the white home uniforms and the bluish-gray road uniforms are bright red and brilliant blue. The ½-inch pants stripes on the white uniforms will be blue, and on the gray uniforms they will be red. The lettering on the shirts also will be in bright red and blue combinations—but the large capital *C* in Chicago and in Cubs will not be gingerbready heretofore. It will be a strong letter that anyone with good eyes can see at a reasonable distance.

With the uniforms approved by P. K. and then designed and manufactured for the 1937 season, the next step was the design of the ballpark. P. K. was determined to emphasize the ideas of fun, sun, and family because he believed it would lead to both a friendlier

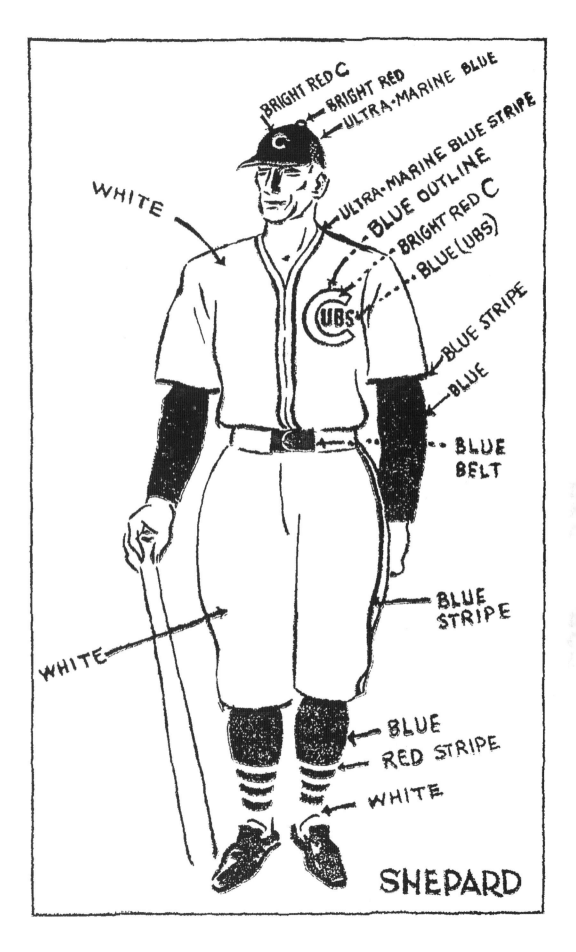

Right: **Shep's sketch of the new Cubs uniform, as published in** *The Chicago Daily Tribune*, **February 14, 1937.**

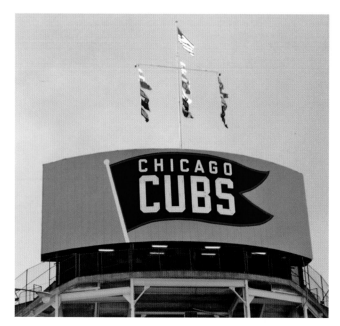

environment and greater profits. So Shep went to work making Wrigley Field and all things Cubs more family-friendly and colorful. The season tickets, vendor jackets, concession stands, and scoreboard were all transformed. The largest project of all was the bleachers, which were renovated in 1937 to P.K. and Shep's specifications. They were expanded to the northeast corner of the ballpark and given wider seats. They were painted a dark green, and ivy was planted on the walls behind them. The flag system of Wrigley Field was also Shep's design. A flag represented all eight teams in the National League, and these were flown in order of rank. The Cubs' own flag, with its bold "C" logo encased in a diamond, flew over Wrigley Field until the early 1980s. Styled very differently was the Cubs' pressroom, nicknamed The Pink Poodle. In 1941, Shep, playing off his friendship with the media, painted caricatures of several local baseball writers on its walls. Pressmen ingratiated themselves to Shep so that they might get a favorable caricature.

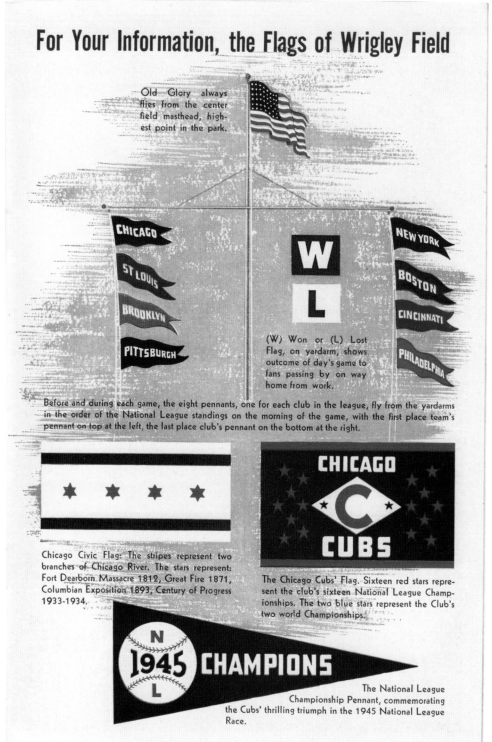

For Your Information, the Flags of Wrigley Field

Old Glory always flies from the center field masthead, highest point in the park.

(W) Won or (L) Lost Flag, on yardarm, shows outcome of day's game to fans passing by on way home from work.

Before and during each game, the eight pennants, one for each club in the league, fly from the yardarms in the order of the National League standings on the morning of the game, with the first place team's pennant on top at the left, the last place club's pennant on the bottom at the right.

Chicago Civic Flag: The stripes represent two branches of Chicago River. The stars represent: Fort Dearborn Massacre 1812, Great Fire 1871, Columbian Exposition 1893, Century of Progress 1933-1934.

The Chicago Cubs' Flag. Sixteen red stars represent the club's sixteen National League Championships. The two blue stars represent the Club's two world Championships.

The National League Championship Pennant, commemorating the Cubs' thrilling triumph in the 1945 National League Race.

Shep's design scheme and color swatches for the pennants that flew over Wrigley Field, along with a photograph of the penants.

NATIONAL LEAGUE PENNANTS
(NEW COLOR SCHEME)

COLOR FOR CINCINNATI TO BE DYED

ST. LOUIS

NEW YORK

PITTSBURGH

PHILADELPHIA

BOSTON

BROOKLYN

CHICAGO

Wrigley Field, undergoing
renovations in 1937.
Right: The scoreboard
and bleachers in progress.
Below: Shep's ivy being
planted on the back wall of
the park. Photographs by
George Brace.

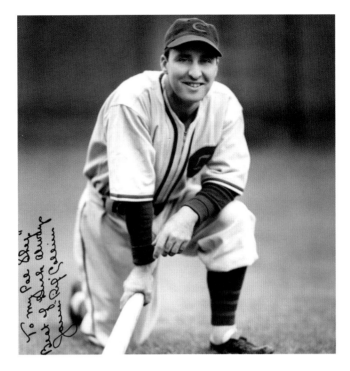

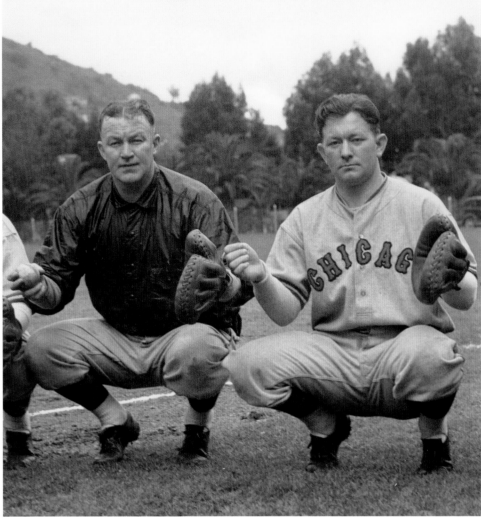

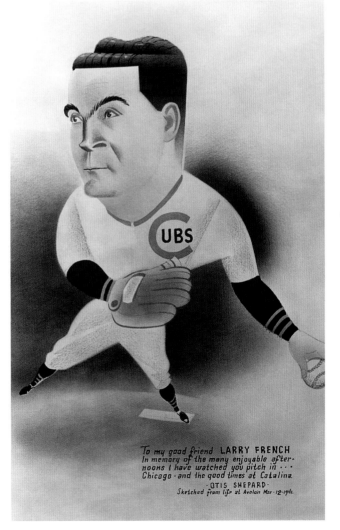

Above, left: **A signed photograph of James "Ripper" Collins, first baseman for the Cubs.**
Above, right: **Catcher Charles "Gabby" Harnett in a photo taken by Shep on Catalina. Harnett is considered one of the all-time greatest catchers in baseball history.**
Left: **A caricature by Shep of starting pitcher and knuckleball specialist Larry French, 1941.**

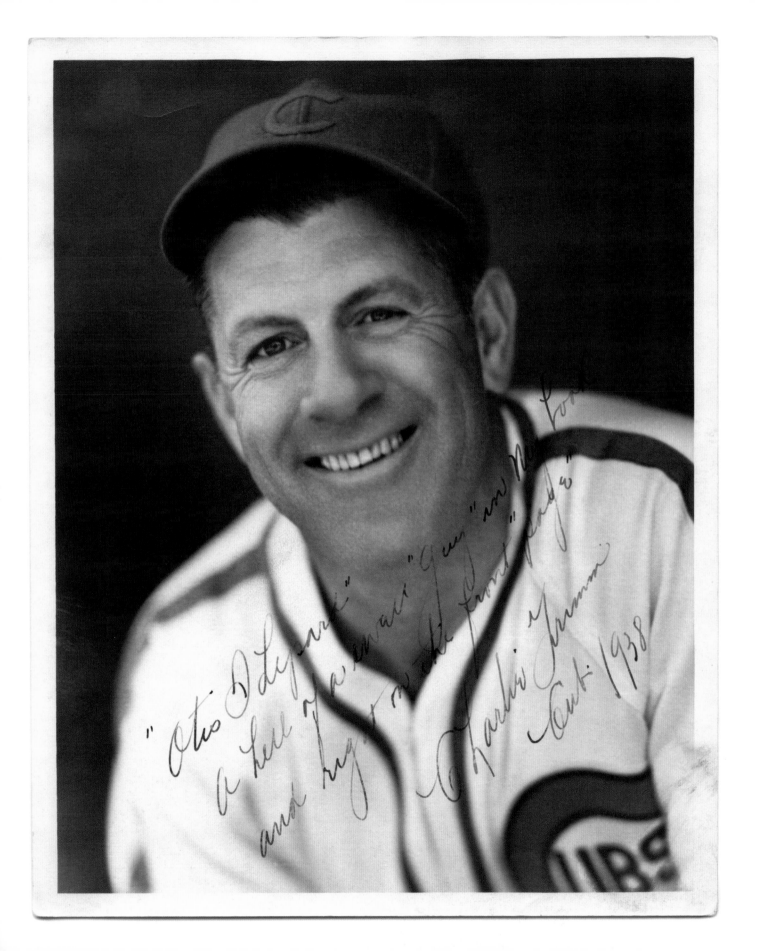

"Otto O Lepini"
A hell of a man. "Gun' on Nice too"
and Lucky on the front page"
Charlie Grimm
Oct. 1938

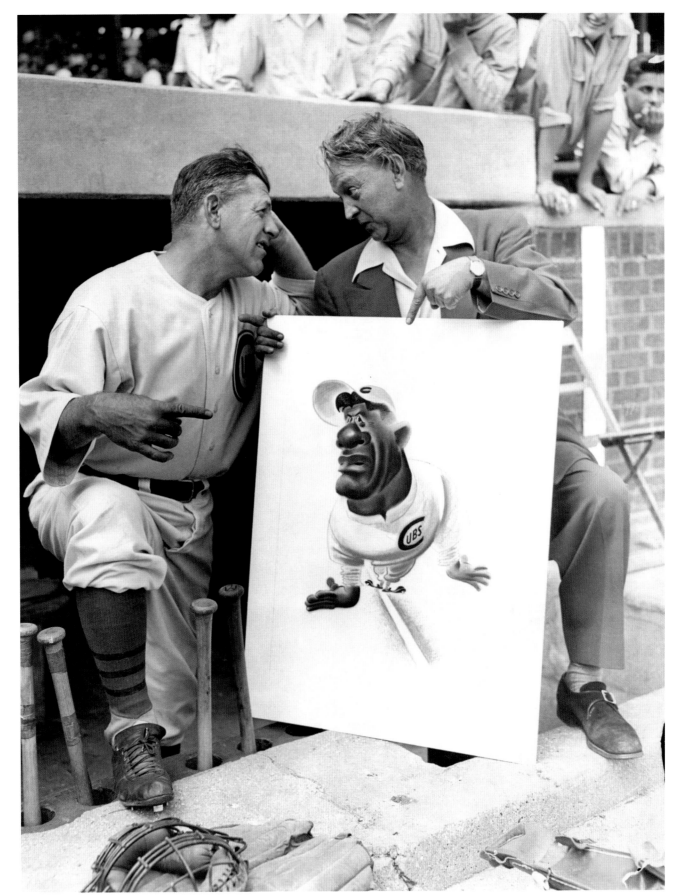

Opposite page: **Cubs General Manager Charlie Grimm in a signed photo to Shep.**
Right: **Shep presenting a caricature of Grimm to the man himself, Wrigley Field, mid-1940s.**

Membership cards for
The Pink Poodle, the Cubs'
exclusive pressroom.
No women were allowed
until the late 1940s.

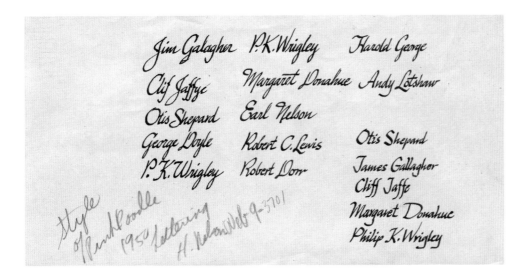

The lettering guide, at left, was completed by Shep's right-hand man, Hubert Nelson, for the 1950 cards.

memdgehr Bold 10 :

mendey light ont

SIZE OF CARD. SAME AS PINK POOPLE OR PASS - THIS IS A LITTLE DEEPER THAN HIS CARD -

HUBERT - LAYOUT THIS CARD. AS ABOVE FOR WORDING AND 2 CUB HEADS AS HE LIKED THIS PART OF THE LAYOUT. USE YOUR OWN JUDGMENT ON TYPE - COLOR RED-BLUE. BLACK. YOU MAY PREFER LARGER CAPS ON HIS NAME - ALL UP TO YOU - CHECK WITH MISS DONAHUE OR NELSON. AS TO QUANITY - ANYWAY GET THEM PRINTED - NO OKS NESSICARY FROM OUT HERE TURN OVER TO CUBS OFFICE THERE WHO WILL SEND ON TO MATTHEWS WHEREVER HE IS.

SHEP.

JUST TALKED TO THE BOSS - HE SAID TO ORDER THE MINIMUM QUANITY AS WE WOULD PROBABLY CHANGE THEM LATER ON, AS CARD WOULD ALSO BE NESSICARY FOR ALL SCOUTS AS WELL.

Above: **Shep's design for the Cubs talent scout business cards, with instructions to Hubert Nelson.**
Left: **The printed card for scout Tony Lucadello.**
Opposite page: **A layout for the Cubs Junior Booster Club, with initial member Henry Aldrich, a popular 1940s and 1950s media character.**

CHICAGO CUBS
JUNIOR BOOSTER CLUB

Has met the standards required for member-
ship and is hereby enrolled in the CHICAGO
CUBS JUNIOR BOOSTER CLUB.

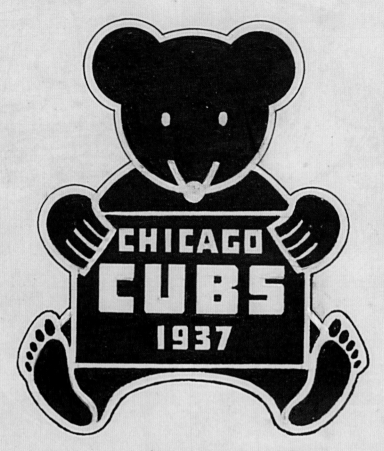

REDUCE TO
1 INCH
BETWEEN MARKS

ON 2ⁿᵈ PIN "PRESS" in
place of "CUBS"...
"CHICAGO" AND "1937" REMAIN
ON BOTH PINS

1937

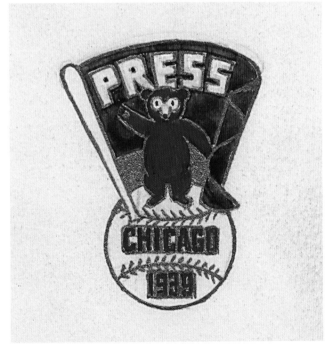

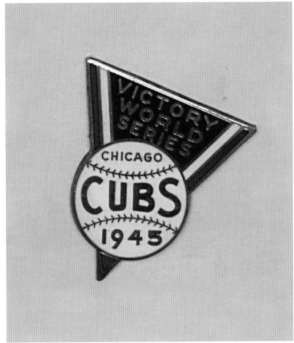

Cubs press pins over the years.
Opposite page:
A pen-and-ink drawing by Shep from 1937.
Above: **Proofs for Cubs press pins from 1937, 1938, 1939, and 1945.**

Opposite page: **An early 1960s Cubs decal by Shep.** This page, clockwise from top left: **1950s** Cubs decal; **1950s** Cubs ticket envelope; **1939 and 1938** home game schedules designed by Shep.

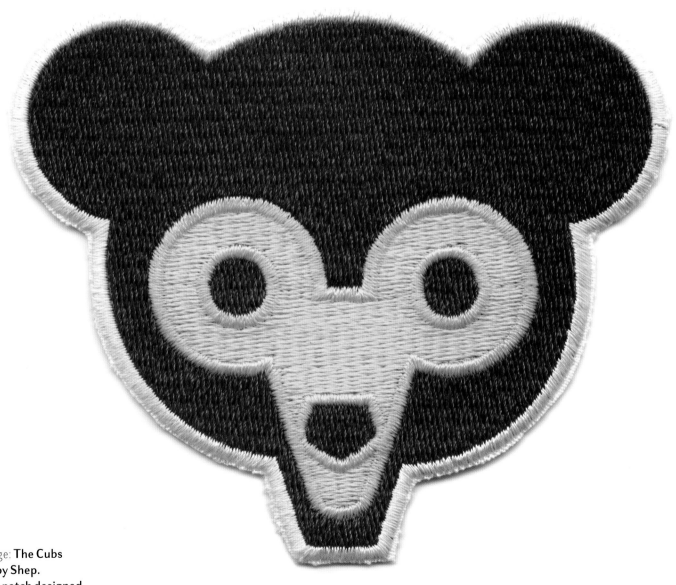

Opposite page: **The Cubs logo patch by Shep.**
Above: **Cubs patch designed by Shep, early 1960s.**

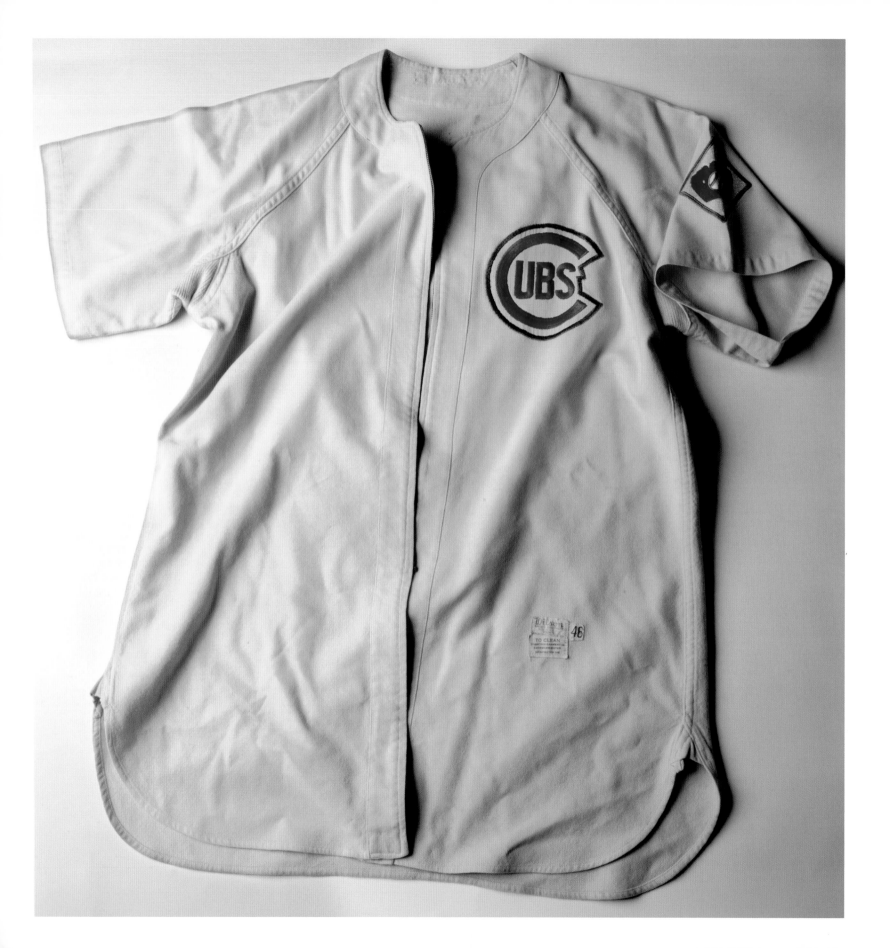

Opposite page: **A 1951 Cubs jersey bearing the National League's seventy-fifth anniversary patch, as designed by Shep.**
Left: **Detail of sleeve patch.**
Photographs courtesy of the National Baseball Hall of Fame Library, Cooperstown, N.Y.

Among the most innovative designs produced for the Cubs were its scorecards and yearbooks. Shep personally illustrated the covers of thirty scorecards and four yearbooks. Some showed baseball players caught in crucial moments of action, abstracted just enough to make the motion palpable to the viewer. In others, Shep focused on the fans, depicting P.K.'s vision of a picnic-like atmosphere at the ballpark with simple pleasures airbrushed in minimal forms. And still others were lighthearted romps, as when Shep focused on a bear cub at play. In the 1950s and early 1960s the leading baseball paper in the country, *The Sporting News Baseball Register*, often reused these images for their own covers.

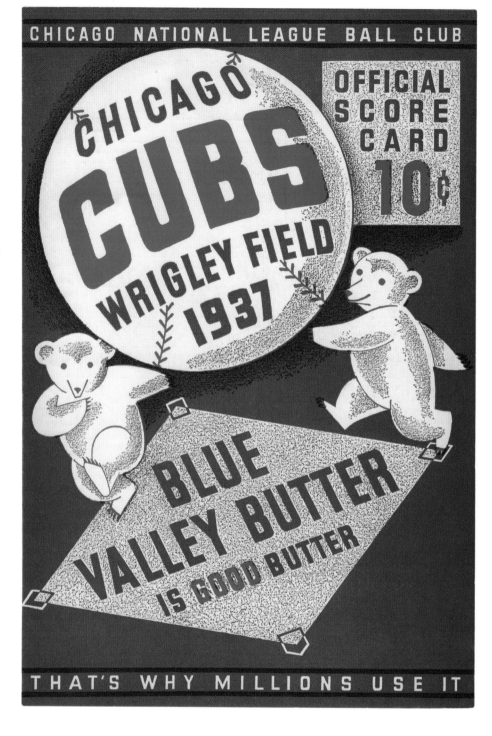

Pages 204–227: **A selection of Shep's vivid, funny, and ingenious covers for the scorecards and yearbooks of the Chicago Cubs, 1937–1968.**
Above: **1937 scorecard.**

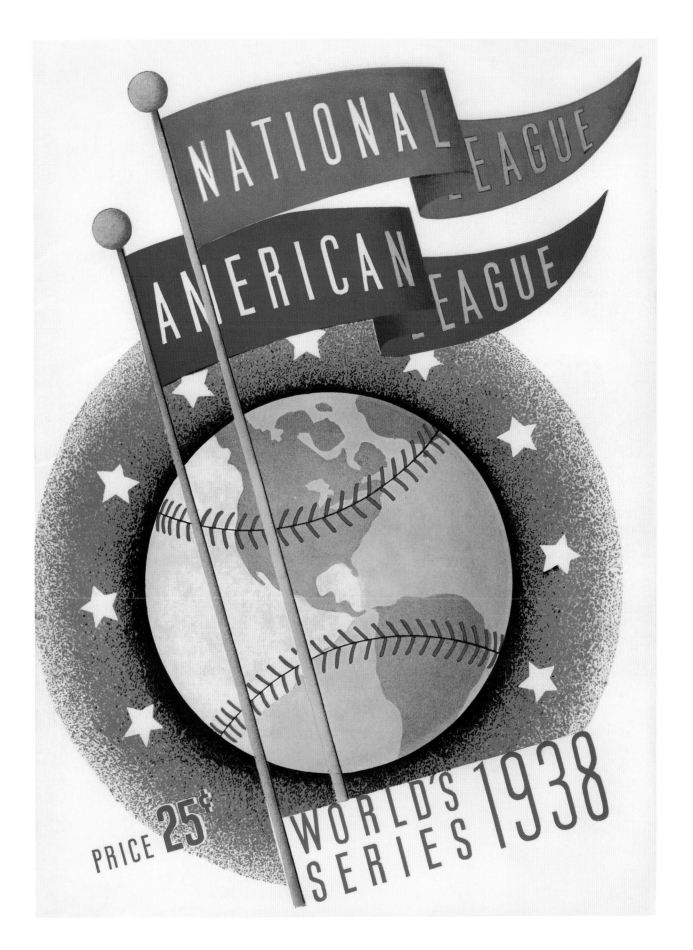

1938 World's Series
program.

1938 World's Series
Program (reverse).

OFFICIAL SCORE CARD 10¢

CHICAGO
CUBS
WRIGLEY FIELD 1941

1941 Official Scorecard.

1943 Official Program.

1947 Official Program.

1948 OFFICIAL PROGRAM 10¢

SHEPARD

CHICAGO CUBS · WRIGLEY FIELD

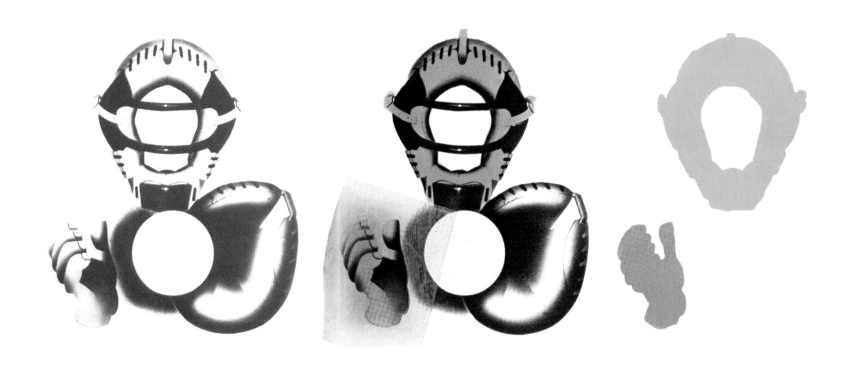

Opposite page:
1948 Official Program.

Above: **Shep's airbrush art in three stages of completion.**

1949

FIFTY CENTS

CUBS YEAR BOOK

1949 Year Book.

1950 Official Program.

CHICAGO CUBS · WRIGLEY FIELD
1950 OFFICIAL PROGRAM 10¢

1950 Year Book.

CUBS YEAR BOOK

1951

FIFTY CENTS

1951 Year Book.

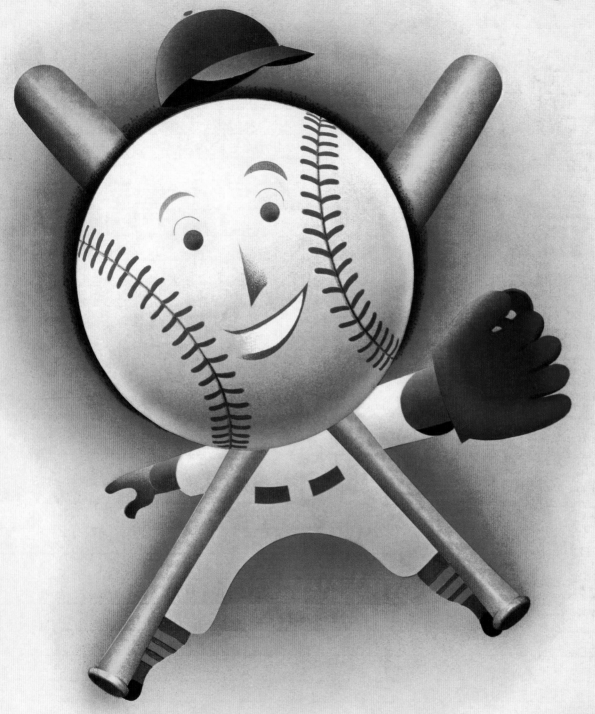

1952 Official Program.

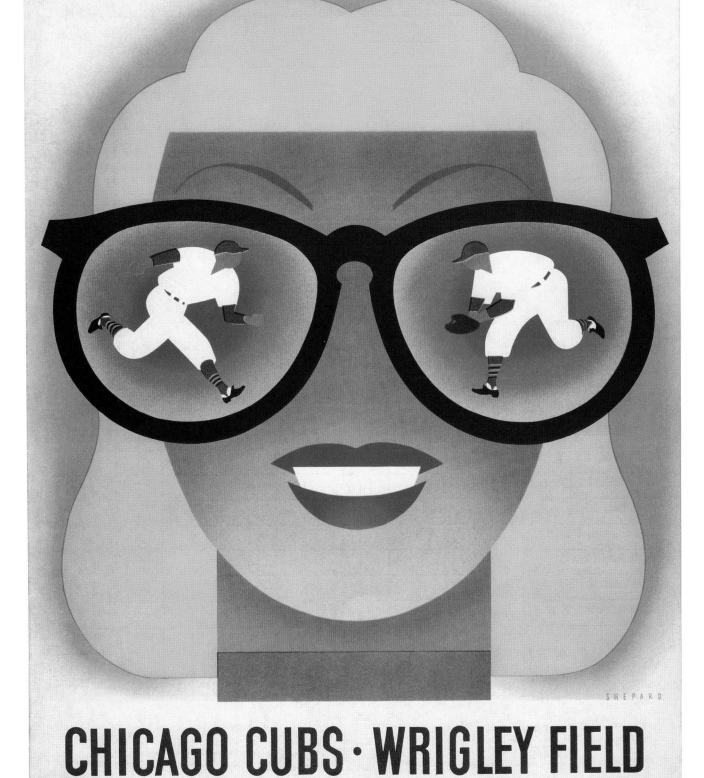

1953 Official Program.

1954 OFFICIAL PROGRAM 10¢

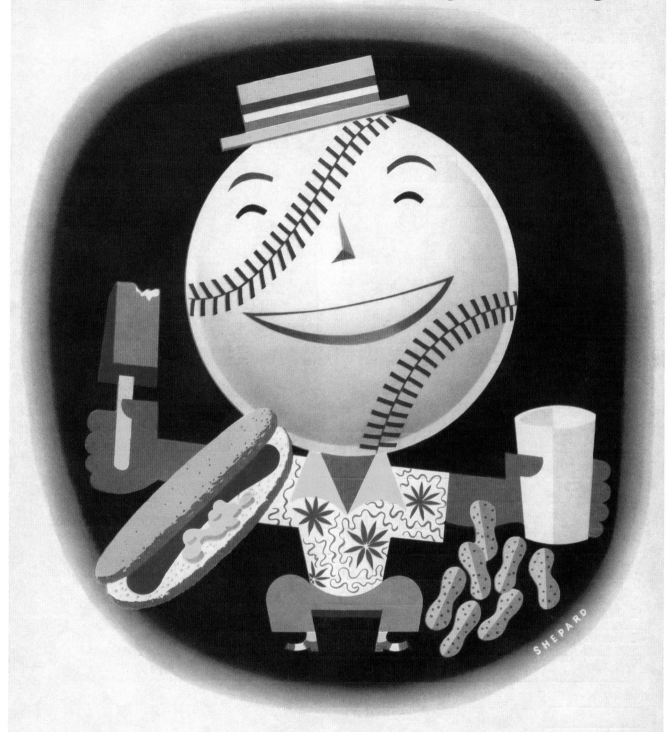

CHICAGO CUBS · WRIGLEY FIELD

1954 Official Program.

An example of how Shep's art was repurposed, and certainly re-colored, by *The Sporting News Baseball Register*.

OFFICIAL PROGRAM 10¢

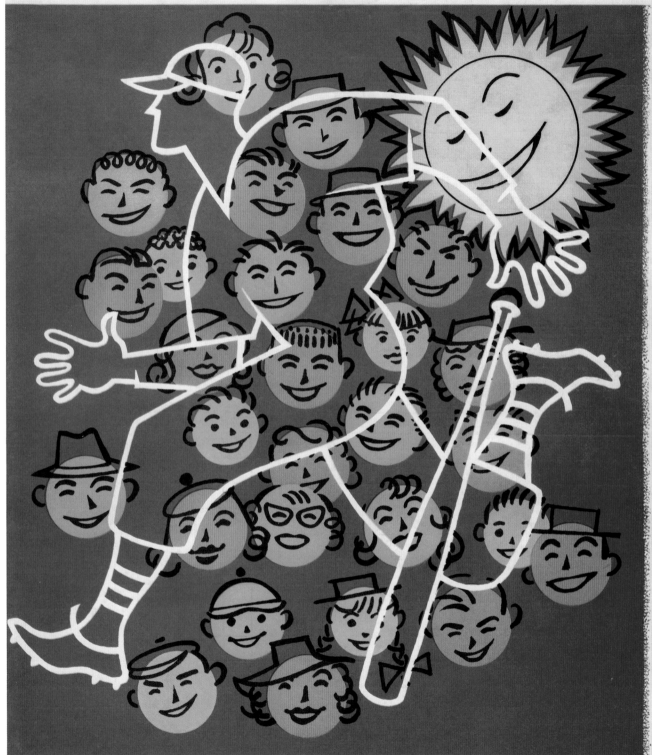

CHICAGO CUBS · WRIGLEY FIELD

1957 Official Program.

OFFICIAL PROGRAM 10¢

CHICAGO CUBS · WRIGLEY FIELD

1958 Official Program.

OFFICIAL PROGRAM 10¢

CHICAGO CUBS · WRIGLEY FIELD

1960 Official Program.

OFFICIAL PROGRAM 10¢

1961 Official Program.

CHICAGO CUBS · WRIGLEY FIELD

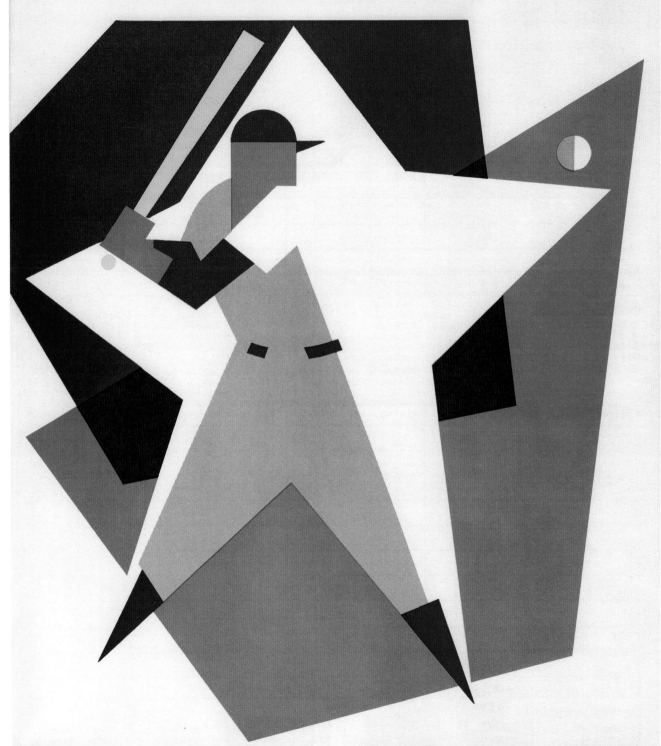

OFFICIAL PROGRAM 10¢

CHICAGO CUBS · WRIGLEY FIELD

Left: **1964** Official Program.
Above: **1964** Cubs schedule.

OFFICIAL PROGRAM 15¢

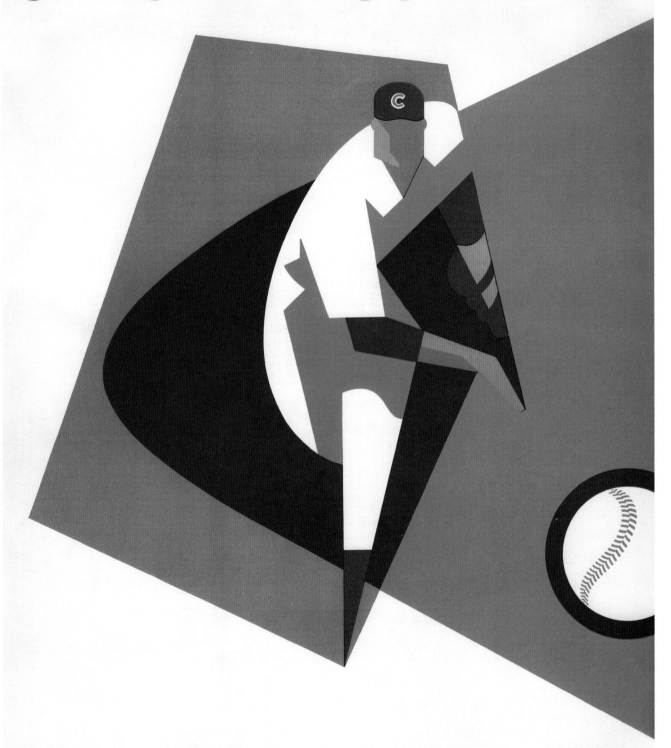

1965 Official Program.

CHICAGO CUBS · WRIGLEY FIELD

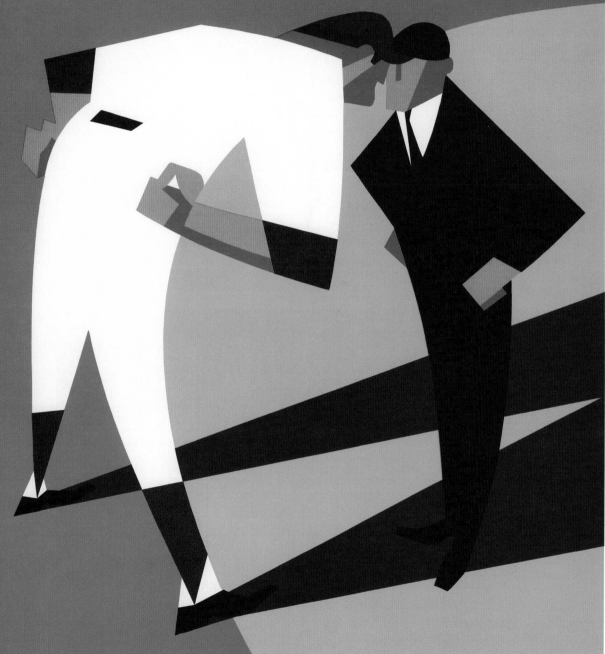

OFFICIAL PROGRAM 15¢

CHICAGO CUBS · WRIGLEY FIELD

1966 Official Program.

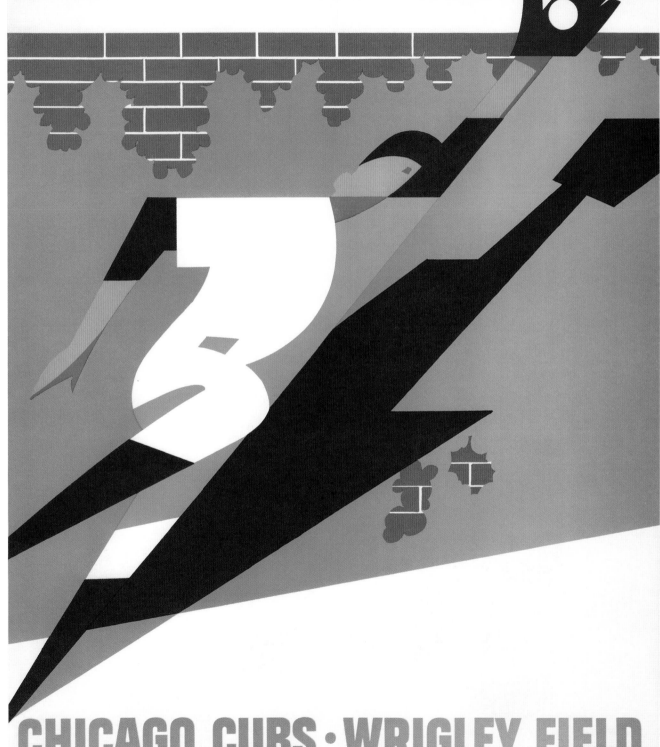

1968 Official Program.
Shep's final scorecard.

In designing for the Cubs, Shep found not only a creative playground but a social one as well. He would watch their spring training on Catalina in the 1930s, and back in Chicago he attended annual Diamond Dinners. Diamond Dinners were parties held each January to kick off the new year. They were attended by the Cubs' coaching staff and members of its front office and the local press. The dinner typically included performances from the guests, and in the 1942 one, Shep and Ed Burns performed a Latin music act dubbed "Studies in Pastel at the Twin Easels by Otis Shepard and Edward Burns." *The Sporting News* called Shep "the unofficial vice-president in charge of fun."[26] In 1947, Shep acted as the third base umpire for the Cubs' inter-squad game. In 1945, he began a tenure on the team's board of directors, which continued until 1963.

 The Cubs were the first team to have a modern uniform design. Other teams followed suit, and eventually national guidelines were applied to the look of the game that dictated logo size and placement, as well as the shape and tailoring of the uniforms. In 1951, Shep designed the shoulder patch worn on all National League uniforms in commemoration of the league's seventy-fifth anniversary. The patch design was also emblazoned on posters made by the league. This recognition by the National League formally solidified Shep as the chief visualizer of mid-century baseball.

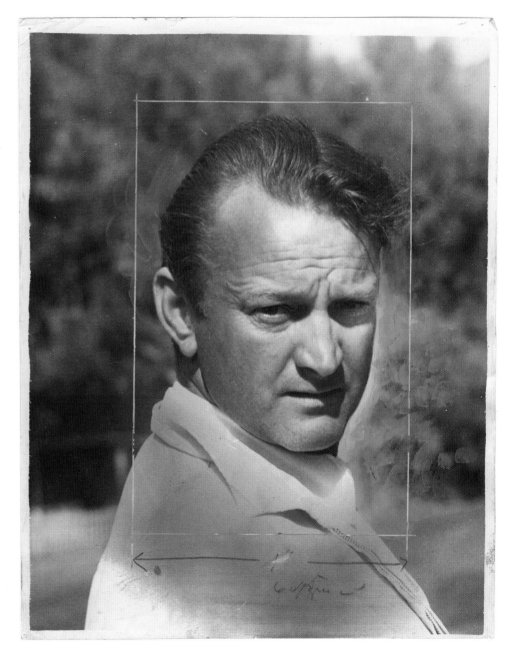

Chicago and Beyond

Together, apart, and together again,
Dorothy and Otis at mid-century

In 1938, Dorothy and Shep returned to Chicago from New York, and a year later their son Kirk was born. On the work front, they were hired in 1939 by P.K. to redesign the interior of the Biltmore Hotel in Arizona, which he owned. They added a pool and cabana area to it, and spiced up the color scheme of the entire property by adding splashes of yellow and red.

As they continued to work, Shep continued to give speeches about modernism in design. Addressing the Outdoor Advertising Association in 1938, he defined his position:

> More and more I think that in the advertising field the artist is playing a greater and more important part, because as our population grows and as our medium grows, it means that more and more we are striving for the attention of the public eye, and I don't know any better way to get it than through the picture. We know that they are probably reading less and less. I mean if we have four ads it's quite easy to read them, but when we get to have four hundred, and four thousand, it gets more difficult to read them. But we can grasp quickly a picture. As the Chinese said, a picture is worth ten thousand words.

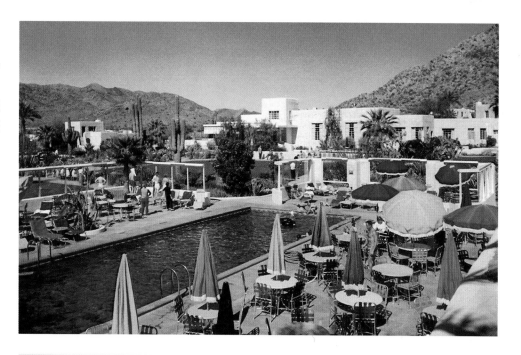

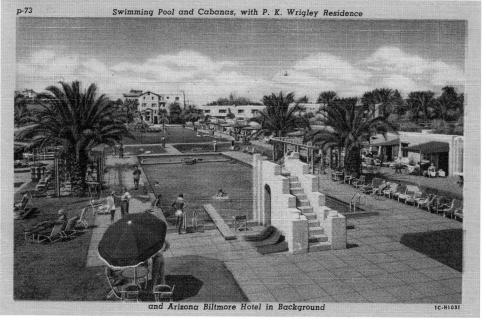

p-73 Swimming Pool and Cabanas, with P. K. Wrigley Residence

and Arizona Biltmore Hotel in Background 1C-H1031

Above: **Dorothy and Shep's redesign of the Biltmore's décor included refreshing the color schemes, as well as interior touches such as Dorothy's design for the carpeting, a sample of which is pictured at left.**

But I would say that even the lettering that goes on it, if not the thought behind it, is put on by a human hand, and I presume the reason we haven't taken the artist quite as seriously as we might—I don't ask you to take him seriously, but rather that you realize that he is there. He has never had a big office; he has never had a big desk; his workshop is usually pretty junky, because it is a workshop—but he is called upon to interpret other people's ideas and to supply a few of his own, and therefore I think that we could all be a little more lenient and conscious of this artist, and particularly generous in our attitude towards newer things. I think that all advertising media can very well embrace newer ideas. We have a change in the times, a change in the public. The buyer today that is twenty-five years old just ten years ago was fifteen, and his art interpretations were all created at that time, and ten years ago that same chap or girl that is now twenty-five was raised on an art education based in the modern vein. It was already here—modern architecture and modern design and painting—and they realize and know something about it.[27]

Shep's speech was intended to encourage an appreciation for the modernism then flowering in Europe, New York, and Chicago. Chicago's collection of European exiles, including artists László Moholy-Nagy and Mies van der Rohe, who Dorothy and Shep counted as close friends, made it a hotbed of modernism. Dorothy even took classes taught by Moholy-Nagy at the Art Institute of Chicago. And Shep participated in events held by the progressive Chicago Art Directors Club.

When the United States entered World War II, Shep contributed to the war effort by designing posters for the navy and a series of enormous murals promoting the sale of war bonds, which were installed in Chicago's Union Station for the duration of the war.

 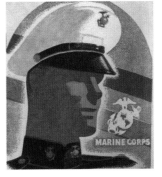 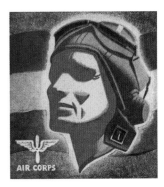
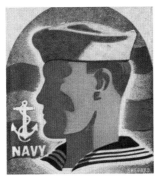 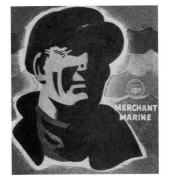 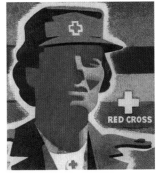
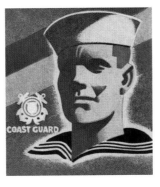 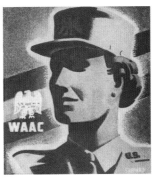
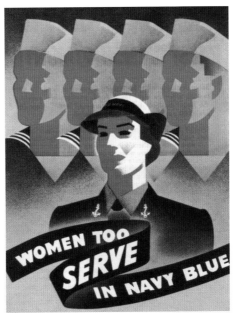

Shep's contributions to the enormous murals in Chicago's Union Station included airbrush portraits of heroic servicemen and -women set against patriotic stripes.
Above: **Eight murals as published in** *The Chicago Daily Tribune*, **September 15, 1942.**
Above, right: **A photograph of one of the murals in situ.**
Left: **A poster by Shep highlighting women's service in the navy.**

235

In 1942, concerned that the war draft was going to absorb too many current and potential professional baseball players, P.K. began brainstorming ways to fill stadiums should the league fail to assemble enough players to make complete teams. Wrigley hit on an idea: a nonprofit professional all-female softball league (later portrayed in the movie *A League of Their Own*), which would entertain factory workers supporting the war effort. There had been women's softball leagues in the past, but they were more focused on men leering at women than women being part of dignified sporting events. As noted in *Time*, the teams had names like Dr. Pepper's Girls of Miami Beach or Slapsie Maxie's Curvaceous Cuties. P.K. had three rules for his league, according to a *Time* magazine profile: " 1) His players would be girls; 2) they would be forbidden to wear slacks or skintight shorts; 3) [the teams would] have good old-fashioned baseball names."[28] He called the league The All-American Girls Soft Ball League.

As he had done with the Cubs, P.K. turned to Shep to design the softball league's uniforms. Shep collaborated on them with P.K.'s wife, Helen Wrigley, and Ann Harnett, already a softball star and the first player signed to the league. The uniform would consist of an above-the-knee skirt, belted and paired with a blouse. Rockford, Illinois, was in peach; South Bend, Indiana, was in light blue; Kenosha, Wisconsin, was in green; and Racine, Wisconsin, was in yellow. *Time* deemed the uniforms "as dignified as the field hockey costume of New England's fashionable boarding schools, ... [while still having] the provocativeness of a Sonja Henie skating skirt." In keeping with his work for the Cubs, Shep also designed scorecard covers for the league, using the airbrush look he gave the Cubs programs.

Opposite page: **Shep's official program for the All-American Girls Soft Ball League, autographed by Olive Little, Dottie Green, and Betty Jane Fritz of the Rockford Peaches.**
Right: **A photograph of the women of the All-American Girls Soft Ball League wearing their Shep-designed uniforms. Images courtesy of the National Baseball Hall of Fame Library, Cooperstown, N.Y.**

d. shepard

Opposite page: **Undated geometric collage by Dorothy.**
Above: **A rare painting on canvas by Dorothy blending her favorite bird motif with biomorphic shapes.**

While 1942 brought great success to the couple's careers, life on the homefront began crumbling. Their son Gordon, now eleven, was suffering from mental illness and was living in the Menninger Foundation sanatorium in Topeka, Kansas, where he was receiving long-term care. Shep's drinking also became problematic, and as had happened on Catalina, there were rumors of infidelity.

Dorothy and Otis separated in the early 1940s. In 1946 Dorothy and Kirk moved west: first back to Catalina, perhaps in hopes of returning to a place where Dorothy had once been happy, and then, in 1949, to Belvedere, California, where Shep bought two homes for his family: one for his mother, Nancy, and the other for Dorothy and Kirk. At the time, Belvedere was an artists' colony in a lush part of Northern California close to Dorothy's beloved San Francisco. In the early 1950s, still holding out hope for the marriage, Dorothy took an impulsive trip to Chicago to surprise Shep. She was devastated to find him living with another woman, and they divorced shortly thereafter. In the ensuing years, Shep would visit Belvedere only once or twice a year to see his family.

Dorothy adapted to life in Belvedere and was an active and popular part of its community. According to Kirk, no matter the circumstance, she was always incapable of saying anything negative about anyone.

In the Belevedere years, she was always elegant, and habitually wore matte red lipstick and bright cashmere cardigans. Her hair, which never lost its dark luster, was kept in a braided bun, usually with a decorative comb. She was an avid swimmer (on Catalina it had been said that you could tell when spring arrived because Dorothy would be spotted taking laps in the harbor) and swam in the nearby lagoon until she was eighty-eight. Having never learned to drive—despite Shep's having bought at least two cars for her and Kirk in the 1950s—she often took the bus to San Francisco to catch up on films and music and pick up a case of scotch, her drink of choice.

Below: **Edward Weston's 1945 portrait of Shep. This portrait, along with the matching picture of Dorothy, on the opposite page, has long signifed to Kirk Shepard the period of darkness that descended on the household shortly before the couple split.**

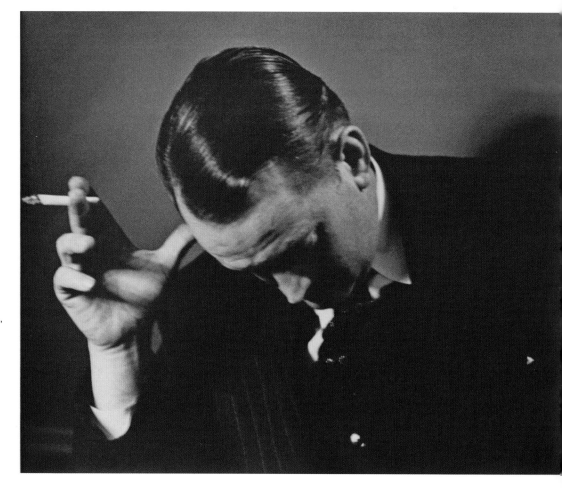

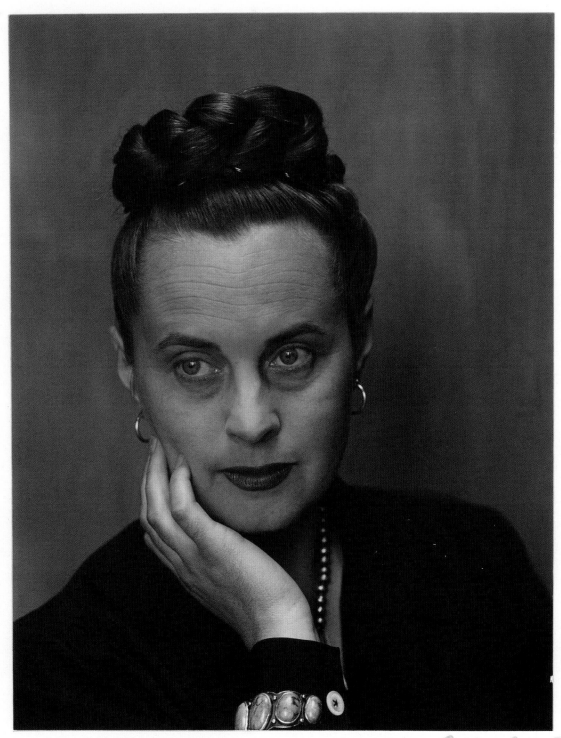

EW 1945

Although she maintained an avid interest in art, particularly the work of Matisse and Brueghel, and lived among and socialized with artists, Dorothy never returned to commercial art after her move. It was as though she needed to leave her old life behind her in order to move on. She took life drawing classes, painted sharp-edged abstractions in her spare time, and traveled—returning to Spain and England a few times—but mostly she tended to the house and looked after Kirk. In the early 1950s Gordon was moved to Sonoma State Hospital to be closer to Dorothy and Kirk, and in Northern California he flourished. Despite his mental handicaps, he—like his parents—was a painter. He particularly enjoyed creating colorful images of circus scenes and was even a featured artist at Creativity Explored, a center for artists with developmental disabilities, from 1992 until his death in 2011.

In the 1950s and 1960s, Shep took on freelance assignments in addition to his advertising and design duties for the Cubs, Wrigley, and the women's softball league. These included designing the program covers for the Arlington and Washington horse-racing parks. He also gave a prodigious number of lectures, and—as was his way—found time for cars. One of his last big splurges was a 1956 red Thunderbird, which he drove from Chicago to Mesa, Arizona, claiming speeds of up to 120 miles an hour.

Opposite page: **Shep's 1954 racing form cover for the Arlington Park racetrack used vibrant colors to differentiate the near-identical forms, and a forward slant to convey intense motion.**
Left: **A 1955 program cover for Washington Park puts the horses front and center, lunging at the viewer.**
Below: **Shep on a Cushman scooter in the 1950s.**

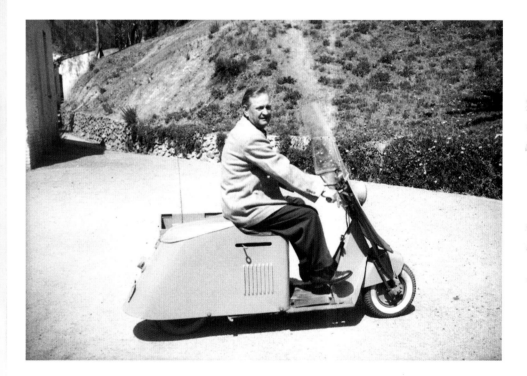

Otis Shepard
Transcript of a talk presented to the Milwaukee Advertising Club, October 23, 1947

It gives me a lot of pleasure to do a return talk to the Milwaukee Advertising Club after eight years, but then, perhaps this group is a new generation of advertising men. Speaking of new generations, I had some figures brought to my attention the other day that you might find interesting.

63 Million Individuals:
No previous experience with a free market for cars, homes, clothing, etc.

68 Million Individuals:
No previous experience with a peacetime economy

83 Million Individuals:
No adult experience under a Republican administration

90 Million Individuals:
No adult experience with the 1929 crisis

110 Million Individuals:
No adult experience with World War I

So you can see that an advertising campaign that talks about the good old days, or how long you have been established, would mean little to these groups.

Now to get on with our subject, advertising. I've spent my life at it, starting as an apprentice in engraving, printing houses, show cards, newspapers, then to outdoor posters, and it has been in this field that I have spent most of my career.

To me advertising is the art of stating the truth attractively. I have further tried to look at advertising impersonally. I shall never forget the first poster design I made for the Wrigley Company. Mr. Wrigley took one gander at it and said, "I don't like it," and I said, "Mr. Wrigley, what has that got to do with it? Are you trying to sell chewing gum or hang this in your parlor?" He looked at me and answered, "You've got something there." I doubt that I made one since that he ever really liked, but what we do think of is whether the buyer we are trying to reach will like it, and we know this best by whether our sales curve goes up or down.

One point I would like to bring out is that we, as advertising men, owe the public something in return for the ads we force upon them. Not so much in the magazine ad, because there they have the privilege to turn the page or throw the direct mail in the wastepaper basket. But in outdoor or car cards, it is not so easy. They come right out and hit you, whether you like it or not.

We also have a further responsibility in shaping the taste for good or bad over our younger generations now growing up. I have a bone to pick with advertising men in general—i.e., there is too much emphasis placed on selling the client rather than on creating ads that sell the prospective customer. But I am for those fellows in the advertising agencies who write the copy, draw the pictures, and do the research, and all the other chores necessary to make a creative, good-looking ad.

Oh, yes, I have a beef with clients too, particularly those who think they know something about advertising without giving it their full-time study. You know the guy who says, "Now what we should have on our ads is, a picture of a pretty baby holding a rattle." Now, mind you, this is going to advertise a bank. Not that people are not interested in pretty babies, but is he not overlooking some vital sales point that might do a much better job of selling his bank to the public?

Another device I believe we use too much of is the pretty girl theme. I have experienced so many agencies that will have an artist paint a beautiful oil painting of a pretty girl draped over the surface of a large canvas, and then on a piece of acetate have a lettering man do some fancy piece of copy as an overlay. Then the salesman takes it out to sell to some client. If he does not buy it, they bring it back; and again, the lettering man makes a new overlay and they do it all over again, but of course for another prospect. And this goes on until somebody buys it.

In every industry there is a sales point that can be done attractively, and which will be individual to the business alone. At this point, I would like to take off my coat and draw a few examples of at least how I would go about designing an advertisement. First I will draw the average shapes to be found in our major advertising medias. Here is the magazine page, the newspaper, direct mail, outdoor poster, and the car card. In all this media you can use as much copy as desired, with the exception of the outdoor poster. But remember that the single poster technique can be used in all.

Poster designing is an art all in itself. The poster artist thinks in simple forms, both in color and composition. If the study of the magazine or newspaper ads reveals

that most all of them are using detailed illustrations, then we might dominate the media with a poster-stylized treatment. Every ad, after all, is in competition with each other for readers' attention. However, the outdoor poster or billboard has a definite time restriction that makes it a "must" for using abbreviated copy in words and picture.

I have spent a great deal of time in research as to how long the average rider in an automobile can see the average poster, and find that it will average about eight seconds. Now, this does not mean that outdoor advertising has only eight seconds, exposure, as it is usually up for thirty days at least, giving the passerby more time to catch some feature that he did not get on the first look.

First of all, a solid color used simultaneously with pastel shades illustrates the stylized technique as against the literal detailed interpretation. I feel that we can attract the eye more quickly with the interpretive or stylized technique, as it is a treatment the average person does not see all the time, and is never in competition with the real thing itself. For example, let us go back to the realistic pretty girl painting. We are accustomed to seeing the pretty girl in the flesh, and in the third dimension every day—well, almost every day. The painting I speak of can only be an imitation of the real thing, while the design or stylized treatment of the same subject can be novel and yet tell the same story more strongly, and this goes for all media.

I further believe that the copy-man and the artist must work very closely together, and that the well-designed advertisement should be planned so that the lettering is an intricate part of the composition and not something added after the fact. If the ad is hard to follow, then the trouble is in the composition. I believe it was Hamlet who made the statement, "A ghost can assume a pleasing shape."

Well, I would like to say in closing that it has been very pleasant doing a return visit here, and that my main purpose in talking before advertising men is in bringing a closer relationship between copy-man and artist; as I really feel that I would like to be considered an impresario for the artist and the work he is doing for advertising, so that he continues to fight for better and more liberal latitude in his work. The advertising profession is a real one and we can all be proud of being in it, because it is ever-interesting and ever-changing, and because we do not have to do the same thing over and over again, but do the same thing differently all the time. It is like the new look—the hems go down, and then they go up.

An undated self-portrait by Shep.

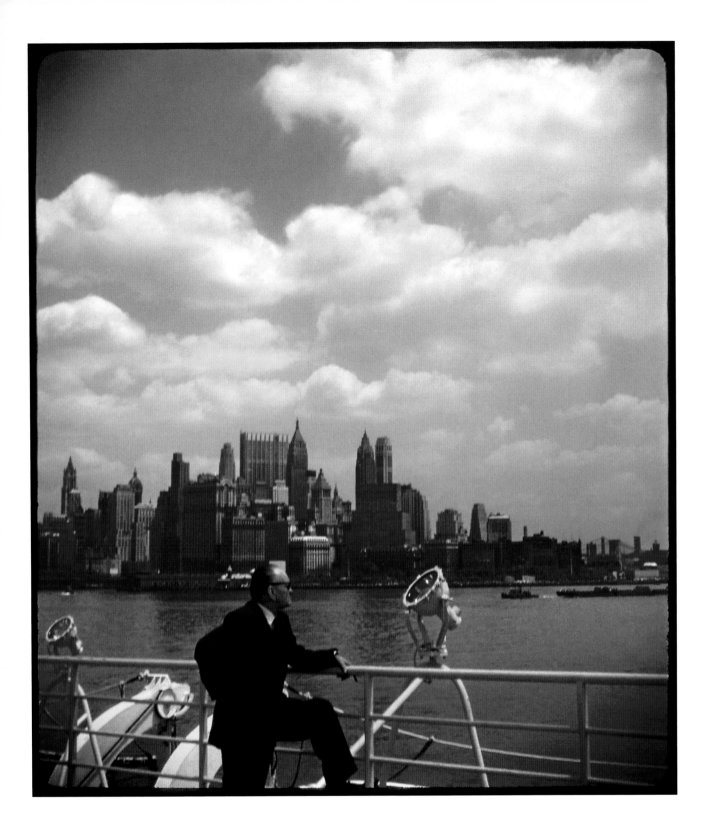

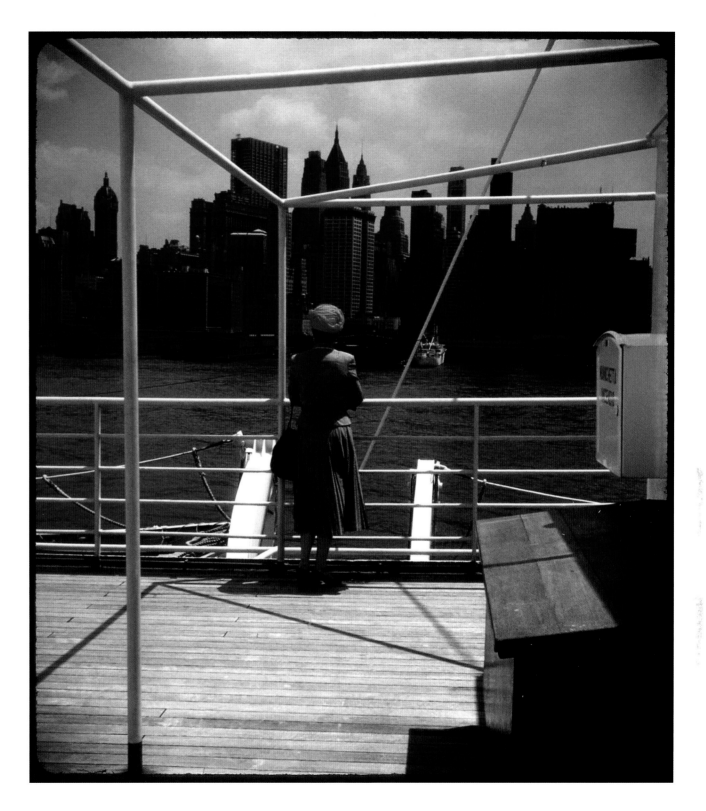

When Dorothy and Shep reunited in 1962, they traveled together to New York. They are pictured here and on the opposite page, each photographed by the other, on a ship rounding Manhattan.

248

Opposite page: **This clever Christmas card shows Dorothy and Shep, together again. On the front is the Chicago cityscape Shep left behind.**
Below: **Inside is the sunny Bay Area life they made together in Belvedere in the 1960s.**

6 LAGOON RD · BELVEDERE · TIBURON · CALIFORNIA

Shep retired from Wrigley's in 1962 and moved
to Belvedere and Dorothy the same year. Their
relationship had improved in the intervening years,
and so he returned to her and she took him in.
They traveled to New York together, spent time in
Palm Springs, and renewed the old romance. They
were remarried in 1965, but within a year Shep's
health began to decline. He developed amyotrophic
lateral sclerosis (ALS), which at the time was a
new, undiagnosable series of physical ailments. His
mind remained sharp, however. In his last years he
would sit in the family's backyard in his wheelchair
and dictate instructions to assemble an artwork
on the backyard fence. Made of driftwood, vinyl
records, Plexiglas, and nuts and bolts, it eventually
ran almost thirty feet long and was the couple's
final collaboration. He also designed furniture,
which a high school student put together. Shep
passed away on February 2, 1969. Dorothy died of
natural causes on December 10, 2000, in Belvedere,
where she'd remained, tending to her family and
her and Shep's artistic legacy, creating detailed
scrapbooks of their time together and apart. Those
books, which are the foundation of this book, were
Dorothy's last great artistic achievement.

Left: **Dorothy in Belvedere
in the 1990s.**
Opposite page: **Shep in Palm
Springs, mid-1960s.**

Acknowledgments

The authors wish to thank the Shepard family: Kirk, Erin, Cathy Wade Shepard, and Faith Robb, for their trust, generosity, and enthusiasm. Without them this book would never have been possible.

Thanks are due to: Joshua Larkin Rowley at Duke University's Hartman Center for Sales, Advertising & Marketing History for his help in locating billboards by Dorothy and Shep, and Chris Adams from Exquisitely Bored in Nagadoches for his photo of the Wrigley's wall sign.

Former Wrigley archivist Linda Hanrath and Jennifer Andreola senior archivist from the History Factory.

John Boraggina at the Catalina Island Museum for his help locating materials.

A tip of the cap to Dan Wallis and Ed Hartig for their invaluable help with our research on the Cubs; Warren Bernard for additional help on Cubs research; Michael Janowowski for the loan of his Cubs scorecards and The National Baseball Hall of Fame.

Lydia Wahlke with the Cubs was a huge help in unearthing many of the images in that chapter. We thank the Cubs and Major League Baseball. Major League Baseball trademarks and copyrights are used with permission of Major League Baseball Properties, Inc.

Thanks to Signe Bergstrom of HarperCollins for her support for this project, and to our editor, Julia Abramoff, for her guiding hand. Thanks are also due to Lynne Yeamans for shepherding us through the design process. Our agent, P. J. Mark, got the whole thing rolling, and we thank him for that.

Thanks also to Donat Raetzo, Ethan D'Ercole, Bill Wasik, Ches Wajda, Carole Coates, Mark Newgarden, Kristine Larsen, Michael Doret, and Steven Bialer.

Opposite page: **One of Shep's airbrush cases with his hand-lettered Wrigley return address label.**

Notes

1 J.G.T. Spink, "Looping the Loops," *The Sporting News*, March 8, 1945. 1, 3.

2 Otis Shepard, untitled, unpublished memoir, undated. 1.

3 Ibid.

4 Augusta Leinard, "Otis Shepard, Man and Artist," *The Poster*, July 1929. 17–19.

5 Otis Shepard, untitled, unpublished memoir, undated. 1.

6 Augusta Leinard, "Otis Shepard, Man and Artist," *The Poster*, July 1929. 17–19.

7 Otis Shepard, untitled, unpublished memoir, undated. 1.

8 Augusta Leinard, "Otis Shepard, Man and Artist," *The Poster*, July 1929. 17–19.

9 Lewis Ferbraché, "Oral history interview with Glenn Anthony Wessels, 1964 Feb. 14," 1964. http://www.aaa.si.edu/collections/interviews/oral-history-interview-glenn-anthony-wessels-11880.

10 Ibid.

11 Steve Strauss, *Moving Images: The Transportation Poster in America*. New York: Fullcourt Press, 1984. 72.

12 Ibid.

13 Steve Strauss, *Moving Images: The Transportation Poster in America*. New York: Fullcourt Press, 1984. 73.

14 Otis Shepard, manuscript for a talk presented to the Milwaukee Advertising Club, October 23, 1947.

15 Chas F. Drake, "Gunning for Gum Sales," *Art and Industry*, May 1937. 197–200.

16 Ibid.

17 Uncredited, "Outdoor, Car Cards Used by Wrigley to Make Juicy Fruit," *Advertising Age*, December 8, 1952. 54.

18 Uncredited, Untitled, *Time*, August 2, 1937. No page number.

19 Uncredited, "Chewing Gum – Sales Agent for Millinery," *Millinery Research*, September 20, 1939. 7.

20 J.G.T. Spink, "Looping the Loops," *The Sporting News*, March 8, 1945. 1, 3.

21 Chas F. Drake, "Gunning for Gum Sales," *Art and Industry*, May 1937. 197-200.

22 Chas F. Drake, "Gunning for Gum Sales," *Art and Industry*, May 1937. 197-200.

23 Steve Strauss, *Moving Images: The Transportation Poster in America*. New York: Fullcourt Press, 1984. 74.

24 Uncredited, "New Avalon Pictured at Public Meeting," *The Catalina Islander*, April 26, 1934. 6.

25 Steve Strauss, *Moving Images: The Transportation Poster in America*. New York: Fullcourt Press, 1984. 74.

26 J.G.T. Spink, "Looping the Loops," *The Sporting News*, March 8, 1945. 1, 3.

27 Otis Shepard, unpublished lecture transcript, 1938.

28 Uncredited, "Ladies of Little Diamond," *Time*, June 14, 1943. No page number.

Opposite page: **Shep's airbrush with "jade" celluloid handle.**